Praise for A. O. Scott's
Better Living Through Criticism

ı̊8

"In this book, as in his reviews, Scott's voice is genial, reasonable, and self-aware. He elucidates complex ideas with snappy language. He's funny, but not cynical or snarky. . . . What he does especially well is explain how art develops and why our varied responses to it matter, pinpointing where criticism fits into the equation." —*Newsday*

"Mr. Scott is very intelligent. . . . What may matter more is that Mr. Scott is fun to read. . . . [Scott] says that the simple questions—always with complex answers—that criticism poses are: 'Did you feel that?' 'Was it good for you?' 'Tell the Truth.' He reminds us that critical judgments, like art itself, demand intellectual and sensuous, even sexual, responses. Mr. Scott answers his own demands."
 —*The Wall Street Journal*

"Rousing and erudite." —*San Francisco Chronicle*

"Witty and thoughtful . . . Reading Scott's book is like watching the stiff-upper-lipped hero of a British 1940s thriller facing down his or her adversaries—modest, brave, and utterly unflappable." —*Los Angeles Times*

"If we were looking for an intelligent, informed, and often funny account of why we can't live comfortably with criticism (in any of the word's meanings), and can't live without it, either, we need look no further, and shall probably want to read this book more than once."
 —*The New York Times*

"Impassioned and deeply thoughtful . . . Scott lays out a taxonomy of meaningful thought (and the meaning of thought itself). . . . His disciplined reasoning, impressive erudition, and deep commitment to his art (as he defines it) are never less than provocative and elegantly articulated. A zealous and well-considered work of advocacy for an art too often unappreciated and misunderstood."

—*Kirkus Reviews*

"This stunning treatise on criticism from *New York Times* film critic Scott is a complete success, comprehensively demonstrating the value of his art. . . . A necessary work that may enter the canon of great criticism."

—*Publishers Weekly* (starred review)

PENGUIN BOOKS

BETTER LIVING
THROUGH CRITICISM

A. O. Scott is a chief film critic at the *New York Times* and Distinguished Professor of Film Criticism at Wesleyan University. He lives with his family in Brooklyn, New York.

Better Living Through Criticism

How to Think About Art, Pleasure, Beauty, and Truth

A. O. Scott

PENGUIN BOOKS

PENGUIN BOOKS
An imprint of Penguin Random House LLC
375 Hudson Street
New York, New York 10014
penguin.com

First published in the United States of America by Penguin Press,
an imprint of Penguin Random House LLC, 2016
Published in Penguin Books 2017

Excerpts from "Reasons for Attendance" from *The Complete Poems of Philip Larkin*,
edited by Archie Burnett. Copyright © 2012 by The Estate of Philip Larkin.
Reprinted by permission of Farrar, Straus and Giroux, LLC and Faber and Faber Ltd.

ISBN 9781594204838 (hc)
ISBN 9780143109976 (pbk.)

Printed in the United States of America
1 3 5 7 9 10 8 6 4 2

Designed by Gretchen Achilles

for Justine

ERNEST: You have told me many strange things to-night, Gil-bert. You have told me that it is more difficult to talk about a thing than to do it, and that to do nothing at all is the most difficult thing in the world; you have told me that all Art is immoral, and all thought dangerous; that criticism is more creative than creation, and that the highest criticism is that which reveals in the work of Art what the artist had not put there; that it is exactly because a man cannot do a thing that he is the proper judge of it; and that the true critic is unfair, insincere, and not rational. My friend, you are a dreamer.

GILBERT: Yes: I am a dreamer. For a dreamer is one who can only find his way by moonlight, and his punishment is that he sees the dawn before the rest of the world.

ERNEST: His punishment?

GILBERT: And his reward.

—OSCAR WILDE, "The Critic as Artist"

From now to the end of consciousness, we are stuck with the task of defending art. We can only quarrel with one or another means of defense.

—SUSAN SONTAG, "Against Interpretation"

Contents

CONTENTS

Introduction

What Is Criticism?
(A Preliminary Dialogue)

Q: What's the point of criticism? What are critics good for?

A: Those are the big questions! The obvious questions, anyway. But they're not exactly the same question.

Q: But isn't criticism just whatever critics do?

A: Sure. And everybody who criticizes is a critic. You see the problem. We've barely gotten started and already we're running in circles. When we talk about criticism, are we talking about a job—a kind of writing, a species of journalism or scholarship, an intellectual discipline of some sort—and therefore the people who make their livings at it? Or are we talking about a less specialized undertaking, something like playing cards or cooking or riding a bicycle, something anyone can learn to do?

Or maybe even a more elementary, more reflexive activity, like dreaming or breathing or crying?

Q: I thought the arrangement was that I would be asking the questions here.

A: Sorry.

Q: So let's start again, and start with you. You are a professional critic, and also someone who thinks a lot about what criticism is and what it's for.

A: Though not necessarily in that order. And not exclusively, of course.

Q: Okay. But what I'm asking is—

A: What good am I? What's the point of what I do?

Q: If you want to put it that way. I might not have been quite so hostile.

A: No worries. Opposition is true friendship, as William Blake said. Every critic grows accustomed to dealing with skepticism and suspicion and, sometimes, outright contempt. *How dare you! What gives you the right? Why should anyone listen to you?* We get this all the time. Provoking people to question our competence, our intelligence, our very right to exist—that seems to be a big part of what it is to be a critic.

Q: And now you've decided to fight back. You're feeling defensive. Would it be accurate to say that you wrote this whole book to settle a score with Samuel L. Jackson?

A: Not exactly. But I'm glad you brought that up. A bit of background: In May 2012, on the day *The Avengers*—you saw it, right? Everyone did—was released on 3,500 screens across North America, I published a review in which I praised some aspects of the movie—the cleverness of its dialogue, the sharpness of the performances—while complaining about others, in particular its sacrifice of originality on the altar of blockbuster conformity. If you'll allow me to quote myself: "The secret of 'The Avengers' is that it is a snappy little dialogue comedy dressed up as something else, that something else being a giant A.T.M. for Marvel and its new studio overlords, the Walt Disney Company." That assessment stands up pretty well, if I say so myself. By the time *Avengers: Age of Ultron* came along a few years later everyone else seemed to be saying more or less the same thing: that its charms and thrills were overwhelmed by soulless corporate spectacle. There is some satisfaction in having been in the vanguard of pointing out the obvious.

At the time, though, I was part of a premature backlash. Not long after my review was posted on the *New York Times* Web site, Jackson, who plays Nick

Fury in the movie and in other Marvel Universe franchise installments, posted a Twitter message exhorting "#Avengers fans" that "AO Scott needs a new job! Let's help him find one! One he can ACTUALLY do!" Scores of his followers heeded his call, not by demanding that my editors fire me but, in the best Twitter tradition, by retweeting Jackson's outburst and adding their own vivid suggestions about what I was qualified to do with myself. The more coherent tweets expressed familiar, you might even say canonical, anticritical sentiments: that I had no capacity for joy; that I wanted to ruin everyone else's fun; that I was a hater, a square, and a snob; even—and this was kind of a new one—that the nerdy kid in middle school who everybody picked on because he didn't like comic books had grown up to be me. (In my day, some of the nerdy kids everybody picked on were the ones who did like comic books, but I guess things have changed now that the superheroes and their fanboy followers have taken over everything. I was picked on for reasons that had nothing to do with comic books.)

The *Avengers* incident blew up into one of those absurd and hyperactive Internet squalls that are now a fixture of our cultural life. Mace Windu had called me out! I had summoned the righteous wrath of Jules Winnfield! Jackson and I were Photoshopped into action-movie combat poses on entertainment Web sites. Miniature

think pieces sprouted like mushrooms after a rainstorm. Our Twitter beef made the news in Brazil, Germany, and Japan. A few of my colleagues embraced the cause of standing up not only for my own beleaguered self, but also for the integrity and importance of the job I was in Jackson's view unqualified to do.

Q: Were you scared?

A: On the contrary. I was grateful. Neither my person nor my livelihood was in any danger, and *The Avengers* went on to become the second-fastest film to date to reach $1 billion at the global box office. I gained a few hundred followers on Twitter and became, for a few minutes, both a hissable villain and a make-believe martyr for a noble and much-maligned cause. It was win-win all around, and then everyone moved on.

But even a tempest in a teapot can have meteorological significance, and I think Jackson raised a valid and vital question. Putting aside the merits or limitations of what I wrote about *The Avengers* or any other movie, it's always worth asking just what the job of the critic is, and how it might ACTUALLY be done.

Q: So you've set out here to defend that job against the attacks—the criticism—of sensitive movie stars and their fans? Isn't that a little bit hypocritical? It seems like you can dish it out, but you can't take it.

A: Well, no, actually. I mean, yes, we all get a little sensitive when the people whose work we write about—or for that matter our readers—find fault with what we do. That's only human. What I'm more interested in here is the general tendency—I would really say the universal capacity of our species—to find fault. And also to bestow praise. To judge. That's the bedrock of criticism. How do we know, or think we know, what's good or bad, what's worth attacking or defending or telling our friends about? How do we assess the success or failure of *The Avengers* or anything else? Because whether or not it's our job, we *do* judge. We can't help it.

Q: And how do we judge? Or maybe the question is "Why do we judge?"

A: Honestly, when I set out to write this book I thought the answers would come much more easily than they did. That there would in fact be answers of a kind I could state clearly and emphatically. Maybe I'd discover that we know what's beautiful or meaningful or even just fun because of neural switches or hormonal responses that evolved at the dawn of human time in order to help us avoid predators and produce more offspring. Or maybe I'd conclude that we are able to make determinations and discriminations of value because we have access to innate and eternal standards that,

though they mutate over the centuries and express themselves differently from place to place, nonetheless keep us on the path of truth and beauty.

You can look at the history of human creativity and find patterns—shapes, sounds, stories—that suggest deep continuity. You can also survey the wild diversity of human making and conclude that no single category or set of criteria could possibly contain it all. Every culture, every class and tribe and coterie, every period in history has developed its own canons of craft and invention. Our modern, cosmopolitan sensibilities graze among the objects they have left behind, sampling and comparing and carrying out the pleasant work of sorting and assimilating what we find. Meanwhile, we are inundated with new stuff, which is also pleasant even if the glut can leave us feeling paralyzed and empty. We marvel at the abundance or worry about the too-muchness of it all. There are so many demands on our attention, so many offers of diversion and enlightenment on the table, that choosing among them can feel like serious work.

Q: And that work—the winnowing and contrasting, the measuring and interpreting—is what you call criticism.

A: Yes. But it's also something more basic and more urgent. It's complicated. Let me go back to Samuel L. Jackson. Six months after the *Avengers* episode, he

revisited our Twitter quarrel in an interview with the *Huffington Post* and gave voice to a widespread complaint about criticism in general, and about the criticism of popular culture in particular. "Ninety-nine percent of the people in the world look at that movie as what it is," he said. "It's not an intellectual exposition that you have to intellectualize in any way." This is an old and powerful—in some ways an unanswerable—argument against criticism, rooted in the ideas that creative work should be taken on its own terms and that thought is the enemy of experience. And it is indeed precisely the job of the critic to disagree, to refuse to look at anything simply as what it is, to insist on subjecting it to intellectual scrutiny.

"Intellectualize" is a deliberately ugly word, the use of which is an accusation in its own right. But really it's just a synonym for "think," and it's worth asking why it should be necessary to deny so strenuously that *The Avengers* might be both the product and a potential object of thought. The movie is very much an "intellectual exposition" in the general sense of having arisen from the conscious intentions and active intelligence of its creators, including Jackson himself. It also, like many other comic-book entertainments, sets out to explore what fans of the genre and veterans of high school English would be sure to recognize as Big Themes, among them honor, friendship, revenge, and

the problem of evil in a lawful universe. And finally (and, from my own perspective, most vexingly), *The Avengers* shows what can happen when a playful story-telling instinct collides with the imperative of global profit that drives so much twenty-first-century Hollywood production.

All of which is to say that *The Avengers* is an extremely interesting and complex artifact, and that its successes and limitations are worth puzzling over. And yet even to contemplate the work of teasing out the good from the bad, finding the context and staking a claim, might be to miss the point. Or, as Jackson put it: ". . . if you say something that's fucked-up about a piece of bullshit pop culture that really is good—'The Avengers' is a fucking great movie; Joss [Whedon] did an awesome job—if you don't get it, then just say, 'I don't get it.'"

But I get it. In particular, I appreciate the double standard that Jackson invokes as he places *The Avengers* simultaneously beneath criticism ("a piece of bullshit pop culture") and beyond it ("a fucking great movie"). He is echoing the reflexive disdain for movies and other low- and middlebrow amusements that came so easily to intellectuals of an earlier era, and at the same time invoking the ancient, superhighbrow idea that a work of art is inviolate and sufficient unto itself. In these circumstances, a critic will be guilty of foolishly

taking seriously what was only ever meant as harmless, easy fun, or else of dragging something sublime down to his own ridiculous level. But guilty either way.

Here's the important thing, though: in doing this, a critic will be no different from anyone else who stops to think about the experience of watching *The Avengers* (or reading a novel or beholding a painting or listening to a piece of music). Because that thinking is where criticism begins. We're all guilty of it. Or at least we should be.

Q: So you've written a book in defense of thinking? Where's the argument? Nobody is really against thinking.

A: Are you serious? Anti-intellectualism is virtually our civic religion. "Critical thinking" may be a ubiquitous educational slogan—a vaguely defined skill we hope our children pick up on the way to adulthood—but the rewards for not using your intelligence are immediate and abundant.

As consumers of culture, we are lulled into passivity or, at best, prodded toward a state of pseudo-semi-self-awareness, encouraged toward either the defensive group identity of fanhood or a shallow, half-ironic eclecticism. Meanwhile, as citizens of the political commonwealth, we are conscripted into a polarized climate of ideological belligerence in which bluster too often substitutes for argument.

There is no room for doubt and little time for reflection as we find ourselves buffeted by a barrage of sensations and a flood of opinion. We can fantasize about slowing down or opting out, but ultimately we must learn to live in the world as we find it and to see it as clearly as we can. This is no simple task. It is easier to seek out the comforts of groupthink, prejudice, and ignorance. Resisting those temptations requires vigilance, discipline, and curiosity.

Q: So then what you've written is a manifesto against laziness and stupidity?

A: You could put it that way. But why cast it in such a negative light? This book is also, I hope, a celebration of art and imagination, an examination of our inborn drive to cultivate delight and of the various ways we refine that impulse.

Q: And all that is the critic's job?

A: It's everyone's job, and I believe it's a job we can actually do. I suggest that the effort might begin with the way we address the works that answer our bottomless hunger for meaning and pleasure, and also, simultaneously, with the way we understand our responses to those beautiful, baffling things.

　　We are far too inclined to regard art as an ornament and to perceive taste as a fixed, narrow track along

which each one of us travels, alone or in select, like-minded company. Alternatively, we seek to subordinate the creative, pleasurable aspects of our lives to supposedly more consequential matters, pushing the aesthetic dimensions of existence into the boxes that hold our religious beliefs, political dogmas, or moral assumptions. We trivialize art. We venerate nonsense. We can't see past our own bullshit.

Enough of that! It's the job of art to free our minds, and the task of criticism to figure out what to do with that freedom. That everyone is a critic means, or should mean, that we are each of us capable of thinking against our own prejudices, of balancing skepticism with open-mindedness, of sharpening our dulled and glutted senses and battling the intellectual inertia that surrounds us. We need to put our remarkable minds to use and to pay our own experience the honor of taking it seriously.

Q: Okay, fine. But how?
A: Good question!

Chapter One

The Critic as Artist and Vice Versa

What is a critic? If you ask around—or read some of my mail—you will learn that a critic is, above all, a failed artist, unloading long-simmering, envious resentments on those who had the luck, talent, or discipline to succeed. This assumption is so widespread as to amount to an article of public faith. Every working critic could easily assemble, from discarded letters and deleted e-mails, a suite of variations on the themes of "You're just jealous" and "I'd like to see *you* do better."

In response, it can always be noted (immodestly, and therefore not always persuasively) that history provides empirical, biographical evidence to the contrary: an extensive roster of important critics who were also masters of various arts. In the mid-nineteenth century, Charles Baudelaire wrote brilliantly about modern painting without harming

either his skills or his standing as a poet; in the second half of the twentieth, John Ashbery and Frank O'Hara did the same. Philip Larkin, another poet, wrote ardently and insightfully, albeit with a touch of his habitual grumpiness, about jazz. Hector Berlioz was a preeminent music critic as well as a great composer. George Bernard Shaw was both one of the greatest English-language drama critics and one of the greatest English-language dramatists of his time. Le Corbusier's writings about architecture have been at least as influential as his buildings, and are perhaps more accommodating. The key directors of the French New Wave— Jean-Luc Godard, Eric Rohmer, Claude Chabrol, François Truffaut—started out as film critics, associated with the journal *Cahiers du Cinéma*. Most of the significant critics of poetry since at least the romantic era have also been poets, and a few (Samuel Taylor Coleridge, T. S. Eliot) have attained canonical stature in both forms. So there!

But the defensive critic may be compelled to admit that such figures are outliers, exceptions that prove a deeply embedded rule. The rule is upheld by the obvious and apparently immutable hierarchical distinction between what critics and artists do. One person may do both, but there is little doubt about where the real value—the real work— resides. *The novels are okay, but it's the book reviews that really stand out.* Is it possible to imagine fainter, more damning praise? The writers and poets of whom this can be said belong mostly to the ranks of the minor and the almost-

memorable, providing thesis fodder for intrepid graduate students and waiting in the shadows with gray, stoical patience for a moment of reassessment and rediscovery. The number of critics who have managed to last—to claim, on the basis of their critical writing alone, a foothold on Parnassus or a spot in the canon—is vanishingly small.

This is no doubt because criticism is understood to be a time-bound, reactive, secondary activity, stealing whatever temporary prestige, importance, or shock value it has from the durable labor of real artists. As their art persists beyond the difficult moment of its birth, it leaves behind not only the original responses it provoked, but also the world that spawned those responses. Moving toward its future—from the church altar to the museum; from the bookseller's stall to the classroom; from the concert hall to the recording studio; from the run-down Times Square grind house to the Criterion Collection DVD box; from the ragged domain of physical artifacts to the seamless digital archive—the work acquires new admirers, fresh skeptics, and calls forth interpretations that discern previously unsuspected meanings and pleasures within its familiar contours. Art, in other words, is durable and also mutable, whereas criticism is fixed and therefore perishable. The job of criticism is to be about art; the job of art is just to be.

Criticism, in this view, is, at best, helpful and disposable, an inessential, changeable prop, like the temporary partition in the gallery on which a painting is hung or the

cover slapped on a paperback edition of a classic book. Useful, perhaps, but basically superfluous. And it is always a small step from recognizing that we can live without criticism to deciding that we should. In the opening pages of *Real Presences*, his study of the unacknowledged intimations of divinity in secular culture, George Steiner envisions a Utopia—a "counter-Platonic republic"—in which "all talk *about* the arts, music and literature is prohibited" and "from which the reviewer and the critic have been banished." That Steiner is himself a critic of considerable renown is not a sign of bad faith, but rather of idealism, of a determination at least to imagine a cultural situation unburdened by "the dominance of the secondary and the parasitic" that defines our unhappy present condition.

Steiner's attack on criticism is a defense of art. This is not a matter of taking up arms against individual critics who spitefully or callously wound the feelings of particular artists, but of a more profound antagonism, the response to a more systemic threat of harm. In Steiner's view, and in the view of many others who share his prejudices even if they lack his learning, criticism is a pernicious, parasitic growth on the mighty trunk of human creativity. At least in the fantasies of anticritical ideologues (who are often professional critics themselves), the glories of creation can only be apprehended if those distorting excrescences are cleared away. It is a mortal, existential struggle: if art is to live, criticism must die.

But exactly the opposite is true. It is my contention here that criticism, far from sapping the vitality of art, is instead what supplies its lifeblood; that criticism, properly understood, is not an enemy from which art must be defended, but rather another name—the proper name—for the defense of art itself.

Let me go further. Criticism is art's late-born twin. They draw strength and identity from a single source, even if, like most siblings, their mutual dependency is frequently cloaked in rivalry and suspicion. Will it sound defensive or pretentious if I say that criticism is an art in its own right? Not in the narrow, quotidian sense in which "art" is more or less synonymous with skill, but in the grand, fully exalted, romantic meaning of the word. That the critic is a craftsman of sorts is obvious enough; I want to insist that the critic is also a creator. And if my own workmanlike efforts are inadequate to support the assertion—because, look, I was on deadline and the editor cut the best parts and nobody understands me, anyway—let me fall back, temporarily, on an argument from authority.

H. L. Mencken, the sage of Baltimore and the scourge of all that was phony and flabby in American culture in the first half of the twentieth century, declared that any good critic was acting not from "the motive of the pedagogue, but the motive of the artist." Rebutting the popular misconception that the critic "writes because he is possessed by a passion to advance enlightenment, to put down error and

wrong, to disseminate some specific doctrine"—in short, to make arguments—he proposed a much more basic impulse. What motivates the critic "is no more and no less than the simple desire to function freely and beautifully, to give outward and objective form to ideas that bubble inwardly and have a fascinating lure in them, to get rid of them dramatically and make an articulate noise in the world." Exactly!

This blithe assertion of intellectual and creative autonomy—supported by the bravura and insight of which Mencken at his best was capable, and by the permanent spot he managed to claim in the American literary pantheon—is complicated by the nature of the particular art form Mencken's notional critic pursues. The contradictory heart of the matter is that criticism is an art produced in reference to, and therefore in conflict with, other arts. T. S. Eliot, who did not hesitate to associate criticism with "the other fine arts," also noted its exceptional status, its essential difference from its siblings. He liked to describe art (in particular poetry, which he favored not only for vocational reasons, but also in deference to its traditional position of supremacy in Western aesthetics) as "autotelic," meaning self-completing or self-sufficient. A poem, a statue, or a piece of music is essentially (supposedly) independent, freestanding, whereas any specimen of the art of criticism, however dazzling in itself, must always lean upon and make reference to something else.

This makes criticism an anomaly. It may be true that art is born of a struggle with the hard facts of life and the obduracy of the materials at hand, but this struggle does not really involve personal, mutual hostility. The sculptor is not the enemy of stone. The painter is not in competition with the human form. The key of G will not take umbrage at a composer's use of it. Words do not hate poets. But criticism, as Mencken notes, is different. In part because it is, or seems, *personal*.

> When [the critic] sits down to compose his criticism, his artist ceases to be a friend, and becomes mere raw material for his work of art. It is my experience that artists invariably resent this cavalier use of them. They are pleased so long as the critic confines himself to the modest business of interpreting them—preferably in terms of their own estimate of themselves—but the moment he proceeds to adorn their theme with variations of his own, the moment he brings new ideas to the enterprise and begins contrasting them with their ideas, that moment they grow restive. It is precisely at this point, of course, that criticism becomes genuine criticism; before that it was mere reviewing. When a critic passes it he loses his friends. By becoming an artist, he becomes the foe of all other artists.

Mencken's conclusion is that this state of hostilities is ultimately beneficial to all concerned: "Literature always thrives best, in fact, in an atmosphere of hearty strife."

Agreed! And so do all the other arts. Criticism is the art that contends against them for their own benefit, and also to further its own aesthetic ends, to make its articulate noise in the world. This means that criticism, far from being a minor, petty, secondary art, is in fact larger than the others. There is more of it, its scope is wider, its methods more eclectic than any of its rivals. It encompasses all of them, and compels them all to serve its needs. It is not parasitic, but primary.

I know what this sounds like: sophistry, vain hyperbole, sheer arrogant nonsense. In the sense that Mencken understood and practiced it, criticism is a relatively new and limited pursuit, and throughout human history a great many artistic traditions have flourished entirely untouched by what we or Mencken would identify as criticism. No cartouche has been unearthed suggesting the existence of an Egyptian sage urging the public not to miss the Pyramids. They were even harder to miss then than they are now. Scribes and calligraphers in the ages before newspapers and magazines did not have the time or inclination to jot down and copy responses to the latest madrigal or altarpiece. Wandering through museum galleries, we can be moved and delighted by African masks, Greek vases, and Chinese scrolls without knowing—in some cases without

even being able to guess—what contemporary local savants might have made of them.

But we can also be sure that these objects and experiences did not make their way to us without passing through a process of judgmental scrutiny that began at the moment of their conception and that informed every stage of their gestation. Every made thing answers to—which is also to say that it struggles against, and sometimes transcends—aesthetic norms and cultural purposes that are implicit within it even as they may be inscrutable to late-arriving or alien eyes. A work of art is itself a piece of criticism.

The purpose of George Steiner's thought experiment—his peremptory sweeping away of the fog of commentary that he sees shrouding the finest products of the human imagination—is to clarify exactly this point. "All serious art, music and literature," he writes, "is a *critical* act," by which he means not only that art in general constitutes "a criticism of life" (in Matthew Arnold's phrase), but also that the arts "embody an expository reflection on, a value judgement of, the inheritance and context to which they pertain."

This is a starchy, pseudo-Germanic way of noting that, far from existing in a state of serene, autotelic isolation, works of art reach beyond themselves, engaging other works that exist alongside and before them and the historical circumstances in which they arise. On one level, the point is so obvious that it hardly needs arguing. Libraries,

course syllabi, museums, and the iTunes Store are all organized around a belief in the organic existence of genres, traditions, periods, and other forms of artistic affiliation. We are routinely taught to attend to "context," an agreeably vague term for the stuff we might want to know about the thing we are looking at, and also, more precisely, for the stuff that thing seems to know.

We may still cling to the myth of the solitary creator, toiling in a garret awaiting a visit from the muse, but the reality of creation has always been much more interactive. Not simply because an individual painter or writer is likely, however cantankerously or reluctantly, to be part of a scene or a school, or even because of the essentially collaborative, collective nature of pursuits like theater, film, architecture, and music. All art that is recognizable as such is in some degree about other art. Every writer is a reader, every musician a listener, driven by a desire to imitate, to correct, to improve, or to answer the models before them. It would be too much to say that every artist is a failed critic, unable to appreciate what already exists without adding to it, but it does not seem to me inaccurate to say that all art is successful criticism.

This is a simple, practical observation, but I also want to gesture toward what I take to be a vaster and more fundamental truth. We are accustomed, in the post-everything present, to an aesthetic of the sample, the mash-up, and the pastiche. For several decades now—an era marked by

hip-hop appropriation, self-ironizing television shows, literary parody, and cinematic homage—culture has thrived on various styles of borrowing, quotation, and metacommentary, much of it bracingly original. At worst, we have been subjected to tiresome and cynical bouts of remaking and recycling, but what is more striking is the sheer novelty that so often emerges from the contemplation and reinvention of the old. Hip-hop is perhaps the supreme example of this apparent paradox: an authentically and at times radically new musical idiom built from the stolen beats and blended sounds of antecedent forms. Similar practices—of nodding and winking, spoofing and honoring, remixing and repurposing—have a way of popping up wherever our gazes happen to land. Filmmakers like Quentin Tarantino and Joel and Ethan Coen (to cite only two of the better-known cases) mine the movie past to make films that are saturated in history without quite resembling anything that has come before. Visual art since the 1980s, when Andy Warhol replaced Jackson Pollock as the supreme influence on the young, has aggressively recombined both the iconography and the literal images of earlier times. A hundred hothouse flowers have bloomed: paintings based on paintings, photographs of photographs, photographs of paintings, and hard-to-classify, hard-to-miss artifacts that count as works of art because no other category exists for them.

Not everyone is happy about this, of course. There is by

now a bursting archive of complaint about the derivative, secondary, unserious aspects not just of particular works or artists, but of entire art forms and of the hectically self-conscious, air-quoting zeitgeist itself. The situation that Steiner calls "our current *misère*" (which to a sensibility less saturnine might look like a whole world of fun) is often faulted for the ascendancy of hybrids, simulacra, and imitations, secondhand stuff that has crowded out the authentic, heroic, self-authorized masterpieces of yesteryear. But whatever you think about specific trends and tendencies within late twentieth-century and early twenty-first-century culture—what used to be called postmodernism and is now just called "now"—they represent the latest iteration of something as old as art itself.

Imitation is not the erosion of originality; it is the condition of originality. History proves as much. The popular culture of the past half century has been a self-propelling machine for the production of novelty that turns almost instantly into nostalgia. An old song is one that was on the radio two summers ago, a classic is the one you danced to at your prom, and the movies and television programs of your childhood are marked with the tints and timbres of antiquarianism. But the thread that connects the generations is a relentless dialectic of copying and reinvention. Every explosion of transformative newness turns out, on closer inspection, to be the recovery and recasting of what was already there, aided by new technology and the eager

devotion of fans striving to pay tribute to their idols by mimicking and surpassing them. The story of rock 'n' roll is a chronicle of successive generations of teenagers teaching themselves Chuck Berry riffs and going from there. As soon as the style grows too big or baroque—as soon as the raw essence of the music is obscured by commercial scale or artistic ambition—someone will come along to give the wheel another turn by reinventing it.

The iconoclasts of the French New Wave were in thrall to the artistry of Hollywood studio hacks—auteurs, in other words—and bewitched by the power of American commercial genres. Jean-Luc Godard's *Breathless* is a movie without precedent, full of freshness, youthful vigor, and the air of Parisian postwar reality, and yet it is also almost entirely a commentary on American crime cinema going back to the 1930s. And, in turn, quite a lot of the most interesting subsequent cinema—from *Bonnie and Clyde* to Wong Kar-Wai—is a commentary on and elaboration of the themes and styles of *Breathless*.

Godard is an exceptional figure, of course, but also, for just that reason, an exemplary one. There has perhaps never been a filmmaker so completely and compulsively obsessed with cinema—as a record of history, a tool for thought, a playpen, and a field of battle. Godard is also a director for whom filmmaking and film criticism are finally indistinguishable. To say that the polemical and appreciative essays he wrote in *Cahiers* as a young man—in which he embraced,

with militant fervor, the movies of Howard Hawks, Fritz Lang, Nicholas Ray, and other misunderstood geniuses of the studio system—were a prelude to the investigations of cinematic form carried out in *Breathless* and beyond is also to say that those films carried out, by other means, the investigations begun in print. In his late work (above all, the eight-part, four-and-a-half-hour-long *Histoire(s) du cinéma*), this continuity becomes explicit, as the sequence of moving images becomes the ideal medium for thinking about the legacy and the future of motion pictures.

Godard's *Histoires* is a grand anomaly and also the apotheosis of a familiar genre, the movie about movies. Cinema is a language with built-in reflexive capabilities that other art forms may seem to lack. Music criticism is unlikely to be scored, or art criticism conducted by means of brush and pigment. But it is precisely in those art forms that Godard's epic collage—a counterpoint of borrowed images and meditative narration—finds its strongest precedents.

The canon of high literature, fine art, and classical music consists of a long conversation between eras, styles, and nations that is at times covert rather than explicit, but that is always there. Some of the principal monuments of literary modernism—James Joyce's *Ulysses*, Ezra Pound's *Cantos*, Eliot's "The Waste Land"—are brand-new tapestries woven out of ancient thread, and some of the most radical innovations of the nineteenth- and twentieth-century avant-garde are acts of recovery and reinterpreta-

tion. Pound's exhortation to "Make it new"—an enduring and perennially refreshable modernist slogan—presumes the existence of that all-important "it," which is to say everything that the frigate of human civilization has left in its wake.

The new does not occur in a vacuum; it requires materials. And the revolutionary impulse that swept, in successive waves, across the arts from the middle of the nineteenth century to the middle of the twentieth involved the compulsive excavation of such materials, for rescue, correction, and adaptation. Manet, the first great modern painter, may have been responding to the social tumult of Paris in the 1860s and '70s, but he was also conducting a passionate argument with Titian and Velázquez and the tradition of European painting, attempting to recover the sources of its vitality and give them currency in his own changed milieu. Picasso, coming a little more than a generation after Manet, began his career with an intensive inquiry into his native tradition, evoking Goya, Velázquez, El Greco, and other Spanish masters in his early paintings. As his ambition grew, he radically expanded his field of influences to include, most decisively, the African masks and figures that inspired *Les Desmoiselles d'Avignon* and the Greek vase decorations that informed his mischievously erotic late drawings and etchings. His intent was not to quote or to appropriate—or to flatter the cleverness of beholders who might "get" the references—but rather to find a vocabulary

of images and techniques able to infuse his own work with the primal, authentic power he desired.

The itineraries of modernism pass through the old—the archaic, the ancient, the atavistic—en route to the new. Similarly, European and American modernisms trafficked in the exotic—the primitive, the alien, the strange—in their search for the immediate and the essential, for that elusive quality that would shake painting, poetry, and music out of their inherited patterns and complacent assumptions. To some degree, this was all a response to the feeling of belatedness that shadows the experience of modernity. The world as found by its restless modern spirits is already crowded, its most fertile areas already carefully farmed or wildly overgrown. The only way forward seems to be *back* and *through*.

But it may be that by "modern" in this instance we really mean something closer to "human." The felt imperative to "make it new" is itself not so new; making it new is pretty much the way it's always been done. Lateness—that sinking feeling that originality has been exhausted and that only repetition remains—has weighed on the souls of artists since the beginning. The Great Originator of English letters, Shakespeare himself, ransacked the cupboards of high and low literature, history, and folklore in search of viable scenarios, cobbling scraps of Ovid, Holinshed, Latin comedy, commedia dell'arte sketches, and medieval fairy tales into an imposing, profligate edifice that nearly every subse-

quent writer of English—American, Irish, African, Caribbean, Indian—would feel free to pillage.

There are different ways of imagining this continual process of ransacking and remaking, which determines the specific course of each art form over time. Apprentices school themselves in the work of the masters, breaking down the mysteries of earlier achievements into techniques that can be imitated and adapted. The fundamental critical process—the hinge that conjoins the twin activities of creation and analysis—may reside in this basic activity of loving demystification. To revert to an earlier example, you hear Chuck Berry on the radio and your pleasure at the sound is redoubled by an impulse that is compounded of envy, admiration, and desire. *I want to do that. How did he do that? Maybe I could do it better!* The budding cineaste— Jean-Luc Godard at the Paris Cinémathèque, craning forward in the first row to catch the image as soon as it bounces off the screen; Martin Scorsese raptly taking in a double feature in the Manhattan of his youth—dreams of casting a spell like the one he finds himself under. The bookworm longing for a deeper connection to her literary idols—for their company—mimics their voices until she finds her own.

The discipline that turns a fan into an adept—the breaking down of the sound into its constituent notes, the film into its shots, the prose into its defining tonalities—can be acquired at school or in solitude, by direct tutelage or

dreamy osmosis. In every case, it involves the transforma-
tion of awe into understanding, and the claiming of a share
of imaginative power. Each of our make-believe fledglings
(the rocker, the director, the poet) is also therefore a critic.
The stronger they grow, the more autonomous and confi-
dent in their mastery of the art in question, the more deci-
sively critical their efforts become, until they succeed in
reversing the direction of influence and altering the work
of their predecessors. Chuck Berry sounds different after
the Beach Boys, Bruce Springsteen, and the Sex Pistols.
They all take it upon themselves to finish what he started,
even if—exactly because—it had seemed self-sufficiently
done to begin with. Godard, the disciple of Hitchcock and
Hawks, is also their interpreter, as Tarantino will be his.
"The past," according to T. S. Eliot, is "altered by the pres-
ent as much as the present is directed by the past."

Eliot's word for this looping temporal relationship be-
tween the old and the new is "tradition," a term that was,
in his time as in ours, somewhat suspect. It can mean a
slavish, timid reliance on preexisting models, or else a way
of doing things hemmed in by conservative, ethnocentric
assumptions. But his understanding of tradition is less re-
strictive, and more dynamic, than his subsequent reputa-
tion as an imperious conservative might suggest. The idea
of tradition is what allows us to perceive patterns and
affinities over time, and to acknowledge that "no poet,
no artist of any art, has his complete meaning alone. His

significance . . . is the appreciation of his relation to the dead poets and artists." Morbid as this may sound, it identifies two crucial components of artistic ambition: the desire to last, to have at least a chance at immortality; and the anxious wish to measure up, to elbow one's way into a company that does not require your presence. "The existing order is complete," Eliot declares, "before the new work arrives," which is both discouraging and realistic. There is never, at any moment, a need for more—Chuck Berry does not require Bruce Springsteen; Velázquez can do without Picasso or Manet—but there is always, at the same time, the imperative to continue, to correct, to improve, to repeat. And, thereby, to change the character of everything that has come before: "[F]or order to persist after the supervention of novelty, the *whole* existing order must be, if ever so slightly, altered."

Whether, in the end, such an order really exists—and whether its existence undermines the autotelic completeness that Eliot elsewhere projects onto any successful individual work—has already been a matter of intense historical and ideological debate. Eliot is talking about European high culture in a prescriptive, defensive tone that presses all kinds of hot buttons, and making a big deal about the necessary "impersonality" of literary creation. It is therefore easy to miss that his real interest—in the essay I have been quoting, published shortly after the end of World War I, when its author, still in his early thirties, was far from the

literary Grand Pooh-Bah he would become—is in what it feels like to be an eager young artist looking for a place to stand in a field crowded with the monuments and muddy footprints of the great.

How to make room for yourself? How to make it appear—to yourself first of all, but then to everyone else—as if you belong? These are the kinds of questions that underlie Harold Bloom's idea of influence, a version of tradition that replaces Eliot's ideal order with the passion and tumult of contending personalities and errant meanings.

"Poetic influence," according to Bloom, "always proceeds by a misreading of the prior poet, an act of creative correction that is actually and necessarily a misinterpretation. The history of fruitful poetic influence, which is to say the main tradition of Western poetry since the Renaissance, is a history of anxiety and self-saving caricature, of distortion, of perverse, wilful revisionism without which modern poetry as such could not exist." Anyone who has not encountered Bloom's own marvelously willful and perverse readings in this tradition—in a series of books, the shortest and grandest of which is *The Anxiety of Influence*—should be sure to seek them out. Literary criticism has rarely been practiced with such a combination of learning and drama, as the designated "strong poets" grapple with each other in a struggle that seems primal rather than modern in its intensity.

Part of what is at stake in that struggle is the assertion of

primacy—not just one poet outdoing another but, more radically, shaking off the stigma of coming afterward and laying claim to originality, to independence, to an authority that makes the rest of the tradition irrelevant. Not all art explicitly proceeds from such a grandiose motive, but very little of it is produced without reference to some idea of greatness, usually one that involves the transcendence of precedent. (It goes without saying that the sorry fate of most art is to fall into imitative mediocrity, failing even to live up to the available models.)

It may seem as if I am enclosing art (along with criticism) in a familiar corral of self-reference, an airless theoretical space in which poets write to, about, and through other poets, movies make obsessive allusion to other movies, and every song is the echo of another song. But what I am really trying to do is zero in on the existential paradox of art itself, which springs out of an urge to master and add something to reality and finds itself immediately confronted with obstacles that are also its available tools. This urge is very old—there is no record of its first occurrence—and also apparently inexhaustible. To understand it requires the resources of science and the inventions of myth.

In Plato's *Symposium*, the supposed transcript of a philosophical Athenian drinking party that prophetically parodies the panel discussions and think-tank roundtables of later

times, the comic playwright Aristophanes offers a fable about the origin of love. (In our own day, the fable has been retold in song by Stephen Trask in the musical *Hedwig and the Angry Inch*.) It is a preposterous and touching story about the destruction of a primordial protohuman race of roly-poly, four-legged, Janus-faced creatures, each one endowed with two sets of genitals. Instead of two sexes, there used to be three—all male, all female, and androgynous—but there was not really any sexuality as we know it, since each body was complete unto itself. One day Zeus, in a fit of Olympian jealousy, split our ancestors in two with lightning bolts, and ever since then each member of our broken species has been tormented by the desire to recover his or her missing half. Our coupling is the clumsy, desperate, occasionally successful attempt to put back together what divine violence broke apart.

In addition to regaling his friends with a fanciful and metaphorically persuasive account of the human libido, Aristophanes touches, in them and in subsequent readers of the *Symposium*, a deeply resonant imaginative chord, one that sounds across cultures and historical eras. So much of our striving—in love, religion, art, and work—seems to be undertaken out of a longing, overtly expressed or not, to restore a sense of lost wholeness. Once, just beyond the boundary of living memory or recorded history, we were complete. Now we are damaged, fallen, deformed.

Often, as in the book of Genesis and its later elabora-

tions, what brought us down was our own arrogance or ambition. According to Aristophanes, Zeus was impelled to dissect us because, as whole, self-sufficient quadrupeds, we threatened the supremacy he and the other immortals had enjoyed since they overthrew the Titans. A more famous myth—chronicled long before Plato's time by the poet Hesiod—similarly situates human origins in a scene of conflict with the gods. The Titan Prometheus, who possessed an "intricate and twisting mind" and who enjoyed punking the haughty and humorless Zeus, concealed fire in a fennel stalk and delivered it to mankind. For this transgression, Prometheus was chained to a rock, to be preyed upon forever by an eagle. For our part, as punishment for accepting his gift, we received a box of woes, delivered to us by a kind of robot-woman, fashioned by the collective artifice of all the gods, named Pandora. "Since before this time," Hesiod recounts in the *Works and Days*, "the races of men had been living on earth / free from all evils, free from laborious work, and free from all wearing sicknesses." So the possession of fire brought about a fall into the world of suffering and vexation we now inhabit, a world leavened by fleeting intimations of hope, the one thing that remained inside Pandora's box.

In later antiquity (in the plays of Aeschylus, for example), during the Renaissance, and even more so in the romantic period, Prometheus was often regarded as a heroic, revolutionary figure. To Percy Bysshe Shelley he represents

"the type of the highest perfection of moral and intellectual nature, impelled by the purest and truest motives to the best and noblest ends"—both the progenitor of human genius and its incarnate ideal. In Shelley's *Prometheus Unbound*, he is the "Champion" of mankind, while Zeus is the "Oppressor," and Zeus's punishment of Prometheus is both a terrible, tragic injustice and a prelude to redemption. For Hesiod, though, Prometheus is a thief and a liar who got what he deserved, leaving his human protégés an unhappy legacy of limited power and pervasive suffering. The moral Shelley extracts from his story is that anything is possible, that the sacred fire freedom is within our grasp. Hesiod reaches the opposite conclusion: "So there is no way to avoid what Zeus has intended."

To illustrate this fatalistic point he unspools a longer, even more pessimistic outline of human history, the narrative not of a precipitous fall but rather of a slow, implacable decline brightened by a few glimmers of hope. There was, at the dawn of human life, a Golden Age, followed by the Ages of Silver and Bronze and then by an Age of Heroes (during which the Trojan War was fought)—all of them leading to the present Age of Iron, where Hesiod and his listeners find ourselves. It is not a happy place. "Never by daytime will there be an end to work and pain, nor in the night to weariness, when the gods will send anxieties to trouble us."

Apart from the polytheistic superstition, this sounds cu-

riously modern, and much of the *Works and Days* resembles that most modern of genres, the self-help book, albeit in a key of melancholy resignation rather than peppy optimism. It is a guide to coping with the stresses and challenges of daily life that combines practical advice with spiritual insight, a compendium of folk wisdom colored by a weary pessimism that is both touching and disconcerting. A twenty-first-century reader, accustomed to living with feelings of belatedness and perhaps susceptible to nostalgic visions of Golden Ages past, might be startled to discover that same malaise settling over a work that is one of the earliest monuments of Western literature, a heroic poem roughly contemporary with the *Odyssey* and the *Iliad*. Before anything had really gotten started, everything already sucked.

Which is exactly Hesiod's point. We labor under a divine curse. The serial myths of origin and history he relates (in the *Works and Days* and also in its companion, *Theogony*) comprise an anthology of exile and punishment, hubris and calamity. We retell these stories in order to be humbled and chastened, but also as inspiration to try again, to recover the loss and repair the damage, or at least, following in the plodding footsteps of the *Works and Days*, to keep going. But every attempt to overcome our condition, whether through momentary consolations or Utopian projects, serves inevitably to remind us of it. To the extent that we are inclined to seek perfection, we are bound to fail,

and out of a combination of morbid discontent and stubborn idealism we are compelled to calibrate, as precisely as possible, the nature and extent of the failure. Our creativity originates in anguish and longing, and our creations, when we contemplate them, seem alien and mysterious. We become morbidly aware of their flaws and infelicities, and almost reflexively note the ways they fall short of the ideal. We doubt their value and question their meaning, and find ourselves by turns enthralled and puzzled by their power.

This is an essentially tragic account of the origin of art, and also, implicitly, of criticism, since criticism finds its home in the shadow that falls between intention and act, between the inspiration and the inevitably disappointing work that emerges from it. Our drive to create originates in—and compensates for—a primal feeling of alienation, of lostness in the universe and confusion about our identity. Frequently aligned with that sense of our original inadequacy is, somewhat paradoxically, a perception of our subsequent decline. The more we do, the further we stray from our sad beginnings, the less heroic we appear to ourselves. It is always the Age of Iron, and the Golden Age is always behind us, giving off a luster that illuminates the terminal shabbiness of our present condition.

But, of course, there is a contrary view, according to which the creative impulse originates in a moment of miraculous discovery and develops progressively, toward a horizon of perfection. For Shelley—and, before him, for

Aeschylus—Prometheus was a hero, not a knave, and the emphasis falls not on his theft from the gods but on his gift to mankind. Art may still appropriate the divine prerogative of making, but it flatters by imitation rather than blaspheming by hubris.

In an example of the happy synthesis of pagan and monotheistic traditions that enlivened the thought of the Renaissance, Giorgio Vasari begins his *Lives of the Artists*—an epochal compendium of gossip, art history, and celebrity worship—with a theological solution to the riddle of historical beginnings. Where did it all start? Did the Greeks invent art, or the Egyptians, or some other ancient people? There is evidence in the archeological record to support various theories, but these are ultimately of little more than passing interest to Vasari, who prefers to situate the genesis of art in the first verses of Genesis. The first artist was God, who, "in the act of creating man . . . fashioned the first forms of painting and sculpture in the sublime grace of created things. It is undeniable that from man, as from a perfect model, statues and pieces of sculpture and the challenges of pose and contour were first derived; and for the first paintings, whatever they may have been, the ideas of softness and of unity and the clashing harmony made by light and shadow were derived from the same source."

Part of the charm of this passage is its elegant solution to a vexing chicken-and-egg problem. Is art primarily the imitation of nature, driven by the desire to replicate what the

eye sees in the world? Or does it always consist of the imitation of some other, prior art? Vasari's answer is "both," since nature itself is, quite literally and specifically, a work of art, fashioned of the same substances that later artists will use to capture it. The first creator worked in clay, stone, light, and color, and his followers will not only render what he made, but also reproduce it, on an appropriately modest scale, in similar media. The great painters are like demigods, exerting an influence almost equal to the divine original: "In my opinion," Vasari writes, "painters owe to Giotto, the Florentine painter, exactly the same debt they owe to nature, which constantly serves them as a model and whose finest and most beautiful aspects they are always striving to imitate and reproduce." Giotto himself, though he was discovered and tutored by the older painter Cimabue, learned directly from the source. According to legend, Giotto was a peasant's son whose first works (the ones that caught his mentor's eye) were pictures of grazing sheep scratched with one stone on another.

It is hard to imagine a less alienated account of the origin of art, and Vasari's book, a compendium of chronologically ordered biographical sketches of Italian artists (from Cimabue to Michelangelo) that sometimes read like mash notes from the world's biggest painting fan, is one of the happiest, most unabashedly positive works of criticism ever written. It helped that Vasari, himself a well-connected painter and architect, had an abundance of good material to

work with, and was able to survey, without straining, a Golden Age of incomparable richness. The roughly three hundred years of history he covers—from the 1200s to the mid-1500s—invite a progressive, evolutionary narrative of continual refinement and improvement. Art, for Vasari, is always tending toward perfection, and the art of the Italian peninsula, moving out of the Middle Ages, discovers new technical resources as it develops. Vasari notes the elements of this progress—advances in the accurate representation of human anatomy and skin tone, the deepening of perspective, the growing dynamism of composition—and concludes that they combine to make "modern art even more glorious than that of the ancient world."

You can argue that our own modern art is far less glorious than his, but my point about Vasari here is that he presents a nontragic, antideclinist story of the origin and growth of art. Not that it's a matter of choosing between the happy and sad versions of the story: there is always plenty of evidence to support both optimism and pessimism, which coexist in counterpoint at every moment of history and within the conflicted sensibilities of every generation.

In our own time, we prefer to look for clues about our origins in science, rather than myth or religion. How did a peculiarly human propensity for making—for distilling harmony from noise, pictures from marks, stories from words, emotions from make-believe—come about? What

function did it serve for our ancestors as they tried to survive and reproduce? Is there a hidden utility in the pleasure and beauty—or even the confusion and terror—we discern in the arts? "Rich and seemingly boundless as the creative arts seem to be," the biologist E. O. Wilson writes, "each is filtered through the narrow biological channels of human cognition." Moreover, "the creative arts became possible as an evolutionary advance when humans developed the capacity for abstract thought." This was, we might say, the Promethean moment—the moment, lost to all recollection and possibly to empirical recovery, when we became conscious of our enormous power and also of our limitations. We found ourselves able to make things and also, as a consequence, to judge them. Not unlike the original critic in Genesis, who cast his eye over what he had made and decided it was good.

How did he know?

Chapter Two

The Eye of the Beholder

I f you know anything, surely you know what you like. How could you *not* know? Who else could know for you? Nothing is more personal than the feelings—of being moved or bored to tears, of being tickled or provoked, of swooning or fuming—that fall under the general headings of taste or, if we want to be philosophical about it, aesthetic experience.

There is, axiomatically, no disputing taste, and also no accounting for it. And yet the conventional wisdom applied to this fundamental human attribute—the neurosensory switch that flips to bliss when we encounter beauty, sublimity, or charm, to boredom or disgust when those qualities fail to materialize—amounts to a heap of contradictions. There is no argument, but then again there is *only* argument. *How could you not like that? Wait, you mean you actually liked that?* Taste, we assume, is innate, reflexive, immediate, involuntary, but we also speak of it as something

to be acquired. It is a private, subjective matter, a badge of individual sovereignty, but at the same time a collectively held property, bundling us into clubs, cults, communities, and sociological stereotypes.

Aesthetic experience takes place in a crowd or in ecstatic isolation. It is, in either case, a series of discrete moments of contemplation and surrender. You stand in front of a painting, sit in a theater seat, look at a screen or a dancer or the page of a book and you are moved, tickled, transported, shocked. Or else you aren't. But over time, those moments aggregate into a pattern—unless, that is, they express a preexisting tendency. You may know what you like—of course you do—but do you know why? Do you know, somehow, in advance? Do you like what you like because of who you are? Or is it the sum of your likes and dislikes that *makes* you who you are?

All this talk of liking may resemble a Facebook wall rather than an attempt at intellectual inquiry, and it's true that social networks and marketing algorithms have displaced, or even rendered moot, some of the more traditional forms of aesthetic discourse. Each of us, inhabiting a private universe of taste, is also invited to link, to share, and to declare as a favorite. *Customers who bought* War and Peace *also purchased* Straight Outta Compton *(deluxe Anniversary Edition) also purchased* The Office *Season 3 on Blu-ray also purchased* The Very Hungry Caterpillar. *You might also like* Euripides: Complete Greek Tragedies, The Naked Gun 2½,

Their Eyes Were Watching God, *and* Born to Run. *Your friends recommend* Blood Feast, I Am . . . Sasha Fierce, Devotions Upon Emergent Occasions, Halo II.

You are, in other words, the kind of person who likes—or could like, or might be persuaded to try—those things. But is that really a kind of person at all? Do those actual and inferred preferences form a coherent picture of a discerning sensibility, or do they just represent a concatenation of consumer choices? A digital, collagist portrait of an individual's appetites, or merely a record of credit card purchases? And what about all the stuff you hate, or don't care about, or never got around to trying? The movies stranded in the Netflix Queue, the unread novels piled on the nightstand, the show you somehow kept missing—what do *those* things say about you?

To complicate matters further, your taste, however defined and dogmatic it might be, is never static. It is something that can be refined, corrected, outgrown, or lost. The album that never left your turntable the summer you were sixteen might sound tinny and overwrought to your forty-year-old ears when you impulsively repurchase it in a specially remastered deluxe digital edition. The book that split you open as a sensitive undergraduate might embarrass you in middle age. And the slow, talky film that bored you stiff back then might make you weep when you stumble across it in the course of a night of sadder, wiser, insomniac cable surfing. You can learn to like something that baffled you at

first sight, and, equally, you can be convinced of the unredeemable flaws in something that thrilled you at the time of your initial encounter.

And much as you might, in deference to the social norms of the age, couch your opinions in modest, subjective language, really, who are you kidding? The careful, nonjudgmental terminology of personal preference is like soft carpeting on the hard floor of objectivity, the ground of certainty on which we secretly, shame-facedly desire to stand. What we mean to say, what we want to say—what we from time to time allow ourselves to say—is not *I like it* but *That's great!* Not *I wasn't really into it* but *That was terrible!*

We set off for the movies or the museum or the iTunes Store and find ourselves suddenly wandering in thickets of philosophical uncertainty, groping through an epistemological fog in search of stable principles. How do we know what we know? Why do we feel what we feel? What are we talking about? These questions, rather than any set of rules or criteria, form the foundations of criticism, an activity that is split at the root between the antithetical answers each question implies.

Its most basic and intractable confusion is about whether, when we begin the work of critical argument, we should be talking about feelings or about things. *Is it just me, or is that a beautiful painting?* It's just you—unless it's just me. That has to be the theoretical starting point. Or at any rate it has been since at least the late eighteenth century, when

Immanuel Kant, having nothing better to do in the Prussian city of Königsberg, set about investigating the fundamental nature of taste.

The result of his inquiry—*The Critique of Judgment*, known among philosophers as Kant's Third Critique, after the earlier critiques of Pure and Practical Reason—is notorious for its dense arguments and vaulting abstractions. Its difficulty may arise not only from the character of Kant's mind, an instrument delicately attuned, as few others have been, to conceptual nuances and logical distinctions, but also from the nature of what, in this instance, he is thinking about. Compared to the other areas of philosophical inquiry Kant staked out and reformulated in the course of his unparalleled career, the question of aesthetic judgment may be especially thorny. The literary critic Terry Eagleton calls it "the joker in the pack of [Kant's] theoretical system." And this is because it seems, even at the most basic stage of definition, to be riven with contradictions and inconsistencies. Though we rarely agree, in practice, about how to distinguish between right and wrong or truth and error— the problems that guided Kant's contributions to ethics and scientific method—there is some consensus about what those concepts mean and thus at least the possibility that some common ground about their application might be discovered.

The tricky thing about Kant's philosophy—and also the source of its liberating power and its constraining rigor,

both of which continue to be felt more than two centuries after his death—is that it conducts itself as much as possible independently of external, preexisting authorities. That is, the good and the true must establish themselves without leaning on religious dogma, political power, or any other tempting logical shortcut. Might does not make right; the categorical imperative does. Believing something does not make it true; proving it within the light of reason does. "Because I said so" is a losing argument, if indeed it counts as an argument at all.

But in matters of taste, it often looks like the only argument. According to Kant, "the judgment of taste is not an intellectual judgment and so not logical, but is aesthetic—which means that it is one whose determining ground *cannot be other than subjective*." This is a starting point rather than a conclusion, since his intention is to drag aesthetic perception up the ladder from sensation to reason, to make the judgment of artistic value akin to the determination of right or the knowledge of truth. To do so, he builds a three-part hierarchy. At the bottom is the purely individual state of pleasure he calls "the agreeable," a condition that hardly counts as aesthetic experience at all, since "those who are always intent only on enjoyment, for that is the word used to denote intensity of gratification, would fain dispense with all judgment." Fun is fun!

But what Kant calls pleasure—which does not seem to

be quite as much fun—belongs to the domain of "the beautiful." Beauty satisfies an impulse higher than mere sensuous appetite. And beyond the beautiful lies "the good," which inspires admiration and respect. Those are what pleasure and delight look like in their rational Sunday clothes. In its highest incarnation, the aesthetic is ennobling in a way that makes it hard to distinguish from moral virtue or spiritual grace, whose ends it serves by indirect and somewhat enigmatic means.

Kant's rendering of the aesthetic dimension of human existence is notably austere, both in comparison to the work of some of his philosophical contemporaries and followers— who find a lot more room for earthiness at the bottom of the ladder and ecstasy at the top—and also when measured against our own everyday experiences. And yet it may be precisely his disinclination to be distracted by pleasure—his disciplined refusal, as a thinker, to be carried away other than on tides of sober dialectic—that makes him so important in the history of criticism and therefore of art.

We can put aside, for a moment, the perpetually contentious questions of whether (or how) aesthetic perception might be good for us. We can also doubt, with considerable historical evidence for our skepticism, that appreciation of beautiful things—poems, paintings, symphonies—leads to moral improvement. Some of history's greatest monsters were passionate patrons of the arts. But Kant laid out, with

unmatched lucidity and rigor, the difficulties we seem to encounter whenever we try to talk simply about what we think we see and feel.

"As regards the agreeable, everyone concedes that his judgment, which he bases on a private feeling . . . is restricted merely to himself personally." This is where, very often, the discussion ends, in a mild and milky pluralism. No one can fail to respect anyone else's feelings. But for Kant, the realm of the agreeable, while pleasant, is also a dull and vulgar place to dwell. Beauty is another matter, though, since it involves not only a higher kind of emotion—meaning both more complex and more exalted—but also a more fruitful and reciprocal relationship with objects. When someone says something is beautiful:

> He judges not merely for himself, but for all men, and then speaks of beauty as if it were a property of things. Thus he says the *thing* is beautiful; and it is not as if he counted on others agreeing in his judgment of liking owing to his having found them in such agreement on a number of occasions, but he *demands* this agreement of them. He blames them if they judge differently, and denies them taste, which he still requires of them as something they ought to have; and to this extent it is not open to men to say: Everyone has his own taste. This would be

equivalent to saying that there is no such thing
at all as taste, i.e., no aesthetic judgment capable
of making a rightful claim upon the assent of
all men.

It is only a small exaggeration to say that most of modern
criticism—as well as most of the arguments against it—is
implicit in that passage. Kant, for his part, is en route to
other questions: the later sections of *The Critique of Judgment*
turn toward matters related to God, freedom, and the im-
mortality of the soul, none of which lie within the span of
my competence or the compass of this book. But along the
way, he formulates what seems to be a crucial paradox:
"[T]he judgment of taste must involve a claim to . . .
subjective universality."

This may be a more startling assertion now than it was
in the 1790s. For Kant, the idea that everyone was in fun-
damental agreement about the nature of beauty may have
seemed less provocative than self-evident. His contempo-
rary, Edmund Burke—a more worldly kind of intellectual,
whose *A Philosophical Inquiry into Our Notions of the Sublime
and Beautiful* was published about a quarter century before
The Critique of Judgment—blithely asserts that "I never re-
member that anything beautiful, whether a man, a beast, a
bird, or a plant, was ever shown, though it were to a hun-
dred people, that they did not all immediately agree that it
was beautiful." This is offered less as a philosophical claim

than a bit of empirically (if not quite scientifically) supported common sense. What for Kant is a theoretical implication with a suitably abstract name—subjective universality—is for Burke a simple fact. That it is stated in perfectly circular fashion is evidence less of sloppiness on Burke's part than of the slipperiness (and also the obviousness) of beauty as a concept. The bird or beast in question is described at the outset as beautiful, and this judgment is conveniently confirmed by a hastily assembled crowd. It's beautiful because everyone thinks it is, and everyone thinks so because it's beautiful.

Whether or not a hundred people ever actually assembled in Burke's presence to behold an especially fine specimen of bird, it is notable that he imagines such a scene as one of unproblematic and immediate consensus, as if there were an agreed-upon scale of aesthetic measurement accessible to every eye and brain. He and Kant are both on the way to what to them seems a more challenging and worthwhile investigation into the features of that scale, the qualities in different objects and artifacts that impel such agreement. Kant will conclude that "the judgment of taste cannot rest on any subjective end as its ground," because such judgment always refers to an object and its properties. Burke will seek to enumerate the specific traits that lend the beautiful its charm and the sublime its power. "Subjective universality"—the notion that what is beautiful to one is beautiful to all—is the precondition for the real work of

THE EYE OF THE BEHOLDER

establishing, once and for all, why the feathers of that bird are so indisputably lovely.

Reading Burke and Kant from the perspective of our own time, it can seem that the world has been turned upside down. My own memory is pretty much the opposite of Burke's: I can't recall that anything beautiful was shown to a group of people, even only two of them, when they did not immediately fall into dispute about whether or not it was beautiful at all. I'm exaggerating, of course (and so was Burke), but my point is that the aesthetic consensus Burke and Kant were able to take for granted has come irrevocably undone. We do, it's true, at times fall into the habit of equating popularity with quality—of saying, with a shrug or a defiant shake of the fist, that a hundred admirers of a given bird can't be wrong—but this is more of a default position or a sociological hunch than a theoretical postulate. We are more likely to ascribe broad agreement in matters of taste to cultural forces or marketing strategies than to intrinsic and immutable aesthetic qualities. Looking at Burke's hypothetical crowd, we are at least as apt to wonder about its composition—landowners or laborers? Men or women? How many and in what proportion?—as we are to wonder about the plumage and pedigree of the bird they all liked so much. We might be led to ask not what kind of fowl is inherently pleasing, but rather what kind of bird was likely to appeal to a cross section of the British public in the mid-eighteenth century.

Our age does not feel comfortable with the idea of subjective universality. The phrase sounds a bit too presumptuous, too coercive, for our sensitive, pluralistic postmodern ears. To suppose that everyone likes the same kind of thing may strike us as a small step away from *requiring* as much, which offends both democratic ideals and consumer practices. We can congratulate ourselves for living in an era in which narrow, authoritarian canons of taste have been overthrown in favor of eclecticism and diversity. Or—it amounts to the same thing—we can bemoan the loss of clear and self-evident standards, which have been muddied by relativism and the overabundance of cheap pleasures.

These opposing, symmetrical attitudes signal a prolonged retreat from the high philosophical confidence of the Enlightenment. Since then—through waves of romanticism and modernism, through Victorian moralism and the countervailing dogma of art for art's sake, through the rise and fall of successive avant-gardes and the explosion of popular culture as an increasingly respectable (and, in any case, unavoidable) precinct of beauty and sublimity—the aesthetic domain has splintered and shifted to such an extent that to speak of it as in any way universal seems preposterous. A hundred people beholding a bird, however unanimous their rapture, is a coterie, a niche, a small circle of Facebook friends. Their like-mindedness proves very little. It's tautological: people who like this bird are like other people who also like it.

And yet we can't give up on subjective universalism altogether. For one thing, to do so would be to retreat into niches and coteries without having any way to account for their existence. There must be *something* about that bird, right? Otherwise taste would be entirely predetermined, a matter of prejudice and conditioning and therefore not really taste at all. There is always the chance that someone outside the self-enclosed bird-lover's circle will love it for other reasons and in a different way. The fact that some works of art survive the circumstances of their making and find adherents in radically divergent times and places suggests that the judgment of their value is not just a local matter. Nor is it merely personal. If it were, no aesthetic experience would rise above the level of the agreeable, and the class of things we call art would have no reason to exist.

So something else must be at work, something that is capable of being communicated and disputed even if it can't always be named. It may be possible to isolate that something scientifically. Laboratory technicians can measure the dopamine levels in willing subjects who encounter various paintings or pieces of music, and compare the readings with other examples. Biologists might propose an evolutionary account of why our species seems wired to seek out a kind of experience that appears to have no obvious adaptive advantage. Art does not help us evade predators or increase our reproductive potential—not directly, anyway. And aesthetic delight is not the same as sexual bliss or

religious rapture, though it can resemble both of those and seems to live in the same cognitive neighborhood. Nor is it identical to other kinds of sensory pleasure or emotional response. It traffics in sensations that are both intense and fundamentally unreal. We laugh, cry, declare ourselves moved or troubled or seduced, but why? And to what end?

It is my hunch—maybe my bias—that philosophy and science are of limited use in addressing these questions. This is not for lack of trying. Since Kant, a great deal of thought has gone into cultivating the two sides of the subject-object divide, into anatomizing both pleasing forms and the pleasures they inspire—as well as, more recently, examining the social and cognitive contexts within which art and experience unfold. Aesthetics has been, intermittently, a thriving discipline within philosophy, attracting thinkers belonging to every school and tendency, from Hegel to John Dewey, from positivists to post-structuralists. But in its various incarnations, philosophical aesthetics tends to retrace the same circuit, from subject to object and back again, at a necessary but also restrictive remove from the actual world of sensations and things. That in-between space is the world that criticism inhabits. The intractable questions that flicker around the edges of our contemplation are best addressed by attending to the play of particular impressions and examples. If we pause to figure out what is happening before our eyes, we may yet catch a glimpse of that rare, perhaps mythical bird, the subjective universal.

. . .

In 2010, from the beginning of March to the end of May, more than 750,000 people passed through the Museum of Modern Art in New York on a somewhat unusual mission. They came from far and wide, camping out in sleeping bags and makeshift tents in the cold and rain on West Fifty-Third Street and, as soon as the doors opened each morning, stampeding through the museum's entrance hall into an exhibition space in the central atrium. There, these fervent pilgrims waited for hours, often literally trembling with anticipation, for the chance to sit for a few minutes in a wooden chair, gazing into the eyes of a sixty-two-year-old woman, also seated, wearing a long-sleeved, floor-length dress, her dark hair drawn back from her expressionless face. During the first weeks of the show, she was separated from her visitors by a simple table, but after a while that was removed, so that literally nothing came between artist and spectator.

But was she the artist, or the artwork? The woman in the chair was Marina Abramović, a Yugoslav-born performance artist and the subject of a major MoMA retrospective. At the center of the exhibition was a brand-new piece, the basic character of which is sketched in the paragraph above, called "The Artist Is Present." Few works in the history of art have been more adequately served by their titles—there she was, just as advertised, sitting in the museum until

closing time every day—and few titles have so succinctly corralled such an unruly swarm of artistic conundrums.

While it was going on, Abramović's show provoked a flurry of media attention, partly because of the sensational, confrontational aspects of some of her other work, and partly because of the MoMA publicity department's shrewd grasp of the overlap between the art world and celebrity culture. The presence of live, naked people in museum galleries—young performers hired to reenact some of Abramović's performances and installations from the 1970s and '80s—unsurprisingly inflamed the curiosity of the prurient public and the smirky, mock disgust of TV-news philistines. But there was more than puritanism at play in their outrage. The gasping, indignant skepticism that has greeted nearly every significant phase of artistic modernism since the Impressionists was reawakened by an exhibition with virtually nothing in it that could be assimilated to traditional formal categories. No paintings; no sculpture in the usual sense (since the stationary nudes in some of MoMA's rooms were actual bodies, rather than marble or metal renderings of human flesh); photographs and videos that seemed to be records of past activities rather than objects to be admired in their own right; all that exposed skin and the strange lady in the chair—*You call that art?*

The posing of this kind of incredulous question, followed by weary or angry dismissals of it—*Of course it's art! How dare you?*—has itself been a public ritual for as long as

anyone can remember. It arises when the art world, an often insular domain absorbed in its own codes, processes, and history, falls under the scrutiny of the proudly literal, belligerently populist worldview promoted by some of the organs of general-interest journalism. Jackson Pollock's drip paintings, Andy Warhol's Brillo boxes, Marcel Duchamp's foundational *Fountain* urinal, and many other canonical works of the past century or so have all taken their turn in the spotlight of scandal, and for many artists the solicitation of such scandal has been an explicit project. A vigorous, self-renewing strain in modern art assumes the task of questioning, even undermining, settled ideas of what can be counted as art, at times expanding the definition to include previously excluded forms and traditions, at other times tautologically narrowing the definition. Art is whatever an artist says it is. An ordinary object or a pile of trash on a museum floor; a gesture or stunt enacted among expectant spectators or out in the workaday world—the assertion that such creations can be called art is meant to demonstrate the power and mobility of the category, a gesture at once idealistic and cynical. Art can be anything, anywhere, but this fluid, boundaryless identity can make it feel more rather than less exclusive. The banal is transformed into the special. What had looked like madness or willful perversity turns out to be inspiration. The catalyst for this alchemy is often actual or assumed bafflement. Someone has to say— or to be imagined saying—*I don't get it.*

Abramović is, in some ways, very much part of this tendency. Much of her work in the 1970s consisted of driving around Europe in a van with her lover and collaborator, a German artist known as Ulay. The couple staged performance pieces—sometimes violent, sometimes silent, sometimes tender—together, but both have said that the real creation, the real artwork, was the journey itself. They shared an evident kinship with other artists emerging from the creative ferment of the 1960s, a time of happenings, process-driven art, and nascent conceptualism. Instead of focusing on making things, these artists (Bruce Nauman, Vito Acconci, Yoko Ono, and Adrian Piper being among the best known) conceived, executed, and recorded episodes and experiences. The "work" could be an idea, the notation or scripting of that idea, the ephemeral performance of it, an audio or video record, or just the feelings evoked among witnesses. Perhaps the essence of the work was all and none of that—an unrepeatable, irreducible collision of intention, body, and audience, a planned eruption of being.

But back to "The Artist Is Present," which has by now taken its place in the history of art, to be analyzed and contextualized, drained of its immediacy as it fades into memory. Like much contemporary art, it was (and is) an intensely cerebral undertaking, arising from a set of theoretical concerns about gender, the body, and (as I've tried to suggest) the institutional and ontological nature of art itself. One

of the ways "The Artist Is Present" answers the "is it art" question is by inviting and rewarding a degree of critical attention, opening itself to a potentially endless cycle of interpretation and counterinterpretation. That is just part of how art and criticism cooperate, through a kind of symbiosis that often seems to marginalize—or do away with the need for—an audience of nonprofessional, unspecialized, agendaless spectators.

As it happened, such an audience of ordinary people was also, at MoMA in the spring of 2010, very much present. And as it grew in size and fervor—many attendees braved the crowds day after day for repeat face-to-face encounters with the ever-present, ever-silent artist—that audience provided its own answer to the "how is this art" question, an answer almost diametrically opposed to the brainy, knowing responses that critics and curators might have provided. It was art because it moved them.

Marina Abramović Made Me Cry is the name of a photo blog on Tumblr that popped up during the MoMA show, a cascade of teary eyes, quivering lips, and silent sobs that records a common and perhaps surprising reaction to "The Artist Is Present." A significant number of spectators, once their gaze settled on what they had come to see, began to weep. An HBO documentary on Abramović directed by Matthew Akers gathers abundant evidence of this phenomenon and catches several instances in which the impassive artist seems to be crying as well, a single tear making its

way down the inscrutable Attic mask of her face. Some of the spectators wept after their encounter, or when they observed an especially powerful connection between the artist and someone else. In Akers's film, the mother of a young boy dissolves into sobs as they leave the gallery. "I'm so proud of you," she says, perhaps trying to give a name to the emotion that has overtaken her, and perhaps trying to explain it to her slightly baffled son in terms he can understand.

Not that her pride is misplaced. The boy had, after all, just endured a long wait with a throng of strangers and braved the company of a woman with a passing resemblance to the wicked witch of a fairy tale. This is an accomplishment. And it may be that part of the rush of feeling bringing forth all those tears from the eyes of his fellow adventurers was a sense of fulfillment, of having *done* something.

But something else—something more powerful and harder to identify, something profound—was also happening in this artist's presence. What was it that was making so many people cry? Tears, of course, are a traditional measure of aesthetic response, palpable evidence that a work of art has reached beyond the shell of its own existence or the clouded bubble of its creator's intentions and made an impact in the world. What is interesting about the tears called forth by "The Artist Is Present" is that they do not seem to have been inspired by the usual emotional cues. The most

obvious and perhaps the most common way we are moved is by represented pathos, by the vicarious experiences of grief or joy triggered by narrative. We weep in sorrow at the death of Little Nell, or Hamlet, or Bambi's mom—or we cry for joy at scenes of heroism, decency, or hard-won happiness—because a specific feeling has been transmitted from a fictional world into our own. Not that this is the only, or even the most common, reason for tears. Our feelings can be stirred by spectacles of sublimity or mastery—by the grandeur or exquisiteness of music, which touches the emotions abstractly and directly, or by the technical magic of artistic accomplishment itself, as talent and discipline combine to make something new. But Abramović, impressive though her feat of endurance might have been, was not making anything at all at MoMA. She was not telling a story or playing a role. She was just there.

The human presence is a powerful aspect of a great deal of art; it is what we perceive in the smile of the Mona Lisa, in the body and voice of an operatic diva in full cry, in larger-than-life close-ups of movie stars, in the whispering lines of poems. Beyond this presence, we infer (or invent) a special kind of attention, an impossible and therefore especially potent form of communication. That enigmatic, long-dead lady in the Louvre is looking, and smiling, at *me*. It is the anguish of *my* soul that is pouring forth from the singer's mouth, *my* innermost thoughts that are simmering in the poem. What Edmund Wilson called the shock of

recognition is equally the thrill of being recognized, an uncanny, impossibly but undeniably reciprocal bond that leaps across gaps of logic, history, and culture.

Klaus Biesenbach, the curator who brought Abramović to MoMA, said that the patrons who sat across from her at "The Artist Is Present" succumbed to a powerful emotional illusion—namely that she was falling in love with them. This sounds like a reversal of the usual dynamic. We say "I love that song," not "That song loves me." (Biesenbach acknowledged this more conventional emotional vector when he described the effect of Abramović's work and of her personality as a kind of serial seduction.) To believe that movie stars or pop singers return our adoration is, at best, an immature fantasy, at worst a full-blown pathology, the kind of thing that leads to restraining orders and the hiring of extra bodyguards. There was a security detail on hand at MoMA to preserve certain boundaries—to remove people who tried to touch, distract, or speak to Abramović, or who interpreted her presence as an excuse to stage impromptu exhibitions of their own. (A number of people were moved to take their clothes off.) Such eruptions were to be expected and were perhaps consistent with some of the points Abramović wanted to raise: about the status of the individual in an age of celebrity, say, or about the altered status of face-to-face contact in a world where human relations are increasingly mediated by screens and networks. The attraction she exerted simply by announcing

and sustaining her presence was perhaps a measure of—and a temporary antidote to—the profound alienation we feel from one another and from ourselves. What does it say about us that we have to go to an art museum to find connection with another soul?

But why else *would* we go? Why else have we ever gone? It is easy enough to emphasize what is atypical and radical about Abramović's work. But perhaps more striking is its essential continuity with a very old tradition. She may call into question some deeply held ideas about art, but there are others, arguably more profound, that she affirms. The primal, powerful connection that spectators felt in her presence may not have been precisely what they sought. The motives that bring us to the door of the museum—to the box office window or the bookstore or wherever else we find ourselves with a little time, the price of admission, and sufficient curiosity on our hands—are often casual, even banal. You were bored. Your friends were all going. You read a review or saw an advertisement. The transformative, galvanic result of the experience was not—could not have been—willed or anticipated. And yet, somehow, it happens: your everyday perception is disrupted by the sense of a presence that is hard to describe but impossible to deny.

Let us shift our gaze from the living person of Marina Abramović, the artist who is her own work of art, to another human figure on display in a museum, and also, more

famously, in the lines of a poem. "Archaic Torso of Apollo" is a sonnet by the German poet Rainer Maria Rilke best known for its last words: "You must change your life."

This imperative has, in the century since the poem was published, frequently been pressed into service as a slogan. This is how art speaks to us; this is the challenge that reverberates through the exhibition halls. *It changed my life.* People say this kind of thing all the time. Magazines publish surveys in which celebrities are asked to name the book, film, or song that changed their lives. Frequently the choices seem uninspired, or have less to do with the intrinsic qualities of the book or film or song in question than with the circumstances of their discovery. But the nature and the mechanism of the transformation—how did your life change? What was the difference between before and after?—rarely receive much analysis. It could be just a figure of speech, but it is also a hyperbolic way of acknowledging the momentarily disruptive impact of art on the equilibrium of everyday consciousness. To say that something changed your life is also to say that it exceeded your available categories of experience. You are in a zone beyond the charm of the beautiful or even the terror of the sublime, in a territory that cannot be marked by the usual signs of *I liked it* or *Hey, that was nice.*

Rilke's sonnet provides a compressed, highly suggestive map of this territory, in the guise of a description—not so much of the statue itself as of what it is like to behold it.

We could never know his astonishing head
where eyes like apples ripened. Yet
his trunk glows now, like a candelabrum
in which his glances, though dimmed,

still rivet and flicker. If not,
the bow of his breast couldn't blind you,
nor could the faint twist of his loins send its smile
through the spring of procreation.

If not, the stone would stand, deformed and cut
under the lucid slope of the shoulders
and wouldn't ripple like a wild animal's fur;

and wouldn't erupt from its boundaries
like a star. For there is no place here
that doesn't see you. You must change your life.

It is striking that the poem begins by invoking what we don't see, the head and in particular the eyes, which have presumably crumbled away, lost forever in the middens of time. This detail, along with the word "Archaic" in the title, signals that we are in the presence of something that survives from a past beyond our imagining. It is a fragment, and yet we intuit, immediately and decisively, its lost wholeness. We—note that Rilke is not invoking what he saw, but what all of us cannot help but see, once he shows

it to us—are able to imagine the invisible in vivid detail. The light in the eyes, their fructifying ripeness: these words bring to warm, sensual life not only the stone in front of us, but also, more remarkably, the stone that has long ago broken off and disappeared. And it is not the shoulders and pectoral muscles that allow us to picture the vanished eyes, but rather the opposite: our implicit, abstract sense of the face that is not there is what illuminates the body that is. If we did not have that inkling of light—of what almost seems to be a living intelligence rather than features carved by a sculptor's hand and polished by time—then what we are looking at would be altogether lifeless, perhaps not even recognizable as a human form.

Our contemplation of that form is hardly a philosophical exercise. It is more of an erotic reverie. Ogling those curves, those loins, the tumescent surge of the breast, the poem can hardly contain its lust. In German, this effect is intensified by the play of hard and liquid consonants in the nouns of the second stanza: ". . . *könnte nicht der Bug der Brust dich blenden . . .*" ["the bow of his breast couldn't blind you"] dissolves into ". . . *der Lenden könnte nicht ein Lächeln gehen . . .*" ["nor could the faint twist of his loins send its smile"], as the eye is drawn downward to the missing but unavoidable throne of the libido. As many readers have noted, this sexual heat, in a poem devoted to a Greek god who embodied coolness and chastity, is more than a little

incongruous. It is almost as if the spirit of Dionysus—Apollo's Olympian rival, the god of impulse and excess, who was dismembered by his frenzied, sex-crazed devotees—had invaded Apollo's poem and indeed his body. The climax of the poem seems to be, or at least to describe, an explosion of pure Dionysian ecstasy, a kind of synesthetic orgasm in which a cold statue is likened to a wild beast and then to a shooting star, bursting forth "from all its contours."

The poem itself, however, stays primly within its own formal boundaries. The sonnet, as Rilke inherited it from Italian and English models, is Apollonian in the balance and decorum of its lines and stanzas, even as it is often (in Petrarch and Shakespeare) the vessel for unruly themes of passion and desire. What this poem seems to be attempting is a synthesis of antithetical artistic principles, a challenge to the idea that a single work must be either restrained, orderly, and rational, or else wild, sexy, and full of feeling. "Archaic Torso of Apollo" is all of those things. So is the archaic torso within it and so, by implication, is every other piece of art. You must, at least, rethink your categories.

The poem is structured around the play of opposites: past and present, blindness and sight, presence and absence, subject and object, whole and part. The statue comes alive to us not in spite of its antiquity, not in spite of its broken-

ness, but because of those qualities. We are able to appreciate its completeness because of the latent light of those missing eyes, without which we would be looking at nothing but cold, broken stone.

But isn't that really, literally, what we *are* looking at? Though the torso Rilke writes about is an actual piece—he saw it in the Louvre—the poem says nothing about its provenance or about the identity or possible intentions of the artist. This torso is in many ways the opposite of "The Artist Is Present": an object rather than a person, an artifact rather than an event, the product of anonymity rather than celebrity. Its power, its artistic authority, derives from its status as a relic of antiquity, whereas Abramović, a living person, is fully a creature of the modern art world. And yet the effect evoked in the Louvre of Rilke's poem of 1908 is nearly identical to that described by those who sat across from Marina Abramović at MoMA a century later. It is the uncanny experience of being seen, of feeling as if the vector of perception had been reversed.

"For there is no place here that doesn't see you." Packed into this dizzying swirl of negatives is a sensation no less real for appearing to defy all logic—the sensation of being suddenly and uncannily visible, exposed, understood. The pronoun shifts at this moment from the first to the second person, from the universal "we" to the subjective (and, in German, intimately familiar) "you," so that the poem itself enacts what it is saying. The statue and the sonnet that at

least informally shares its name are at that moment fused in the impossible, unmistakable act of seeing *you*, even though it is your eyes that are fixed on the stone or the page. You are opened up, exposed to the universe, which sends you a message, through the ventriloquism of ancient marble and modern literature. *You must change your life.*

The message is loud and clear, but it also requires some decoding. You might take it as a warning against the kind of activity that has brought you to this strange place, where eyeless statues stare at you and sonnets tell you how to live. Time to stop leering at the naked torsos of half-forgotten deities. Time to give up German poetry. Stay out of the Louvre altogether.

But, of course, that is the opposite of what the poem means. Its last words declare, quite literally, a vocation, calling the reader to enter the domain of feeling—of art— that is traced in the previous lines. This is a realm where logic is overridden by a different kind of sense, a way of perceiving neither entirely physical nor entirely cerebral. The poem and the statue are the result of disciplined, concerted labor, but the outcome of that work is a kind of cognitive and erotic frenzy, the thing we have been rather drily calling aesthetic experience.

The archaic torso (the poem perhaps more than the statue) is like a gateway drug, an initiation into a mode of existence more rarefied and more intense than the everyday. *You must change your life.* But how exactly, and into what?

The answer is a sublime tautology: into the kind of life that obeys the imperatives issued by sculptures, paintings, and poems. You must become the person who is willing to change your life based on the exhortations of art.

This is obviously not the path of a connoisseur or a tourist, wandering through galleries smiling at ancient marbles before moving on to the café or the gift shop. Nor is it the path of a critic, at least not according to Rilke's view of criticism, an activity he purported to despise. "Works of art are of an infinite solitude," he wrote to Franz Xaver Kappus in 1903, "and no means of approach to them is so useless as criticism." This may strike us as a little disingenuous in the light of "Archaic Torso," which is an act of self-dissembling criticism, an effort of interpretation, description, and evaluation disguised as a dismissal of all of those things.

The poem is, even more, an act of extravagant appropriation, a brilliant example of the supposed critical vice of going too far, reading too much into a self-contained, self-evident thing. Beholding a headless, almost sexless human figure, this poet infers a smile, eyes like apples, and potent genitals. He finds—or imposes—specific meanings in this piece of marble. What kind of person does this? A certain variety of critic: the kind more apt to tremble in awe than to attempt analysis. These were not rare in Rilke's youth, an era that saw the rise, in England, of a critical movement, known as aestheticism, based on the exquisite

self-sufficiency of art. The point of aestheticism was to collapse the distinctions between creator, critic, and spectator, to imagine each of them sharing equally in the rapture of art.

But at least in the German version, each one is fundamentally alone. Rilke's correspondence with Kappus has been collected into a book, *Letters to a Young Poet*, that has circulated more widely, and been taken to heart more passionately, than anything else he wrote, with the possible exception of the last line of "Archaic Torso of Apollo." This is partly because the biographical identity of the "young poet" is irrelevant (all respect to Kappus, who saved the letters and arranged to have them printed). Nothing is clearer than that they are addressed to *you*. The translator of the most popular English-language edition, Stephen Mitchell, reports in his introduction that he discovered the book when a copy of the French edition was "given to me in Paris by a girl I was in love with when I was nineteen." An inscription on the flyleaf of my own yellowing Vintage paperback recalls a similar circumstance. I doubt Stephen Mitchell and I are in any way unique, much as we might have liked to think otherwise at nineteen. What better gift for a dreamy boy with vague aspirations toward poetry? Since its first German publication in 1929 the book has become—I imagine it still is, as it was for Mitchell in the early 1960s and for me a quarter century later—a touch-

stone of youthful literary seriousness, a manifesto of artistic integrity.

Rilke himself was twenty-seven when he started writing to Kappus (who was nineteen at the time), visiting Paris (home of his idol Rodin as well as the archaic Apollo) and still wrestling with his identity as a man and a poet. Part of the enduring appeal of these documents—there were ten letters, written over five years from various spots in Europe—is that they blend the exemplary modern discourses of self-help and self-examination. The latter was, for Rilke, the crucial undertaking of an aspiring poet. He saw the journey of the artist as, above all, an inward quest, involving less the mastery of technique or tradition than the relentless exploration of the soul. "Sir," he wrote to Kappus in the first letter, "I can't give you any advice but this: to go into yourself and see how deep the place is from which your life flows." If, in the course of that existential spelunking, he discovers that he is "called to be an artist," he will have found a heroic and lonely vocation. A creator "must be a world for himself and must find everything in himself and in Nature, to whom his whole life is devoted."

The true creator belongs to a tiny priesthood, an order of the elect whose membership is highly restricted. This notion is irresistible to a certain type of young person, and vague enough to authorize a dreamy and introspective apprenticeship. Going into yourself and finding the deepest

sources of your life may not resemble what the rest of the world thinks of as work or education. It looks more like idleness and solipsism, but such accusations fuel the sense of specialness. *Of course I'm misunderstood; I'm an artist!* And vice versa. Rilke's continued popularity—especially in the *Letters*—owes a great deal to his extreme and passionate defense of the romantic image of the creative soul as a thing apart, a solitary, suffering, and preternaturally sensitive organism.

But the cultivation of these qualities—or, rather, the state of being open to their expression—is available to everyone. The great paradox inherent in Rilke's idealized, agonized portrait of the artist is that it is at once severely elitist and profoundly democratic. Only a few *will* be called, but the conditions of entry are such that in principle anyone *could* be. All it takes is the willingness to identify oneself as the person being addressed in the last line of "Archaic Torso of Apollo," or the person for whom Marina Abramović's gaze is intended. You have already changed your life; you are not like everybody else.

Art can make you feel different. It can make you aware of yourself by drawing your attention to something else. Rilke describes this in sweeping, melodramatic terms. The spiritual stakes in his poems and letters are very high, and his tone is aptly grand and grave. But what he is describing— the thrilling, transformative encounter between a work of

art and its beholder—is not limited to works of great antiquity or Olympian ambition. It can happen by accident, outside an anonymous nightclub on an ordinary evening.

That is the setting of "Reasons for Attendance" by Philip Larkin, a poet known for concealing a subtle romantic sensibility within a bluff, gruff, plain style. Temperamentally allergic to lofty talk and high-flown sentiment, Larkin nonetheless could be said to have in common with Rilke a strong sense of the value of solitude. As in many of his best poems, the speaker in "Reasons for Attendance" is alone, standing apart from others in the stance of a quizzical, half-sympathetic, slightly envious observer. In this case:

> The trumpet's voice, loud and authoritative,
> Draws me a moment to the lighted glass
> To watch the dancers—all under twenty-five—
> Shifting intently, face to flushed face,
> Solemnly on the beat of happiness.

The poem turns on the difference between this passerby—presumably over twenty-five, though Larkin was barely into his thirties when the poem was published—and the excited young people inside the club. Each has different reasons for being in attendance. "Why be out here? / But then, why be in there?" The answer to the second question seems obvious enough: "Sex, yes . . ." You go out dancing

in the hope of finding sex—or at least the possibility of it—amidst "the smoke and sweat, / The wonderful feel of girls." Our speaker, however, is a bit skeptical about that whole business.

> *Surely, to think the lion's share*
> *Of happiness is found by couples—sheer*
> *Inaccuracy, as far as I'm concerned.*

His own reasons for attendance are different:

> *What calls me is that lifted, rough-tongued bell*
> *(Art, if you like) whose individual sound*
> *Insists I too am individual.*

Art sneaks diffidently into the poem, tucked in between parentheses and invoked not with any great claims but solely, it appears, for lack of a better term. This is popular art, in any case, not the pedigreed thing that might have moved Rilke or Kant to paroxysms of spiritual delight. The trumpeter and the tune are unnamed, but it's not hard to infer, given the era (the postwar, pre–rock 'n' roll 1940s or early '50s) and what we know of Larkin's tastes, that we are listening to jazz, and that the horn player is taking a solo during one of the verses of a standard tune. The anonymity of both the musician and his accidental listener heightens the serendipitous nature of the encounter, and

also its essential privacy. Neither one is known to the other, and each affirms the other's uniqueness. The spectator hears something special, something different in the voice that calls out to him, and the particularity of that voice "insists"—a notably forceful, uncompromising word—that he is special too.

Not that his specialness is exclusive:

> *It speaks; I hear; others may hear as well,*
> *But not for me, nor I for them . . .*

The music is general, public, shared by an audience—but at the same time irreducibly specific to every member of that audience. No one can do anyone else's hearing. It is at once a common and a private experience, subjective and universal. And also beyond argument:

> *Therefore I stay outside,*
> *Believing this; and they maul to and fro,*
> *Believing that; and both are satisfied . . .*

But a Larkin poem would be false to itself if it came to rest on such a harmonious, tolerant note. So this happy conclusion—the dancers have their sex; the man outside has his art—takes place under a shadow. This mutual, separate satisfaction is possible only "If no one has misjudged

himself. Or lied." By means of a simple conditional, the poem undoes the spell of that emphatic trumpet, that smoky room, and returns us to the reality of the human condition, from which both art and sex promise momentary and illusory escape. Misjudgment and deceit are hard to avoid, in art or in love, and so it seems likely that the satisfactions of the evening are unlikely to last, though at least—for this is an optimistic poem—they can be attempted anew. Still, the implication of the last line is that, much as you might wish otherwise, you probably can't change your life.

Larkin's speaker has nonetheless been reminded, rather forcefully, that he is alive. And this is what his poem has in common with Rilke's: both attempt to dramatize the fundamental power of art using a vocabulary purged of appeals to taste, beauty, or any other received aesthetic vocabulary. They are trying to evoke the same primal, ineffable experience that Abramović provoked in so many viewers, and part of my intention in juxtaposing these three examples is to sketch a composite picture of that experience without tying it to specific styles, historical periods, or kinds of work. The nameless trumpeter, the headless torso, and the voiceless, affectless presence of the artist do not resemble one another at all, save in certain of their effects. These have something to do with sex—the illusion of love between Abramović and her audience; the mutual

arousal of the archaic torso and its poem; the erotic trans-
actions enabled by Larkin's trumpeter—but they are not
exactly sexual.

Art is not sex carried out by other means, but it seems
to be subject to similar anxieties and taboos. "Talking in
bed ought to be easiest," Larkin observed in a later poem,
and talking about art ought to be even easier. Or, it should
be possible and sufficient not to talk at all, to allow the
experience to speak for itself. And yet, Larkin concluded,
even in a state of postcoital bliss, a state that represents "an
emblem of two people being honest":

> It becomes still more difficult to find
> Words at once true and kind,
> Or not untrue and not unkind.

So criticism rears its head again, the snake in the garden of
what should be our simplest pleasures. It has always been
part of the landscape, though, arising from our desire—
nearly as strong as the urge toward pleasure itself—to think
about, recapture, and communicate our delights, to make
them less solitary, less ephemeral. The origin of criticism
lies in an innocent, heartfelt kind of question, one that is far
from simple and that carries enormous risk: *Did you feel
that? Was it good for you? Tell the truth.*

Self-criticism
(A Further Dialogue)

Q: What about you?

A: What about me?

Q: What do you like? You've been talking about taste in an abstract, general way, with examples that seem to have been chosen more because of what they represent than because they reflect your own passions or preferences. I mean, come on. Rilke? Are you really that into Marina Abramović?

A: Maybe not. I'm a big Philip Larkin fan, though.

Q: That figures. But nobody likes everything, and nobody—least of all someone like you—walks around like a sponge soaking up experience willy-nilly. You choose; you seek out some things and avoid others. You trace a pattern of

engagement. You build on primal encounters with the things that changed your life—your own specific, subjective life. So what were those?

A: That's kind of personal, isn't it?

Q: Maybe, but haven't you been arguing—or at least implying—that the ladder of criticism starts down in the foul rag and bone shop of the heart, with the spontaneous pleasures and reflexive revulsions of the individual spirit? Didn't Oscar Wilde say that "the highest as the lowest form of criticism is a mode of autobiography?" Isn't what you call judgment or interpretation really just a lover's confession?

A: Fair enough. But where should I begin? With books? *Hop on Pop*? *Catch-22*? The age-inappropriate movies I went to see when I was too young to understand them? The prime-time sitcoms I was allowed to stay up to watch or the forbidden late-night shows I'd sample when I slept over at the houses of friends with more permissive parents than mine? The 1960s rock I played on my parents' phonograph when I was a kid? The punk and post-punk albums I bought with odd-job money when I was in high school? The blues and jazz and country-and-western reissues I snapped up in my moldy-fig, red-wine-and-Camel-straights undergraduate phase? *London Calling*? *Sketches of Spain*? *Annie Hall*? *Stranger Than Paradise*? *Less Than Zero*?

Q: Do you mean the Elvis Costello song or the Bret Easton Ellis novel? Once again you are spewing out your own questions instead of answering mine. But any of the things you named would work perfectly well.

Really, though, you need to get over yourself. You act as if you're reeling off a collection of random phenomena or showing off a precious collection, when actually you're describing something—someone—very specific and totally familiar. Show me what's on your iPod or your DVR or your bookshelves and I'll tell you who you are. There's no easier clairvoyance.

And it takes no effort at all to peg you, my friend, as a Gen-X baby in the throes of middle age, flailing between the Kubler-Ross stages of denial and acceptance as you mourn your lost youth. You grew up in the backwash of the baby boom, with educated parents who subscribed to the *New Yorker* and bought the well-reviewed novels of the day. Gore Vidal. Erica Jong. *Watership Down*. As for movies, you got to the 1960s New Waves and to '70s New Hollywood a little too late: your touchstones were *Saturday Night Fever* and *Star Wars* rather than *Mean Streets* and *Nashville*. In many cases, you read the *MAD* satire long before you ever saw the movie, if you ever got around to seeing the movie at all. You saw *Breathless* in college, probably for a class. You saw *Bewitched* in reruns.

Punk rock saved you from feeling late for everything, and then a little after that hip-hop freed you from the nagging

sense that you inhabited a stale, small world of provincial whiteness. You read those Vintage Contemporary paperbacks with the watery aquamarine quasi-surrealist covers and then graduated to the bright monochrome University of Minnesota Press Literary Theory volumes so you could feel cooler than your friends. That was the same reason you went to foreign films and listened to old-time music; the same reason some of your peers fetishized horror movies and comic books; the same reason others professed an "ironic" affection for the kitsch and crap of earlier pop-cultural eras. Your life is college radio, literary snobbery, a conspiracy of the high and the low against the middlebrow; HBO and Adult Swim and the Criterion Collection; graphic novels and alt-country and *Seinfeld*—the narcissism of small differences elevated to an aesthetic principle.

A: Well, when you put it that way . . . I can't say you're wrong. But I can say that you're being maybe a little too cynical and much too sociological. It would be foolish for me to deny the determining facts of my generation, class, education, and background. I don't make the mistake of supposing that my feelings and perceptions are either uniquely mine or somehow untethered from influence and circumstance. Nobody floats above the common run of tastes, plucking only the most exquisite posies on the basis of pure intuition. It's always contingent, always relative, always a matter of who and where you happen to be.

Q: But haven't you been suggesting the opposite? Isn't your theory of taste grounded in spontaneous encounters, in the erotic bliss that erupts when you hear music or confront a statue, when beauty catches you unawares?

A: Let me finish, though. Of course, we're all determined beings, made by circumstances beyond our control. But we're also changeable creatures, highly susceptible to the influence of accident, free agents with the power to invent ourselves. Sometimes we react the way we do because of birth or conditioning, sometimes because of a more mysterious force, sometimes by the operation of our own will. We don't always like what we're supposed to like, and we also move in the other direction, toward forbidden or nonapproved pleasures. In the next chapter—

Q: We'll get there. But you're drifting back into abstraction. Maybe you could illustrate what you mean with reference to your own tastes and interests.

A: I'll try. Everything you said about me just now is true. Like just about everybody else who has marched in the parade of postwar American generations, I grew up in circumstances of astonishing and unprecedented cultural abundance. The world had been organized to deliver an overwhelming variety of stimuli directly to my brain, which was quickly filled with pop-song hooks, sitcom catchphrases, movie montages, and stream-of-

consciousness monologues from late-night talk shows and experimental novels.

It's not an exaggeration to say that all that stuff supplied the architecture and the furniture of my emerging self. Which is how I wanted it. It's widely recognized—it's a cliché, really—that young people are innately curious and instinctively adventurous, hungry for knowledge and experience. But I think what they—what we, certainly what I—crave, above all, is expanded consciousness.

Q: It sounds like you're talking about drugs.
A: No, but almost. I'm definitely talking about radically altered perception.

At a certain point when I was a child I received the terrible news of my own mortality. The most offensive thing about dying—the most frightening part, the worst insult—was that I would stop thinking. It also struck me as horribly unfair that, in the course of my lifetime, I would only ever get to occupy a single mind. I would only ever think and feel within the arbitrary limits of who I was. It would have been so much more interesting to be able to be a lot of different people in succession, and I was sorry not to have grown up in a religion with strong ideas about reincarnation or the transmigration of souls.

Reality as I knew it was entirely inadequate to my

needs, and my restlessness drove me to try to expand it, mostly through books and movies, but also in other ways. You could call this escapism—and it's true that I've always been something of a daydreamer, and occasionally an outright fantasist—but I dislike that term because it implies that the impulse to travel beyond your literal and immediate circumstances is trivial and irresponsible. For me it's a kind of knowledge.

Q: What kind of knowledge? When you read a novel or watch a movie what is it that you actually learn?

A: There's really no limit. The world is enormous. Travel is exhausting. Time travel is impossible. But you can go anywhere, to any period in history, in the pages of a book or sitting in front of a screen, and acquire a more intimate, richer sense of what is found there than you would through classroom study or organized travel. You can get inside feelings and habits. You can, through the magic of empathy, know what it was like to live in ancient Rome or the modern Chinese countryside or for that matter in some entirely invented place like Middle-earth or Gotham City. And it's not only narrative forms that do this, though for me movies and novels are especially valuable for their density of detail and their absorptive power. An old painting is a portal into another age and country; a piece of music can transport you to Brazil or Salzburg or the Mississippi Delta and

inject you into the emotional world of someone living in one of those places.

Q: Frankly it sounds very superficial to me, like a kind of tourism, with some of the same ethical problems. You hop around the world grazing on the things other people have made, using their hard realities for your own amusement. And you seem blind to the privilege that underwrites your adventures—the available leisure, the disposable income, the educational advantages, the assumption that you are entitled to all this cool stuff without really working for it. You're talking about taking ownership of—or at least borrowing—experiences that don't belong to you and making them your own. Isn't what you call empathy really a kind of imperialism?

A: Well, it's not as if I'm stealing anything. I take it that all these works—books, films, songs, and so on—are acts of communication, and that I have as much right as anyone to listen to what they're saying.

Q: But don't you ever think that maybe they weren't meant for you?

A: What are you suggesting? That I should have stayed within the boundaries of my identity? Sought out pleasures closer to home?

There was no shortage of those, and I did plenty of that. In American culture—and elsewhere as well—the

decades surrounding my birth were a high-water mark of white male self-obsession and of adolescent self-assertion through various kinds of rebellion. You could hardly avoid it. There on my parents' bookshelves were *The Catcher in the Rye* and *On the Road*, *Rabbit, Run* and *Portnoy's Complaint*. There in my hot little hands were *MAD* and *National Lampoon*. There on the radio were the successive generations of rock 'n' roll heroes—the poets and the prancers and the punks—acting out their patented styles of aggression. All those seemed like perfectly plausible selves for me to explore. If not role models, then secret idols and alter egos. But why did I have to stay within that range? To stick with my own supposed kind?

Q: Because it's greedy otherwise, in the way that some of those guys were greedy. You couldn't be content with wanting to be Jack Kerouac or Bob Dylan or Johnny Rotten or Spider-Man. You had to want to be Joan Didion and Patti Smith and Leadbelly.

A: First of all, it was no small leap to imagine myself as Kerouac or Dylan. It's not as if I really had anything in common with them, apart from some demographic traits shared by a few million others as well. Second of all, one of the ways Patti Smith got to be Patti Smith was by wanting to be Bob Dylan—and also Rimbaud and a lot of other guys. Who's to say where the bound-

aries are? Who gets to draw them? And I suspect that if it was the other way around, if I was describing a pale-face pantheon of dudes with daddy issues and girl trouble as my major sources of selfhood, you would accuse me of being too narrow, too provincial and exclusive, unable to appreciate difference, confined to my own cultural comfort zone.

Q: Of course, I would. And I'd be right either way.
A: I just can't win then.

Q: Poor you.

Chapter Three

Lost in the Museum

Let's say you want to see some art. What happens when you see it might turn out to be intense and complicated, but surely finding the stuff is a simple enough proposition. Art lives in museums. So why not set a course for one of the biggest and most famous—and by far the most frequently visited—museums in the world? We're in need of some culture. We'll go to the Louvre. We may even catch a glimpse of the broken statue that moved Rilke to such lyrical ecstasies.

But right away, things start getting confused. Not the travel arrangements or the scheduling of the visits, but the conceptual framework that underwrites the journey. The whole idea of "culture," that is. In *Keywords*, his indispensable glossary of modern thought, the literary scholar Raymond Williams observes that "culture is one of the two or three most complicated words in the English language." In some of its early senses, it is nearly synonymous with

education, referring to the growth and tending of young minds. It suggests farming and gardening—agriculture, horticulture, cultivation—but it also carries with it the burdens of civilization. An old Latin root links it with the words "colony" and "couture," and so by implication with conquest and refinement, with fancy clothes and brutal exploitation.

But you don't have to dig that deep into the etymology to find trouble. Modern usage is a riot of contending meanings. In newspapers and magazines, the Culture Desk signifies the domain of the arts. In the business world, as in the field of anthropology, a culture is a set of habits and practices. Do these arise naturally, or are they carefully nurtured and tended? Are you born into a particular culture, or is culture in general something you acquire as you grow? Are some cultures better than others? And if so . . .

On our way to the museum, we have wandered into a semantic quagmire, and language games may not be sufficient to pull us out of it. Is culture—"our" culture, however that might be defined—what we bring with us, or is it what we are looking for? Do we imbibe it with our mother's milk, as a primal identity that can't be broken and that determines everything we go on to do, or do we acquire it at a later stage, through school or the rituals of citizenship? If culture is membership in a group, how big is the group? As big as a nation or (speaking of complicated words) a race? As small as a community, a neighborhood, a family? Is cul-

ture something we're stuck with, or something we aspire to? Can we change cultures, or belong to more than one, or somehow get more of it, as if it were a kind of money? Common phrases and familiar sentences don't clarify much: culture wars, popular culture, multiculturalism, "culture and anarchy," "culture of poverty," "it's the culture, stupid."

So there we are. Maybe we shouldn't worry so much. Maybe, for now, we can pretend that "culture" is nothing more than the transparent, atmospheric medium—the water or the oxygen—in which our experience, in this case our experience of art, takes place. And maybe "history, another fraught concept," is just the series of chronological accidents that delivers a particular work of art to our attention. We can't, after all, escape from the facts of language, geography, class, gender, and belief that condition what we see, any more than we can will ourselves into another time. We might select our path to the Louvre, but we hardly control the conditions or the occasion of our visit. Even before we arrive, we might suspect that we are here neither by choice nor by accident.

Within a given year, more than eight million people will pass through the corridors of the Louvre. It's not just the most visited museum in the world, but also a symbol and a shrine, the embodiment of an idea of civilization—of culture—so durable that it might be taken for a fact of nature. The Louvre is more like the Grand Canyon than the art galleries of Manhattan or Beijing: a pilgrimage

spot in an age of compulsive international travel, a mighty, inexplicable thing you must see, even if the reasons are not entirely clear. This eminence may testify to the success of a centuries-long publicity campaign: Paris and its museums have been sold to the world as unique repositories of beauty and refinement. From Bilbao to Abu Dhabi to Bentonville, Arkansas, ambitious curators, architects, and philanthropists have tried to orchestrate similar triumphs, to turn collections and the buildings that house them into irresistible destinations.

Not everyone who passes through the galleries of the Louvre, whether moving at the deliberate pace suggested by the cues on the audio-guide headset or in the headlong haste dictated by dragged-along children on the verge of a meltdown, will pause to contemplate the archaic torso that supposedly inspired Rilke to change his life and write his poem. Relatively few are likely to heed the instructions Rilke inferred within its contours. Honestly, who has the time? Schoolchildren, tour-group visitants disgorged from buses, solitary students, honeymooners, and the handful of actual Parisians wandering the corridors will no doubt resume whatever lives they were leading before they came. Passionate, romantically inclined readers of German poetry may be more likely to appreciate the idea of changing their lives than to feel compelled to obedience. And even highly sensitive, aesthetically susceptible souls might find themselves too distracted to hear the message in the mar-

ble. It's so crowded in here. The line for tickets is endless, especially in the summer months, which is why guide-books advise purchasing, in advance, a weekly pass that will admit you to most of the major museums and attractions in the city. You will also be able to skip the lines at the Musée d'Orsay and the Centre Pompidou and elbow your way toward the Gauguins, Monets, Kandinskys, and Warhols along with everybody else.

But today, like it or not, you are at the Louvre. If you came home from Paris without having seen it, you would feel like an idiot. And so you cross its vast, shadeless, grav-elly courtyard, glancing over your shoulder across the Tuil-eries at the place de la Concorde, where an obelisk plundered from Egypt and shipped home by Napoleon serenely over-sees a perpetual traffic jam. In the farther distance, about 60 degrees apart as you look west, are two other monu-ments of Paris's hectic nineteenth century: the Arc de Tri-omphe, commissioned by Napoleon in 1806 to celebrate his imperial glory; and the Eiffel Tower, an engineering marvel built for the 1889 World's Fair to celebrate itself and the city—already, a century after the storming of the Bastille, a destination for leisured, cultured travelers—that it would soon come to represent on postcards and key-chain trinkets.

In other words, as you descend the escalators from I. M. Pei's once-scandalous glass pyramid (completed exactly one hundred years after the Eiffel Tower for the revolutionary bicentennial and the greater glory of François Mitterrand,

at the time the president of the republic) into the museum's cavernous underground lobby, you are cocooned in the cosmos of modern global tourism. You are sandwiched, like the cream in a napoleon pastry, between layers of history, including, of course, the history of art. A staircase will lead you up from Greek and Roman sculpture to European painting, and a folding map will conduct your progress from antiquity to the Middle Ages, by way of China, Egypt, and Byzantium. You can amble past altarpieces and suits of armor, escritoires and amphorae, taking one of many detours to behold—or to avoid—the most famous painting in the world. You know she's in there, of course, and you have already seen her likeness a thousand times. Brought from Italy by the French king Francis I, the *Mona Lisa* was elevated by the nineteenth-century British critic and aesthete Walter Pater to the status of supreme masterpiece, a simple portrait of an enigmatic lady that became the summa of Renaissance glory and the herald of modern life. It is not really the likeness of the smiling woman that has captured the modern imagination, but rather the fame of the painting itself. It has been stolen and vandalized, psychoanalyzed by Sigmund Freud, mocked by Marcel Duchamp, and mined for conspiratorial clues in Dan Brown's *Da Vinci Code*. The *Mona Lisa*, flanked by guards and set off by velvet cordons, is now seen only through a series of screens: the Plexiglas shield that protects her; the thousand cell phones aimed at her during every minute of

the museum's operating hours; the countless reproductions, including on the museum ticket crumpled in your pocket. This is hardly the serene contemplation of ineffable beauty, but it is nonetheless among the central experiences of art in our time.

Keep it moving. Where are you staying? Who did you come with? How much was the ticket? This is precisely the kind of inquiry that would seem to threaten the purity of the experience you are seeking out in the first place, the abstract but also highly particular encounter with something unique and timeless. Social and economic considerations will only cloud our gaze and embarrass our conscience. Still, we must admit that neither we nor the beautiful objects of our contemplation arrived here by accident or by natural processes. We came by jet and bus or *métro*, fueled by credit cards and advantageous exchange rates and enticed by marketing, peer pressure, word of mouth, and the ennui of the late-capitalist leisure class. Anything but innocent, we contrive to stand in the presence of serenely guilty things. Those treasures of civilization housed in this gargantuan pile of masonry were purchased, stolen, commissioned, or coerced so that we, exercising a freedom that can feel like obligation, might have a look and pick up a cheap souvenir manufactured by sweated labor half a world away. Beneath the steady tread of tourist feet you can hear a faint echo of primordial violence—exploitation, appropriation, objectification. According to Walter Benjamin, "There is

no document of civilization that is not at the same time a document of barbarism," and while this might sound melodramatic, we can't deny that the artifacts we cherish and conserve—the things we dignify with the name art—come to us bearing the telltale traces of money and power, scarred by domination.

This doesn't necessarily mean that art is a ruse or a conspiracy, a trick played by unseen forces or scheming rulers on the rest of us, who are gullible enough to believe our eyes or cynical enough to suppress the stirrings of guilt or outrage. There is a school of critical interpretation that specializes in the unveiling of hidden agendas that are never really hidden at all, and prosecuting the already self-evidently culpable cultural authorities. The art world, you may be shocked to learn, is underwritten by bankers and industrialists. The Hollywood studios are hotbeds of corporate greed. The masterpieces of Renaissance painting and sculpture were enabled by the patronage of corrupt popes and ruthless princes. The European novel arose as the looking glass and plaything of a vain and entitled bourgeoisie in an age of brutal colonial adventurism. The ancient marvels stuffed into Western museums from Berlin to Los Angeles were snatched from poor or militarily unlucky countries by imperial raiding parties, and the treasures themselves were more often than not artifacts of despotism and superstition. The objectification of women, the glorification of illegitimate power, the dehumanization of the

Other—it all hangs seductively and poisonously before our eyes. If we adjust our perspective—or correct our naïve vision with properly skeptical lenses—we will see that what we have taken for beauty is really the afterimage of cruelty, inequality, intolerance, sexism, and greed.

This is the longest, most dogmatic route to the museum, but here we are. The walls of the Louvre fall under the expansive and at the moment relatively benign purview of the French state, which maintains the facility partly as a reminder of the barbarous, civilizing beast it used to be. This building, which stretches for blocks between the banks of the Seine and the arcades of the rue de Rivoli, came into being as a fortress built by an absolute monarch and grew into the administrative home of an aggressive and tyrannical old regime. Even then, during the reign of Louis XIV, it was a place devoted partly to the exhibition of beautiful objects, a showcase for the cosmopolitanism and cultivation of the monarch and his court. It was also a home for several of the academies that formalized his government's commitment to art, science, and the production of knowledge.

The era of the Sun King, who ruled France from 1638 to 1715, was also *l'âge classique*, a high pinnacle of French accomplishment in music, architecture, philosophy, and literature. Molière presented his farces at court and in public theaters. Racine composed the tragic hexameters that would be drilled into every French lycée student's ears for

centuries to come. Ornate gardens and graceful fountains decorated the grounds of grand, symmetrical palaces, including Versailles, which in 1682 displaced the Louvre as the primary royal residence.

This was also, and not incidentally, a golden age of criticism, during which observations and patterns gleaned from antiquity and the Italian Renaissance were formalized into systems and rules. The fundamentally descriptive, historically minded impulses that inspired Aristotle's *Poetics*, Horace's *Ars Poetica*, and Vasari's *Lives of the Artists* became the basis for prescriptive theories and normative arguments. Ideas like the unity of time, space, and action, which Aristotle had inferred from the plays of his own time, were recast by critics like Boileau and La Rochefoucauld into laws of proper dramatic composition. In the visual arts, classical ideals of harmony and balance derived from Greek, Roman, and Italian models were tethered to the insights of contemporary science, philosophy, and mathematics. The shape of a successful building or the composition of a good painting was understood to be not only pleasing or practical, but also fundamentally truthful, conceived and executed in harmonious concord with the laws of the universe.

Seventeenth-century France was hardly unique in embracing the idea that the artistic products of its particular culture—forged out of post-Reformation Catholicism, political absolutism, ancient Gallic custom, and protomodern scientific method—were erected on foundations of univer-

sal and objective truth. Many, perhaps most, societies mistake their local variations on human practice for its deep and permanent essence: the way we do things is, as far as we can tell, the way things are supposed to be done. And in the annals of early modern European imperial arrogance, France had serious competition. Italy and Spain got there first, England made a more enduring case for its supremacy, and the German-speaking lands, tardy entrants in the game of universal culture, played it in the late eighteenth and early nineteenth centuries with unmatched ferocity and refinement.

But let's not wander from the designated path just yet. We can talk about Beethoven and Goethe and Hegel—or Dante, Velázquez, and Milton—some other time. For now, while we're here, we can entertain the pleasant conceit that Paris is the center of the universe, that France is the universal nation, and that the Louvre is a clearinghouse of distant and bygone civilizations and therefore the architectural and curatorial avatar of civilization as such.

The museum has achieved this status partly by outlasting the social and political order that oversaw its birth. The revolutionaries who toppled the monarchy in 1789 zealously and violently tried to erase all vestiges of the old regime: they renamed the months of the year, started the calendar at zero, and sent thousands of suspected royalists into exile or to the guillotine. But attempts to kill the cultural legacy of the Bourbon kings proved short-lived and

ineffectual; rather than raze the Louvre and burn its contents, the leaders of the new republic opened its doors and declared what was inside to be the property of the people. It became a democratic place, which is more or less what it has remained through the many changes of regime—imperial, restored-royalist, republican, collaborationist, Gaullist, and so on, up until the Eurozoned present—that ensued.

To some degree, whether we recognize it or not, we—that is, the motley twenty-first-century throngs traipsing through the Louvre, our headsets offering guidance in Korean, German, English, and Spanish—are the legatees of a brief, highly local phenomenon, the accidental heirs of an agitated flurry of activity that occupied a few hundred years on a cramped and rocky landmass perched between the North Atlantic and the Mediterranean. The terms of the inheritance are both generous and demanding, their enforcement as benign as it once was brutal. This art (and the thought that surrounds and supports it) belongs to all of us, but it also insists on making us in its image, requiring that we acknowledge the power of its ideals and submit to its lessons.

We do and we don't. We are in pursuit of an experience at once solitary and social, particular and universal, contemporary and tied to the past. Its value is at once self-evident—This is the Louvre! This is Paris! How can you *not* want to see it?—and mysterious, even alien. What does this

sprawling warehouse, with its ancient, painstakingly orga-
nized contents, mean to us? The fact that the institution is
now open to everyone in many ways makes its essential
contradictions more acute—makes it indeed something of
a monument to the paradoxical status of art in the modern,
flattened-out, notionally egalitarian world. We enter with-
out distinction, from every continent and walk of life, sur-
rendering our individuality to the leveling anonymity of
the mass. But distinction—the aristocracy of artistic ac-
complishment or, at the very least, the accidental grace of
lasting—is precisely what these paintings and sculptures
promise. They are unique, important, designated by time
and tradition as masterpieces.

What are we meant to do with them? What do we see
when we look? It is sometimes supposed that the present
generation has lost the ability to appreciate such works, an
odd but surprisingly powerful idea, since in purely quanti-
tative terms the world's great art is more thoroughly appre-
ciated now than ever before. More people see it and study
it, whether firsthand or by means of mechanical and digital
reproduction. Still, it is possible to gaze upon the hordes
snapping cell phone pictures of the *Mona Lisa*—even as you
constitute part of their number—and conclude that they
are going about it all wrong, denying themselves the por-
tion of sublimity that is included in the price of the ticket.

It is also possible, however, to suspect that the museum

itself is complicit in the denial of the very experience it ostensibly exists to provide, that the Rilkean rush of exaltation—or even a more transitory shiver of delight—is, by design, an outlier. If everyone walked out of here committed to self-transformation, where would we all be? Aesthetic bliss, in principle universally available, must in practice be contained, limited, even minimized. The more common reaction to the Louvre, the one enough of us have had to make it the rule rather than the exception, is the one that befalls Christopher Newman in the opening pages of *The American*, by Henry James.

One name for it is boredom. We meet Newman on "a brilliant day in May, in the year 1868" as he rests on a settee "staring at Murillo's beautiful moon-borne Madonna in profound enjoyment of his posture." The painting, a representation of the Immaculate Conception, is a curious example of Spanish Baroque Catholic iconography, in which the Virgin perches on a lunar orb about the size of a yoga ball, floating placidly in space as naked cherubim flutter and stare. But their baby fat and Mary's heavenward gaze occupy Newman's thoughts less than his aching feet and weary eyes. A physically fit specimen—"long, lean, and muscular, he suggested the sort of vigor that is commonly known as 'toughness'"—James's American is nonetheless overcome by the exertions of touristic art appreciation. "[H]is attention had been strained and his eyes dazzled, and he had sat down with an aesthetic headache."

This is James's precise anatomical rendering of the exemplary modern malady known as museum fatigue. In Newman's case, it is mitigated by the presence of pretty young women copying the pictures on the wall, a spectacle he finds more engaging than the masterpieces themselves. "[I]f the truth must be told," James notes, Newman "had often admired the copy much more than the original," a bit of information that sets up his fateful flirtation with an especially attractive copyist.

This is, of course, another variety of aesthetic experience public museums have long existed to propagate. Since art perpetually hovers in the neighborhood of sex—all that passionate creation; all that naked flesh rendered in rosy oil-paint pigments and silky-smooth marble—it can hardly be surprising that the Louvre would present itself to James's eye as something of a pickup scene. It is also a perfect place for him to introduce the novel's theme, which is, not for the first or last time in his work, the fraught encounter of an American with Europe.

The terms of this meeting are familiar enough, and were well on their way to being clichés even in 1877, when *The American* was first published. Newman, as handsome as a movie star, with a blatantly allegorical surname, is a practical man transplanted to an alien world of sensibility. Very much the male counterpart of Isabel Archer in *The Portrait of a Lady*, he is less an unworldly innocent than someone whose fresh perception and candid nature put him at great

moral risk among the cynical aristocrats and adventurers of the Old World. James's condescension toward Newman—as toward his other vigorous and gullible Americans abroad—is tempered by a genuine admiration, a patriotic rooting interest that survived decades of expatriation and a lifelong devotion to the superiority of European culture. Newman is not simply an American rube blundering through a storied place he is too unsophisticated to understand, or a newly rich Yankee in search of a Continental wife, though he is both of those things.

Above all, he is a businessman, an avatar of capitalism who finds himself confronted with other, mysterious kinds of value:

> His physiognomy would have sufficiently indicated that he was a shrewd and capable fellow, and in truth he had often sat up all night over a bristling bundle of accounts, and heard the cock crow without a yawn. But Raphael and Titian and Rubens were a new kind of arithmetic, and they inspired our friend, for the first time in his life, with a vague self-mistrust.

Newman tries to dispel this feeling by offering to buy a reproduced masterpiece from Noemie Nioche, whose patron he will later become, but let's leave them to their business and dwell for a moment more on the curious sen-

timent that haunts the Salon Carré where our American is lounging.

His "vague self-mistrust" when confronted by the work of the Renaissance masters is not that far from the psychic upheaval Rilke would intuit, a generation later, from the broken torso under the same roof. Newman's way of thinking has been challenged, his self-perception altered, albeit in alienated rather than ecstatic fashion. Here is a man used to dealing in quantities who finds himself exposed to qualities that resist enumeration. These paintings just don't add up. But rather than dismiss them or deny their value, he casts doubt on himself. We can only admire his honesty, and, if we are honest with ourselves, confess that we have been here too, standing before something the importance of which we can acknowledge without feeling what we are supposed to feel. *I just don't get it. What's wrong with me?*

In Newman's case, as it plays out, the answer might be that he was wrong to have left the manageable world of account books in the first place. His bemusement at the Louvre is the first sign that he is playing on hostile, foreign turf, and that the rationality and self-confidence that made him a winner back home—where he is a prosperous industrialist involved in the manufacture of never-specified commodities—will not help him out here. For the rest of us, the implications are perhaps more pedestrian, and certainly more diffuse, but nonetheless consequential.

Like Newman, we are out of place, estranged from sur-

roundings that by now belong to everyone and no one. And we might recognize—and resent—the element of coercion that pushes us through the teeming corridors. A museum like the Louvre is the ultimate example of an argument from authority. Its institutional power of judgment, exercised invisibly over a long period of time, shaping collective taste the way wind carves the faces of mountains, is far greater than our own tiny, hesitant gestures of liking and disliking. We are here because we are supposed to be here, and our reactions matter less than our submission. When confronted by the fleshy allegories of Titian or Rubens, or the grand, cinematic history paintings of David, or the mute strangeness of rough stones dug from the oblivion of ancient tombs, our own opinions are less than trivial. They barely even register; the work of evaluation has been done in advance. Our job is to accept, and to doubt ourselves if, like Newman, we can't.

Or alternatively, we can mount an argument against authority, and refuse to grant to what we see—or read or listen to—the approbation that it claims as an eternal birthright. Our rebellion can take a sulky, passive, diffident form, as we doze over Tolstoy, daydream at the opera, smile politely when a friend plays Charlie Parker or Bob Dylan records, or hurry through the exhibition halls to reach the snack bar and the gift shop. If we choose, we can be more defiant and obnoxious in our dissent, attacking established

masterpieces as overrated and assailing the corrupt, conspiratorial thinking behind the consensus. Confronted with the pantheon, the canon, the curriculum of classics and "greats," we can stifle a yawn, thumb our noses, and ask: *Says who?*

It is an interesting question, actually, and one that has received its share of intellectual attention in recent years, especially in American higher education. In the 1990s, a skirmish broke out—an episode in an apparently endless ideological identity crisis known collectively as the culture wars—about what books should be taught to college students. As is usually the case with this kind of argument, a great deal of nuance was sacrificed, especially when the supposed battles between Dead White Men and the forces of feminism, multiculturalism, and other newfangled movements were reported in the news media. The debate often took the form of an especially loud dialogue of the deaf. On one side were those who saw determinations of cultural value—the supremacy of Shakespeare or Beethoven; the centrality of traditions of thought and creative endeavor stretching from Mediterranean antiquity to Euro-American modernity—as both self-evident and in constant need of defending. Against them were those who argued that such hierarchies were always, at bottom, political, rooted in the exclusion of other traditions and points of view and serving the interests of those in power. The writers and artists

whom generations of young people had been taught to revere in school were revealed, wittingly or not, to be the tools of patriarchy, Western hegemony, capitalist domination, and other bad things. The case for their innocence— for their nonpolitical virtues—seemed, at best, naïve, at worst complicit with racism, sexism, and snobbery.

No one was seriously proposing that trusty staples of the syllabus be thrown away, but rather that they be supplemented, so that the humanities could live up to the pluralism implicit in their name and reflect a social reality that was ever more diverse. It was never a matter of choosing between Shakespeare or Toni Morrison—even if some commentators, for their own dubious reasons, chose to frame it that way—but rather of making room for both. Whether this project was laudable, naïve, or covertly totalitarian (as some of the more hysterical right-wingers warned, before dropping the matter entirely and declaring war on evolutionary biology and environmental science), it was not altogether new.

Both sides made the mistake of supposing that the canon was an age-old, immutable register of worldly wisdom rather than a perpetually renegotiated, frequently improvised list, a barometer of fluctuating tastes, ramified prejudices, and unexamined habits. Certain books are assigned in class because they always have been, others because they reflect the interests of professors and students,

and still others fade into disuse without much scandal or lamentation. From time to time, a demand for novelty—for a more relevant or responsive set of texts—will be met with skepticism and resistance. This happened in Great Britain in the 1930s, when scholar-critics like F. R. Leavis advanced the radical notion that relatively recent (i.e., postmedieval) English writing could be taught on an equal basis with the Greek, Latin, and Anglo-Saxon classics. It happened a decade later in the United States, when the addition of American literature to the curriculum, a patriotic necessity to its proponents, struck defenders of tradition as a dubious novelty, a concession to intellectual trends at the expense of permanent values.

The barbarians, in other words, are always at the gates. In fact, they are already inside, subverting the city from within. But, of course, this means that those barbarians— the others and outsiders clamoring for inclusion—have already absorbed some of the dominant values they aim to dethrone. Both the forces of revolution, who demand redress for long-standing grievances, and the forces of reaction and stasis, who wish to halt progress and stop time, are missing the point as they utter their war cries. Their battle may be fought within institutions like museums and schools, which seem to offer shelter from the demands of the marketplace, but it is nonetheless the logic of the market that tends to supply the terms of peace. The solution, in

democratic, consumer societies, is always the same: more. More discourse, more classes, more access, more opinions. Instead of hierarchy, we will have pluralism; instead of picking our way along the narrow path of "or," we will frolic in the broad meadows of "and." Why should anyone have to choose between classics and moderns, between high and low, between Dead White Males and hyphenated rainbow people? We can have it all.

In place of canons and pantheons and other highly exclusive, instantly obsolescent repositories of value, we will have polls, lists, and menus. The lurking, philosophical question that haunted our earlier trips to the museum— *Who decided what should hang on these walls? Who told us to look at this picture?*—can now be supplied with the happiest possible answer. *We did!* Those ever-proliferating lists of the essential books to read, movies to see, albums to download, and places to go are the result of our collective activity. We vote online or at the box office, and our hive-mind tendencies are collated and packaged and fed back to us.

If they are to survive—if they are to remain relevant instead of fading and crumbling—venerable institutions like museums, symphony orchestras, opera companies, and theaters will have to pander. The Louvre may be a palace, a relic, an archive, and a bazaar, but it is also, and maybe preeminently, a brand. Why are we here, stumbling along a hallway lined with masterpieces toward the room where the world's most famous painting hangs behind protective

Plexiglas and a velvet-rope cordon? The answer is a perfect tautology: we are here because everyone else is here too, and has already been here.

This kind of populism—this pleasing loop of self-perpetuating popularity, in which communal judgments are confirmed and modified by the public and its representatives—looks perfectly and happily democratic. The pedagogical and bureaucratic bosses, including the critics, who once might have pushed us through the door to the museum or turned us away, have lost their mojo. Their intimidating, coercive power has been replaced by a benign form of peer pressure, exerted through social networks, algorithms, and the actual recommendations of actual friends. No one will tell you that you have a duty to like, or even to look at, certain things, and anyone who tries to guilt-trip you in that way can be dismissed as a snob or a scold. Nor will anyone deny you entry to the charmed circle of appreciation. The world is no longer divided into aristocrats and peasants, priests and laymen, or even into distinct traditions. We are all consumers. A miracle cure for aesthetic headaches has been found. You can do what you want. You can take it or leave it.

But the leveling of old taste hierarchies does not resolve the problem of cultural authority and does not necessarily make us any freer. The consumer economy is profoundly unequal, raising barriers to entry on the basis of income and access rather than pedigree. And the story of human

progress, of opening minds and increasingly cosmopolitan pleasures, is also a tale of loss, of standardization and homogenization. The modern world, accelerating toward the horizon of globalization—toward the media-saturated, wired-together village prophesied by Marshall McLuhan and others in the 1960s—reverses the biblical story of Babel. The world, according to this myth, was once divided into distinct, local cultural enclaves, each with its own integrity. People lived in possession of what T. S. Eliot, one of the great twentieth-century voices of backward-looking wishful thinking, called a unified sensibility. Meanings and values were transparent, embedded in a shared language, a common tradition, and an agreed-upon set of beliefs. The forces of globalization—of imperial conquest, trade, and capitalism—eroded these local cultures and began to replace them with cheap entertainment and commercial products, epitomized by Hollywood movies, which began their project of global conquest in earnest in the second half of the twentieth century and have only grown bigger, louder, and more aggressive in the twenty-first.

But don't people just really like those movies? And doesn't the loosening of local traditions and customs, as it makes people freer and more mobile, produce new and exciting hybrid forms of expression? Authenticity is surely a dubious and sentimental concept, applied most often condescendingly and from a distance. Isn't it better to live in a world of endless novelty and abundant choice, where we

can pick and choose from a perpetually replenished cornu-copia of exotic and homely delights, than in a state of bore-dom and deprivation like our miserable ancestors?

Maybe it is, and, in any case, we don't seem to have much choice in the matter. Culture now lives almost en-tirely under the rubric of consumption. Christopher New-man, though he may have felt out of place in the hallowed galleries of the Louvre, oppressed by an invisible and in-comprehensible regime of taste, was in fact at the vanguard of modern aesthetic experience. His native language was money, and he belonged, by trade and temperament, to the world of transactions and commodities. His defeat, in the pages of *The American*, by the old, strange world of Euro-pean high society, with its elaborate codes of behavior and occult notions of value, was a temporary setback. His wealthy countrymen would return en masse early in the next century to buy up European paintings by the crateful and ship them home to Detroit, New York, and Philadel-phia. They were followed in due course by the polyglot middle-class hordes whose presence signals the planetary triumph of Newman's American-style capitalist values.

And also the ascendance of a new kind of power. The commodification of aesthetic experience has the effect both of eradicating old hierarchies—my enjoyment is just as valid as yours after all; the painting you glance at on the wall of the Louvre is functionally equivalent to the movie you watch on the tiny seat-back screen on the plane

ride home—and of erecting new divisions. The forces of marketing that shape the contours of culture sort us relentlessly according to broad demographic categories and fine-tuned algorithmic niches. Your patterns of consumption are understood to reflect your age, race, gender, sexuality, religion, political beliefs, educational level, and so on. More than that, those presumed identities tell you what you are supposed to like, more aggressively and persuasively than any bossy critic.

Can you ever escape? Should you even want to? We are here at the museum, after all, tolerating the crowds and looking forward to the gift shop and a quiet café where we can bask in the satisfaction of having crossed a major item off the checklist. Our lives have not really changed at all.

Is that all there is? Does the wide, undifferentiated availability of aesthetic stimulus—of stories and games, pictures and characters, nearly all of it branded and marketed—foreclose the kind of rapture that Rilke exalted and that poor Christopher Newman was not quite able to achieve? This question carries an even darker implication: that the ecstasy was never really there at all, but was only a contingent, epiphenomenal side effect of larger, deeper, more consequential forces. Art—the making and the reception of it—can always be dissolved into a different context. There is always money, politics, technology, or society to explain why certain things look beautiful, even to you. Who are

you, after all? Just the kind of person who is conditioned to respond a certain way, having been thrown into being by history for just that purpose.

But even if you know that, you also know otherwise. Your life is more than just context: it is a record of desires and sensations, and if most are condemned to banality, surely a few must transcend it. Your sensory apparatus is uniquely yours and so is the consciousness attached to it, and your progress through the world cannot entirely be programmed or replicated.

It may be easier to appreciate this if we follow another pilgrim to a different museum. Like Christopher Newman, Julius, the narrator of Teju Cole's novel *Open City*, is a man displaced from his native environment. Or it might be better to say that displacement *is* his native environment. The son of a German mother and a Nigerian father, Julius grew up mostly in Lagos and now lives in New York, where he works as a psychiatric resident in a Manhattan hospital. *Open City* is the record of his wanderings through New York, punctuated by reminiscences of his earlier life and a brief sojourn in Brussels. Julius is acutely aware of the play of identities and contexts in the uprooted, multicultural modern world. He has complicated encounters with fellow African immigrants, sometimes bristling at their assumptions of solidarity, sometimes welcoming their empathy. He catalogs his reading, his love affairs, his friendships, and

his chance conversations, always alert to the political impli-
cations of human contact in the post-9/11 imperial me-
tropolis.

Julius is what Baudelaire might have called a *flâneur*: a
footloose, casual pilgrim in constant motion, stopping to
loiter over an interesting sight, peering in windows and
discreetly eavesdropping on conversations, contained in
his own solitude and yet eagerly attentive to his human
and physical surroundings. One day his peregrinations
take him to the American Folk Art Museum, where he
happens on an exhibit of paintings by John Brewster, an
eighteenth-century American portrait artist.

Julius, an erudite cultural omnivore—and in that re-
spect, as well as others, very similar to his creator—sketches
a bit of biographical and historical context for Brewster,
who was, like most of his subjects, profoundly deaf. After
sharing some interesting ideas about how deafness and
blindness are represented in art and culture, and about the
silence that hovers in certain paintings, Julius loses himself
in contemplation of a picture of a young girl called *One
Shoe Off*. Loses and also finds himself, not as the citizen of
any demographic group or nation or time, but as an instru-
ment of pure perception:

> I lost all track of time before these images, fell
> deep into their world, as if all the time between
> them and me had somehow vanished, so that

when the guard came up to me to say the museum was closing, I forgot how to speak and simply looked at him. When I eventually walked down the stairs and out of the museum, it was with the feeling of someone who had returned to the earth from a great distance.

That's what we're looking for.

Chapter Four

The Trouble with Critics

Criticism is not nice. To criticize is to find fault, to accentuate the negative, to spoil the fun and refuse to spare delicate feelings. Everyone is a critic, of course, at least some of the time, since none of us is entirely free of the impulse to point out the various ways that the best efforts of our fellow human beings come up short. *The pasta was kind of gummy, to tell the truth. Yes, actually, that outfit does make you look fat. It was so thoughtful of you to sing "Happy Birthday," but honestly? F is not your best key.*

Most of the time we know better than to say such things out loud. It is generally accepted that the suppression of the critical instinct is one of the keys to the maintenance of harmony, civility, and a decent social order. *If you can't say something nice . . .* At the same time, however, we place great value on (or at least pay habitual lip service to) truthfulness and sound judgment, the pursuit of excellence, and the maintenance of high standards. And this persistent

ambivalence—do we want to be honest or would we rather be friendly? Do we *really* want to know what our friends *really* think of us?—is reflected in a cultural discourse that seems both corrosively argumentative and dismayingly soft. Look at the world from one angle, or through the lens of certain broadcast outlets, and what you see is all aggression and hostility, a daily cycle of takedowns, humiliations, and snark attacks. But if you change the channel, or listen to what some of those angry shouting heads are complaining about, it's all unicorns and rainbows, group hugs and treacly affirmations of consensus. We are all winners, we are all special, and no one can challenge the sovereignty of our opinions or the integrity of our dreams. Or else—and also?—we are lazy and corrupt, dumbed down and self-deluded, hopelessly passive until we suddenly turn violent.

This is not really a matter of differing tastes, temperaments, or political beliefs. The world is not divided into rival tribes of emoticons, the smileys and the frownies. Nor is our civic life a battle between the nasty and the nice, or a tidy dialectic of conflict and consensus. Instead, a civil war—a culture war, you might say—rages within every brain and heart. Each of us harbors an inner kindergarten teacher, dispensing smiles and gold stars and gentle reminders, and also an inner radio talk-show host, spewing mockery and venom. We are split at the root, self-polarized, our appetites in conflict with our reason, our emotions in revolt against our better judgment, our minds never fully

made up. We seek out the guilty thrill of contempt, but we also like the warm glow of sanctimony. We watch competitive reality shows to root for the dreaming, striving singers, chefs, and fashion designers who are so touchingly steadfast in the faith they express in their own abilities. But we also savor the brutal scenes of humiliation that greet their earnest efforts when the assembled jury of experts dissolves those dreams in the acid of truth. Every child wants to hear that her finger painting is a masterpiece destined at least for the temporary pantheon of the refrigerator door. But every child also knows that some things are better than others, that being ranked and sorted is an intrinsic part of every public and worthwhile endeavor.

One of the chief embodiments of this state of internal antagonism—scapegoat and paragon, scold and saint, id and superego—is the critic. And the critic is therefore a creature of paradox, at once superfluous and ubiquitous, indispensable and useless, to be trusted and reviled. From the moment the primal human activities of making pictures, telling stories, dancing, and producing organized patterns of sound separated themselves from magic or religious ritual, it became necessary to judge, to compare, and to interpret the results. At a certain point, sometime after the opening exhibit at the Lascaux caves and long before the first previews of the hottest new Athenian tragedy, the duty of communicating those judgments, upholding artistic standards, and explaining what was going on began

to fall to a designated, most likely self-authorized, group of experts. The content of their expertise was, then as now, somewhat elusive. They did not seem capable of actually daubing hunting scenes on the cavern walls, nor yet of composing poetic reconstructions of the horrible deaths of ancient kings, but they appeared to have paid close enough attention to have something to say about how such things had been done and should be done. Or maybe they were just the loudmouths, sitting by the fire or ambling in the agora, who needed to talk. A certain number of their fellow citizens wished these noisy know-it-alls would shut up and go away, while others listened and then returned to the paintings and the plays with renewed interest and insight.

So it has gone ever since. The history of criticism, in addition to being a compendium of recorded opinion, analysis, and debate, is also—and perhaps more strikingly—an endless cycle of complaint and accusation, a series of protests against the activity of criticism itself, and in particular against the blindness, stupidity, and destructive aggression of its practitioners. Although there is no record of how the critics of prehistory were received or what they said—no Rotten Tomatoes aggregation preserved in cuneiform, no Charlie Rose roundtable captured on a cartouche—we can find a concise early indictment in the last sections of what survives of Aristotle's *Poetics*, in a grumpy statement attributed to Glaucon (who as it happens was Plato's older brother): "Critics," Glaucon said (according to Aristotle),

"jump at certain groundless conclusions; they pass adverse judgment and then proceed to reason on it; and, assuming that the poet has said whatever they happen to think, find fault if a thing is inconsistent with their own fancy."

In our own time, the world of book reviewing in particular undergoes periodic fits of anxiety about the manners of critics and the feelings of authors and readers. A few years ago Jacob Silverman, writing in *Slate*, complained that an "epidemic of niceness" was undermining literary culture, replacing the stringent work of judgment with an atmosphere of "clubbiness and glad-handing" rooted in the gooey, smiley etiquette of social media. Dwight Garner, my colleague at the *New York Times*, took to the pages of the Sunday Magazine to extend the point, arguing that the book world is awash in "yes-saying critics." Needed instead, he argued, are "excellent and authoritative and punishing critics—perceptive enough to single out the voices that matter for legitimate praise, abusive enough to remind us that not everyone gets, or deserves, a gold star." But then, in the Book Review, a review appeared—its author was William Giraldi; the books under consideration were *Inside* and *Signs and Wonders*, both by Alix Ohlin— that seemed to some commenters to cross the line from toughness to outright and unfair brutality. It was a thorough, unsparing, and sarcastic demolition not only of the book, but of the writer's very sensibility, and it was not only her admirers who cried foul.

Book reviewing is too nice? What are you talking about? It's way too mean! Was it ever just right? In 2003, in the inaugural issue of *The Believer*—which would grow into a bastion of frequent journalistic excellence and occasionally irritating literary whimsy—Heidi Julavits launched a broadside against the mean-spirited "snark" that she believed was the snake in the garden of modern letters. More than forty years before that, in a *Harper's* magazine essay that would serve as something of a manifesto for the soon-to-be-launched *New York Review of Books*, Elizabeth Hardwick made the opposite case. "A book," she wrote, "is born in a puddle of treacle," and the result was a decayed, flabby discourse. In 1959, according to Hardwick, books were patted on the head, cosseted, and praised for the sincerity of their efforts—more or less in the way that Heidi Julavits would later demand and Jacob Silverman and Dwight Garner would later, once again, decry.

It would be a mistake to suppose that Hardwick's argument prevailed for a while, and that book criticism grew fangs until Julavits came along to file them down, followed in turn by the quick sharpenings performed by Silverman and Garner, who were then punched in the mouth by the friends of Alix Ohlin. Criticism (if I may change the metaphor) is not a pendulum swinging from age to age between savagery and softness. It is, rather, a pit of opposing impulses, existing in a state of perpetual confusion and self-doubt. At any moment in history—for that matter within

any single issue of a publication containing even a handful of reviews—it would be possible to single out both horrifying cruelty and softheaded niceness, and to sound the requisite alarm. *To the barricades! Group hug!*

Really, there is nothing new under the sun. On any given week, in a tweet or in the arts section of a newspaper, you can find an aggrieved filmmaker, pop singer, writer, actor, or restaurateur paying inadvertent tribute to Glaucon. *The reviewer didn't understand what I was doing. I don't do it for the critics, anyway, but for my fans and myself. And besides, I never pay attention to reviews.* The foundational sin of the critic—or, more usually, the unnamed "critics" who travel, at least rhetorically, in a predatory pack—is lack of sympathy with the artist. The critics follow their own agenda, impose their own ideologies and prejudices, and thus fail or refuse to see what is in front of them.

At best, this is a distraction and a nuisance, one that patient artists and their devoted admirers learn to tune out. In the age of mass culture, when sales figures and box office rankings reflect the infallible authority of public taste, vindication can be found in popularity. *Maybe those snooty critics didn't appreciate my movie or memoir or love song, but ordinary people did.* And if they didn't, perhaps posterity will. In the meantime, at their worst, the critics can be guilty of aesthetic and even literal homicide. They have the power to shut down plays with bad reviews and to consign worthy books and their authors to cruel and unjust oblivion.

When Herman Melville, a popular author of exotic travelogues and tales of nautical adventure, published *Moby-Dick*, his grand, tragic, philosophically ambitious narrative of an ill-fated whaling voyage, the British and American reviewers were variously lukewarm, dismissive, condescending, and sarcastic. The notices for his next novel, *Pierre, or The Ambiguities*, were even worse. "HERMAN MELVILLE CRAZY" was the headline accompanying the review in the New York *Daily News*, and thereafter the author retreated into bitter obscurity, supporting himself with dreary bureaucratic labor and publishing his later work, often at his own expense, to almost no attention at all. He died virtually forgotten in 1891, forty years after *Moby-Dick* was published and several decades before its canonical status was at last recognized.

That belated recognition was also the work of critics, but we are not quite ready to acknowledge their constructive contributions, or to decide whether these constitute the exception or the rule. The calendar of crimes attributed to critics is lengthy, and the perceived logic of criticism itself, which is assumed always to put the negative before the positive, requires that the prosecution complete its case before the defense can be heard. As a group—as an only possibly imaginary, anonymous cabal spreading poisonous cynicism down through the generations—critics must still and perpetually answer for the death of John Keats. Legend has it (and there is at least some medical and

biographical evidence to support the legend) that Keats, just twenty-four years old and afflicted with tuberculosis, was pushed into his final, fatal bout of the disease by the brutal treatment of his long, ambitious "poetical romance," "Endymion," in two of the leading journals of the time, the *Quarterly Review* and *Blackwood's Edinburgh Magazine*. In the latter publication, John Gibson Lockhart, referring to Keats's training as a pharmacist, wrote an especially vicious variation on the "don't quit your day job" theme: "Back to the shop Mr. John," he wrote, "back to plasters, pills, and ointment boxes." Instead, Keats went to Rome and died.

The poet's friends accused Lockhart of doing Keats in. He was a casualty in the literary establishment's war against the "Cockney School," whose humble backgrounds, radical politics, and poetic innovations the conservative tastemakers at *Blackwood's* and the *Quarterly* despised. But while those quarrels have long since cooled, Keats's martyrdom has remained an important aspect of his posthumous fame. A broken lyre was engraved on his tombstone, and his fellow poet Percy Shelley was sufficiently enraged and inspired to write "Adonais," a long elegy (though not as long as "Endymion") that Shelley, preemptively self-critical, judged "the least imperfect of my compositions."

In the thirty-seventh stanza, Shelley rails against his friend's assassins—"thou noteless blot on a remembered name"—prophesying, perhaps vainly, that they will eventually be consumed by remorse at their own spite before

being justly forgotten by posterity. His invective, however, achieves true eloquence in the preface he published with "Adonais," which sounds some of the central tropes of anti-critical discourse. Shelley questions the critics' taste: how, he wonders, can we credit attacks on "Endymion" coming from philistines who praised such worthless works as "*Paris* and *Woman* and a *Syrian Tale*"? That these works are now all but forgotten shows that Keats and Shelley prevailed in the long run, but at the time their self-evident badness (at least to Shelley) made the injustice of the assault on Keats all the more deplorable.

Why, then, take the criticism seriously at all? If his indignation is to have any force, Shelley's indictment of the critics' nullity as fair judges must go hand in hand with an acknowledgment of the power of their judgment, just as he must turn his fellow poet's susceptibility to critical bile into its own kind of strength. "The genius of the lamented person to whose memory I have dedicated these unworthy verses," he asserts, "was not less delicate and fragile than it was beautiful; and where cankerworms abound what wonder if its young flower was blighted in the bud?" Where cankerworms abound! The critic and the artist are natural enemies, the one a parasite existing only to destroy the other. And the more susceptible to such destruction the artist is, the more pure and delicate his genius must be.

There is, needless to say, an element of romantic hyperbole in Keats's case, and also in the use Shelley made of it

to advance the cause of his own work. (Even a casual reader of "Adonais" will observe that, in the end, it's all about him, something that was immediately obvious to his wife, Mary.) Bad reviews wound, but they rarely kill, and the insecure artist can usually fall back on a measure of praise from somewhere to balance even the most vicious opprobrium. "Endymion" hardly lacked for champions in the British literary press. (Nowadays it tends to be neglected in favor of its author's shorter lyrics.) But the gothic extremity of Keats's tale is what makes it exemplary. It is not an anomaly so much as a real-life parable, anchored in the kind of natural symbolism that the romantic poets cherished.

The critics are vermin and their prey is a flower. Not the poet himself, but rather, in the somewhat overheated logic of Shelley's indictment, the poetry that sprouted from his genius. The metaphor of the poem as blossom is an old one in English—the pun on "poesy" and "posy" was a fortuitous legacy of the Norman Conquest—and the idea that poems might grow "the way flowers bloom" (to paraphrase the German poet Heinrich Heine) was a staple of late eighteenth- and early nineteenth-century aesthetics. The aptness of the image may be arguable, its sense a bit hazy, but the effect, and perhaps the intention, of construing works of art as natural phenomena is to place them beyond the reach of criticism. Who but a lunatic or an idiot would critique a rose or a mountain or a sunset, or for that matter an earthquake or a thunderstorm? The charm and power of such

objects and events is self-evident, beyond the reach of argument, analysis, or judgment. And if poems are classified in the same way, then the quarantine extends to them as well.

Or, to put it more decisively, "a thing of beauty is a joy forever"—which happens to be the first line of "Endymion." Keats does not, right at that moment, specify the type of "thing" he means, but there is no doubt that he intends his poem to be an example. In the finely wrought, elaborately musical prefatory passage that unfolds from that emphatic opening, he proceeds through a catalog of earthly beauties ("the sun, the moon, / Trees old and young . . . daffodils"), all of which he insists are not ephemeral but permanent in their beauty. And into the list he slips, almost casually, "the passion poesy," a source of profound delight so primal and essential that it "always must be with us, or we die."

In that case, there is really nothing to discuss. If poetry—which can stand for any exalted, fully artistic human creation—is functionally indistinguishable from the work of divinity and, moreover, essential to life, then only the lowest kind of worm would possibly want to nose out its blemishes. And Keats's poetry abounds in assertions of the self-sufficient integrity of aesthetic artifacts and experiences, their immunity not only to criticism but also to the passage of time and the corrosive effects of thought. The most frequently quoted such statement comes at the end of "Ode on a Grecian Urn," a declaration that is often cele-

brated (and sometimes mocked) as a motto of art for its own sake.

> . . . *"Beauty is truth, truth beauty,—that is all*
> *Ye know on earth, and all ye need to know."*

Such certainty! Such finality! *"All* ye know on earth." "A joy *forever."* If the experience of beauty is eternal, and if beauty itself is identical with truth, then the temporal, investigative activities of comparing and interpreting are superfluous, if not altogether impossible. The critical impulse has been definitively checked.

Except, of course, that "Ode on a Grecian Urn" is itself a piece of criticism. The poem is all about the contemplation of a work of art—an ancient painted jar—and can hardly be said to leave the work alone in its self-sufficient, self-disclosing beauty. The speaker of the poem, far from standing in mute, rapt communion with this fascinating old pot, teases out of it stories, meanings, and context, giving the silent thing a voice that is also his own. Those famous last lines, decorously placed in quotation marks, are not literally inscribed on the amphora. They represent the poet's paraphrase of what the silent, ceramic vessel must be saying, and as such they provide examples both of the hubris that condemns criticism in the eyes of its enemies and of the humility that justifies it to its careful defenders. All the poet–critic is doing, after all, is calling attention to the glory

of an ancient artifact, and, moreover, placing it in a realm of eternal, absolute, aesthetic accomplishment, beyond any argument. At the same time, though, he is obscuring the urn, obliterating it, rendering it literally invisible, at best apprehensible through the secondhand fog of his own language.

It seems clear enough that if "Ode on a Grecian Urn" is criticism, it is operating at a level far above the sneering and scrabbling of everyday reviewing. Unlike the poison pens at *Blackwood's* and the *Quarterly* who would be fingered as Keats's assassins—the worms blighting the poetic buds of his genius—Keats is a distinctly more exalted kind of critic, the kind whose perception of an artwork exists on the same plane as the work itself.

Over the centuries, going back at least to Aristotle, defenses of criticism have lamented the gulf between the way it tends actually to be practiced—stupidly, meanly, and capriciously—and the ideals to which it should aspire. In every generation, the majority of critics can be counted on to do it wrong, at least according to the scourge who rises from their ranks, just as reliably, to tell them so, and to point out the right way. A little more than a hundred years before Keats's fatal encounter with British book reviewers, another young poet, Alexander Pope, taking inspiration from the ancient Roman poet Horace and, more immediately, the French *litterateur* Nicolas Boileau, attempted to lay out, in the 744 energetic, rhyming lines of "An Essay on Criticism,"

the dos and don'ts of literary judgment. Pope's epigrammatic advice is offered to those "who seek to give and merit Fame, / and justly bear a Critick's noble Name." Many stanzas of the poem offer minilectures on the bad habits that might lead the aspiring critic astray: ignorance, vulgarity, showy displays of wit, slavish devotion to fashion. (Many of these are also thinly veiled attacks on Pope's elders, rivals, and contemporaries.) But the reader seeking more positive practical tips or constructive career advice is swept up into a realm of abstraction and tautology, encountering a series of dazzling, witty, and perhaps not altogether helpful philosophical propositions:

> First follow NATURE, and your Judgment frame
> By her just Standard, which is still the same:
> Unerring Nature, still divinely bright,
> One clear, unchang'd, and Universal Light,
> Life, Force, and Beauty, must to all impart,
> At once the Source, and End, and Test of Art.

Though Pope lived in the age of English classicism and espoused canons of taste and precepts of ideology utterly different from those that would galvanize Keats, Shelley, and their comrades, the classical and romantic sensibilities both appeal to nature as the wellspring and horizon of artistic excellence. In Pope's case, nature manifests itself less in the form of flowers, birds, rugged landscapes, or meteo-

rological phenomena (all touchstones of the romantic lyric) than through the work of the great authors of the past: "Learn hence for Ancient Rules a just Esteem; / To copy Nature is to copy Them."

A thing of excellence, you might say, is a joy forever. The consideration of works of art—which are temporal, secular, and made by human hands—must be grounded in the eternal, the natural, and the divine, rescued from the grubbiness of the quotidian. Workaday reviewers, "while they prosecute their inglorious employment, cannot be supposed to be in a state of mind very favorable for being affected by the finer influences of a thing so pure as genuine poetry." That was William Wordsworth's version of what was already, two hundred years ago, an age-old complaint. Wordsworth's indictment of the ignoble scribblers of his day—the same crew, more or less, with John Keats's blood on their cynical hands—provoked an unusually eloquent and systematic (if somewhat belated) response from Matthew Arnold, in "The Function of Criticism at the Present Time."

The dryness of that essay's title—a title that has been echoed and imitated perhaps more widely than any other this side of Swift's "A Modest Proposal"—is redolent of Victorian sobriety and common sense. Arnold, a poet and an educational bureaucrat (his professional title was Her Majesty's Inspector of Schools), is perhaps best known now as the author of "Dover Beach," a grand and tortured poem

of thwarted passion and historical pessimism that survives as a staple of the English 101 syllabus, and also as a name dropped in the canon wars that flared up on American campuses in the 1980s and '90s. Arnold's understanding of literary and intellectual tradition as "the best that is known and thought in the world" has been invoked on one hand as a vigorous defense of Western civilization, on the other as a brief for the oppressive cultural authority of Dead White Males. But the phrase occurs in "The Function of Criticism" as a definition of what criticism should be and how it should work. It should, above all, steer individuals and the society they inhabit away from the narrow, petty, and partisan concerns of politics. "It is because criticism has so little kept in the pure intellectual sphere," Arnold argues:

> has so little detached itself from practice, has been so directly polemical and controversial, that it has so ill accomplished, in this country, its best spiritual work; which is to keep man from a self-satisfaction which is retarding and vulgarizing, to lead him towards perfection, by making his mind dwell upon what is excellent in itself, and the absolute beauty and fitness of things.

How could any critic quarrel with such a high-minded and flattering job description, especially since quarreling would make you part of the problem, and therefore the wrong

kind of critic? But at the same time, the critic eager to find
some plausible account of his or her function in the world
as it is might be a little mystified. What Arnold sees as the
goal of criticism seems to be clear enough—it is to provide
a road map to the perfect and the absolute—but its proce-
dures are harder to infer. "The absolute beauty and fitness
of things" recalls the inviolate integrity of Keats's urn or
Pope's Nature, but in those cases the appropriate response
of criticism is to remain circumspect, even silent, to say or
do nothing that would disturb the tranquil sublimity of the
objects.

The right way to do criticism, in other words, is not to
do it. This is a paradox explored with particular rigor by
Susan Sontag in her essay "Against Interpretation," which
reframes Arnold's Whiggish traditionalism as a manifesto
for the modernist avant-garde. What Sontag opposes is not
the passing of judgments but the digging up of mean-
ing, which she believed had become, in the mid-twentieth
century, the pervasive and toxic activity of critics. In the
past, the excavation of content from form might have been
useful, salutary—or at any rate not destructive. But that is
decidedly not the case in the world Sontag surveys:

> Like the fumes of the automobile and of heavy
> industry which befoul the urban atmosphere,
> the effusion of interpretations of art today poi-
> sons our sensibilities. In a culture whose already

classical dilemma is the hypertrophy of the intellect at the expense of energy and sensual capability, interpretation is the revenge of the intellect upon art.

Even more. It is the revenge of the intellect upon the world. To interpret is to impoverish, to deplete the world—in order to set up a shadow world of "meanings."

Shelley may have sounded extreme when he charged a handful of reviewers with murder, but Sontag goes much further, indicting the entire enterprise of criticism for ecocide. Crimes against art are equally crimes against nature, and against the kind of immediate, sensual aesthetic experience that recalls, at least ideally, our ecstatic encounters with the world of nature. Against the sterile, destructive imperialism of the intellect, Sontag proposes a criticism based on "transparence," which she defines as "experiencing the luminousness of the thing in itself, of things being what they are." In practice, this means more attention to formal analysis or to "really accurate, sharp, loving description of the appearance of a work of art." But Sontag's rhetoric, rather like Arnold's, pulls her reader away from programmatic suggestions toward something at once more immediate and more abstract. Whereas Arnold's purposes were moral and ethical—art and criticism in the service of a calm, mature, and rational citizenry—Sontag's are much

more primal: "We must learn to *see* more, to *hear* more, to *feel* more."

But how? According to Sontag: "In place of a hermeneutics we need an erotics of art." That is an appealing and provocative slogan, but it also contains an awkward implication for professional critics. If criticism is—or should be—a way not just of expressing love for art but also of making love to it, what does that make the people who do it for money?

"How exactly is that a job?" I suspect that most critics have heard—or asked themselves—some version of this question, which was posed to me one summer afternoon by a thirteen-year-old boy of my acquaintance named Max. Both of Max's parents are respectably and usefully employed. His father is a professor of engineering, who not only knows how to solve difficult equations and make complicated machines, but also teaches other people how to do those things. The boy's mother is a therapist, trained to translate her insights into the human condition into workable solutions to individual problems. Like most modern children, moreover, Max grew up with images of adult labor that emphasize practical, hands-on activities—an idealized world of smiling, striving doctors and teachers, firefighters and bus drivers, astronauts and animal trainers. But now, on the edge of adolescence, he was starting to

glimpse a slightly more complex reality, having reached an age when the imperative to do well in school is pressed into the service of vague but nonetheless urgent future ambitions. What do you want to be when you grow up? When the dreamy childish answers no longer suffice, it turns into a tricky question, and one way to address it is to ask various grown-ups what they do.

So what *I* do, I had just explained to my curious young friend, is go see a lot of movies and then write down what I think about them. There's more to it than that, of course: sometimes, in order to write about one particular movie, I need to watch some other movies; and sometimes, in order to refine my own thoughts, I need to read what other people think. Every now and then—not as much as I used to—I read books and then write about those. I have colleagues and friends who watch television, or go to concerts or museums or plays, or even restaurants, and then write about those. Pretty cool, right?

But also, when you think about it, fairly bizarre. I can't deny that I have been prone to periodic spasms of parental anxiety at the thought that my own children might grow up thinking that watching DVDs of all the *Star Wars* movies in one sitting—for purposes of research, naturally—is a reasonable way for an adult to make a living. What kind of grown man sits through *Kung Fu Panda* scowling at the screen and taking notes? I also worry, more seriously, that the pleasures of reading and moviegoing and the special

aesthetic challenges of contemplating works of art in various media will be scarred for my children with the stigma of duty. Even work you love is drudgery sometimes. But to complain about being obligated to do what for everyone else is a leisure-time activity, the happy opposite of work—there is something irreducibly freakish about that.

The fact that a certain number of people are paid to do it indicates that criticism is obviously a profession. Whether it should be a profession and how long it is likely to remain one are matters very much open to doubt, and it is worth taking those doubts seriously. Put another way, it is worth taking young Max's question—How exactly is it a job?—seriously, both as an expression of incredulity and as a literal request for information. What kind of adult career consists of a combination of scholastic drudgery and entertainment— the dutiful churning out of book reports about stuff that everyone else does for fun? What kind of person does that?

A weirdo. A snob. A loser. Literature and popular culture provide a rich storehouse of images, almost none of them flattering. To take one classic example:

> In a cold but stuffy bed-sitting room littered
> with cigarette ends and half-empty cups of tea,
> a man in a moth-eaten dressing-gown sits at a
> rickety table, trying to find room for his type-
> writer among the piles of dusty papers that sur-
> round it.

This man, who hovers between the merely pathetic and the utterly abject—"If things are normal with him he will be suffering from malnutrition, but if he has recently had a lucky streak he will be suffering from a hangover"—is the nameless, archetypal subject of George Orwell's "Confessions of a Book Reviewer," a brutally frank and funny tour of the squalid margins of the literary profession. This caricature of a prematurely aged fellow with varicose veins, poor hygiene, unpaid debts, and a welter of distractions is also a tongue-in-cheek self-portrait, since Orwell was, at the time of its publication in 1946, one of England's most industrious reviewers. And also one of its most candidly self-flagellating writers: in that same year, he published "Why I Write," a stirring defense of the life of letters that also dumps cold water on romantic myths of that life. "All writers are vain, selfish and lazy," Orwell declares in that essay, but the critic is a special case. In "Confessions," he grants that "every writer . . . is rather that kind of person"—meaning a grasping, slovenly scrounger—but goes on to note that "the prolonged, indiscriminate reviewing of books is a quite exceptionally thankless, irritating and exhausting job." (The only thing lower, in Orwell's blunt estimation, is film criticism.)

More than that, book reviewing is a pointless enterprise, a drain not only on the spirit of the critic, but also on the vitality of the culture. The hapless critic is caught in a self-undermining spiral, whereby his ostensible goal—to

celebrate the good and condemn the bad—is thwarted by the sheer mass of mediocrity with which he must contend. The public, understandably enough, wants "some kind of guide to the books they are asked to read, and they want some kind of evaluation. But as soon as values are mentioned, standards collapse." In other words, the doling out of consumer advice inevitably drags the act of discrimination into the swamp of relativism. The good enough—for this week's paycheck or tomorrow's edition—becomes the enemy of the best, and the chances of discerning and communicating the lasting merit of a given book crumble under the weight of superfluous opinion.

Orwell is clearly exaggerating for effect, and his view seems unduly fatalistic. Surely there is some utility, even some virtue, in the endless work of sorting wheat from chaff. Someone needs to take care of that, to help the rest of us figure out where to direct our attention and how to spend our money. The question that reverberates in Orwell's pages—and echoes into the present, with a few alterations of detail—is less about the labor of criticism than about the suitability of the critic for the task. Why should we trust this guy, of all people? We can update the portrait, substituting a laptop for the typewriter and Starbucks latte for the cold tea, but the gist is the same. How could this marginal creature, whether basement blogger or Grub Street hack, possibly have the authority to tell us what we

should read or see? How can so much cultural influence—
or any at all—rest in those nicotine-stained hands, with
their gnawed cuticles and alcoholic tremors?

One way to answer the question—or perhaps to re-
phrase it—is to change the critic's costume, swapping the
ratty dressing gown for a natty tuxedo. In the popular
imagination, critics tend to belong either to Orwell's piti-
able tribe of scribblers or to a more entitled caste of cul-
tural mandarins. The anonymous book reviewer squirrel-
ing away in his dingy room amid unread books and unpaid
bills is one archetypal image that comes to mind when we
hear the word "critic." But we might just as easily conjure
an opposing image of glamour and ruthless savoir faire,
picturing the critic as domineering rather than pathetic, as
powerful rather than craven.

We might picture someone who came to prominence a
few years after Orwell's "Confessions" appeared, a fellow
who, by his own account, needs no introduction (except,
perhaps, "to those of you who do not read, attend the The-
ater, listen to uncensored radio programs or know anything
of the world in which we live"), even though he never re-
ally existed. I refer to Addison DeWitt, narrator and deus
ex machina of the peerless backstage drama *All About Eve*.
His description of his role can stand as a sardonic précis
of the function of the critic: "My native habitat is the
Theater—" he says, "in it I toil not, neither do I spin. I am

a critic and commentator. I am essential to the Theater—as ants are to a picnic, as the boll weevil to a cotton field."

The words were written by Joseph Mankiewicz and uttered by George Sanders, and they reflect, and have contributed to the perpetuation of, a common conception, only partly a misconception, about the role and personality of the critic. There is, first of all, the exquisite condescension and self-importance: "[I]t is perhaps necessary to introduce myself," Addison sighs, fully aware that anyone who knows anything knows something about *him*. He is integral to the life of the theater, or at the very least unavoidable within its ambit. But at the same time, he is peripheral, even parasitic. The theater, Addison's chosen art—or the art that chose him—is his "native habitat," but he does not perform any productive labor within it. On the contrary, his work, if you can call it that, is implicitly destructive. He is vermin, a pest. He ruins the work and spoils the fun of others, like the ant at the picnic or the weevil in the cotton field. And yet, as the old saying goes, you can't have a picnic without ants. The boll weevil, in the vernacular of the American folk song, is an agent of destruction and also a stubborn figure of resilience, a kind of trickster outsmarting all attempts to drive him away. Addison's self-deprecation, in other words, is laced with flattering self-regard. He is a scourge to be feared, but also a permanent feature of the landscape.

As we come to learn in the course of the film, he occu-

pies a zone of mysterious, perhaps unwarranted authority. Addison, modeled on the feared and fabled daily newspaper drama critics of the midcentury, can close a play, make or break a career, and otherwise alter the fortunes of the hapless, striving mortals who surround him. He seems at once the most waspishly cynical—to bring another insect metaphor into the mix—and the most sincere of men. Is he a cruel and capricious hanging judge, or a high priest of culture? He does seem removed from the petty strivings of the troupers whose scheming and dreaming is the intended focus of our interest in *All About Eve*, but it is not clear if that aloofness makes him more or less trustworthy as a guide to their doings or as an explicator of their motives. He is not one of them, and not one of us either. He does not toil or spin—nor, however, does he laugh and cry, or stand up and applaud.

Without Addison DeWitt, *All About Eve* would be a far duller and much less accurate portrait of Broadway at the apogee of its glamour and pop-cultural appeal. Jump ahead a little more than half a century—to an era obsessed with the art, meaning, and spectacle of food—and you find a taller, gloomier version of Addison in the figure of Anton Ego, the feared and influential restaurant reviewer in the Pixar film *Ratatouille*.

Whereas Addison was a bon vivant, a social butterfly as well as an aesthetic gadfly, Ego (no one would dare address him by his first name) expresses his devotion to art through

a forbidding and monastic asceticism. He writes his scathing notices from a sepulchral, coffin-shaped room, and sits alone in restaurants, as skeletal and funereal as the grim reaper. A bad review from him can be a death sentence, but his motives do not seem vicious or sadistic. Rather, he approaches food with a rigor and reverence more likely to bring him pain than pleasure. "Don't you like food?" an innocent diner asks him. "No," he says, "I love food," placing an emphasis on the word "love" that evokes religious devotion rather than romantic longing or erotic pleasure. And that love, which exists on an ideal, Platonic plane, produces a steady diet of disappointment in the actual, secular world of ordinary eating.

People go to restaurants to have a good time, and like the uncultured rats in *Ratatouille*, we eat in order to survive. And while most art is not as directly rooted in biological necessity, the perception of a gap between the ordinary appetite for art and the critic's taste only grows more pervasive as aesthetic experience becomes increasingly tied to consumer behavior. Every working critic regularly receives variations—sometimes apologetic, sometimes antagonistic—on a familiar litany of complaints. *I just want to have a good time. Why do you have to take it all so seriously?*

Which is really another way of asking how, exactly, it is a job. We might hope to find an answer—or at least a clue to an answer—in a 1938 essay by R. P. Blackmur called

THE TROUBLE WITH CRITICS

"The Critic's Job of Work." Blackmur, who lived from 1904 to 1965, has never enjoyed the celebrity of the fictitious Addison DeWitt, but he was a formidable analyst of literature—poetry in particular—and a thorny and intermittently brilliant poet in his own right. And yet the very first sentence of his essay is disarming, if not discouraging: "Criticism, I take it, is the formal discourse of an amateur."

So not really, in the conventional sense, a job at all. "Amateur" is a nicer word than "parasite"—the word that hovers over both the dandy DeWitt and Orwell's shabby scribe—but the thrust is not all that different. If there is a vocational or professional world of artistic making—of the theater, poetry, music, film, or cooking—then the critic, by definition, is marginal to it. And yet also central, since the burden of Blackmur's essay is that criticism supplies some of the oxygen that allows poetry to breathe, and that defends it from being wholly assimilated to the more worldly, responsible, professional discourses of politics or scholarship. Etymologically, "amateur" means "lover," though in a somewhat neutral, nonsexual sense. The amateur is a collector, a dabbler, a devotee caught in an awkward spot between the generative passion of creation, which drives and defines the artist, and the casual promiscuity of the consumer, who picks up and discards works of art or cultural experiences based on momentary whims and interests. What does love have to do with it, if we know what we like?

The critic, an enemy of pleasure, is thus imagined to be chaste: asexual, unproductive, and certainly unmanly. The various personas of the critic—the slob, the snob, the scold, the shrew—are manifestations of a scapegoating impulse that expresses, in turn, a peculiar anxiety. In a democratic culture, the critic is frequently, perhaps definitively, at odds with the public taste, and is, for that reason, typically imagined as odd.

There are, of course, assertions to the contrary—attempts to ground criticism not in mysterious authority, otherworldly love, or neurotic obsessiveness, but rather in common experience. "At the center of all truly successful criticism there is always a man reading a book, a man looking at a picture, a man watching a movie." These words, written by Robert Warshow in 1954, are striking today for their obviousness and their unreflecting sexism. Surely some successful criticism might involve a woman doing any of those things. But Warshow's insistence on masculinity is hardly accidental, if we recall that criticism in the 1950s was very much haunted by the sexually ambiguous specter of Addison DeWitt. Warshow is trying to claim for criticism not only a strong relationship to the cultural habits and practices of ordinary people, but also a virile normalcy. In the macho world of postwar letters, criticism had quite a lot to prove, and Warshow wanted to prove that it could be both straightforward and straight.

This is not to suggest that Warshow, a brilliant film critic whose career was cut short by his death, at thirty-seven, in 1955, was motivated by overt or even subconscious homophobia. Rather it is to say that he was intent on defending criticism as a democratic kind of writing, and he expressed this impulse in the idiom of his time. As a writer whose main ambition was to take popular culture seriously—to grapple not only with Hollywood and foreign movies, but also with comic books and pulp novels—Warshow was acutely aware of the intellectual biases against such an enterprise. "A man watches a movie," he went on, "and the critic must acknowledge that he is that man." This is a tautology, of course, but it is also a radical challenge to the notion of a vested, mystified critical authority. The critic, in other words, is not a high priest of high culture, nor yet a sociologist parsing, at arm's length, the pleasures of the lower orders, but rather an entirely typical, even generic citizen.

It does not seem strange—either to Warshow or to his readers, then or now—to argue that this status is something the critic "must acknowledge." Alienation from the common lot is so deeply embedded in the basic idea of what a critic must be that it becomes necessary, again and again, to assert otherwise. Warshow's "man" is a version of Blackmur's "amateur," and a precursor of the democratic (as opposed to royal) "we" that enlivened the prose of the great

film critic Pauline Kael. And Kael, like Warshow though with far less anxiety, positioned herself as a smart, passionate antisnob, pitting the supremacy of the immediate experience against the puffed-up authority of high art connoisseurship or highfalutin scholarship.

But Kael was hardly a cheerleader for popular opinion, any more than Warshow was—any more than any individual critic can be. Critics work in isolation, with a deep and sometimes uncomfortable (though sometimes also self-aggrandizing) sense of idiosyncrasy, of difference from everyone else. And yet, at the same time, the critic tries to speak to and to some degree *for* everyone else, and so finds it necessary to declare, as if it were in doubt, a common humanity. *I'm a regular guy, just like you.*

And indeed it *is* in doubt, as the imaginary examples of Anton Ego, Addison DeWitt, and Orwell's bed-sitter suggest. But there is no requirement, or even possibility, of choosing between the authoritative or the populist critic: what I have been arguing is that the tension between them is intrinsic to criticism itself.

The idea of critical authority and the ideal of common knowledge are not in competition, but are rather the antithetical expressions of a single impulse toward comprehensive judgment, toward an integral aesthetic experience, the achievement of which would eliminate the need for critics altogether. We wander through a maze of stories, images, sounds, and tastes, haunted by doubts that are ultimately

about the value of our own experience. *Should I like that? Did I get it?*

> The old fable covers a doctrine ever new and sublime; that there is One Man,—present to all particular men only partially, or through one faculty; and that you must take the whole society to find the whole man. Man is not a farmer, or a professor, or an engineer, but he is all. Man is priest, and scholar, and statesman, and producer, and soldier. In the *divided* or social state, these functions are parcelled out to individuals, each of whom aims to do his stint of the joint work, whilst each other performs his.

That is Ralph Waldo Emerson, in "The American Scholar," going as usual to the mystical heart of the matter. The problem he identifies is not the alienation of the intellectual from society, but rather the estrangement of thinking from the totality of human life. And the consequence of this "divided or social state" is that people appear to one another as stunted creatures worthy of Dr. Mabuse's island: "[T]he members have suffered amputation from the trunk, and strut about so many walking monsters,—a good finger, a neck, a stomach, an elbow, but never a man." "Man Thinking," Emerson complains, devolves into the thinker, a specialist whose job is a distorted, shrunken version of

what should be a universal undertaking. The critic, to extend his grotesque bodily metaphor, would perhaps be a walking pair of eyes, or perhaps a tongue, to signify the specialized function of taste.

You can answer, on practical grounds, that specialization is necessary to the simple and orderly functioning of a society or a culture. We all have a job to do, and therefore it should be perfectly natural that some of us have the job of criticizing—of managing, so to speak, the collective taste. But such a notion cuts against the instinct that Emerson celebrates, and the wild, prophetic tone of his essay testifies to how deep that instinct lies.

We should not, ideally, have any use for critics at all, except insofar as we should all aspire to become critics. But this does not mean remaining comfortable in our prejudices or mistaking reflexive judgment for the operation of sensibility. We need critics to remind us that discrimination and evaluation, even—or perhaps especially—of our designated amusements, is a kind of work. Critics take up that job of work by default, and temporarily, in advance of the day when we can finally and fully do it for ourselves. Which is why the arguments in defense of criticism are also arguments against it. In order for true criticism to begin—the recovery of immediate experience, the simultaneous apprehension of truth and beauty, the fully erotic and spiritual love of art—criticism as we know it must stop. There is always too much of it, and never enough.

Practical Criticism
(Another Dialogue)

Q: So here we are, back in the fallen world, where because of original sin or the division of labor or the wrath of the gods—or whatever—we are stuck with professional critics. And much as you seem to want to dance around the fact and change the subject, you are one of them. How did that happen?

A: How does anything happen? Fate. Accident. Poor decision making on my part and on the part of whoever hired me.

Q: Nonsense. You were born to do it. It's the only job you can ACTUALLY do, whatever Samuel L. Jackson might say. How did you become aware of your vocation?

A: In the usual way. First of all, as I was saying earlier, I found myself drawn into worlds that other people had imagined. I was a fan, an amateur in the beautiful old aristocratic sense that, in the utilitarian modern world,

only children are encouraged to explore—though maybe not as much as they used to be. I was a reader, a moviegoer, a discomane, an art lover. As a consequence, I became a reader of criticism. Or maybe not "as a consequence." When I said in Chapter One that criticism is primary rather than parasitic, that it's the egg that comes before the chicken of art, I wasn't just trying to be provocative. I was speaking from my own experience, fashioning a dogma out of the muddle of memory. It's quite possible that I started reading, say, Pauline Kael before I started seriously going to the movies, and that I plowed through back issues of *Rolling Stone* well in advance of my major record-buying phase. I'm certain that I read a great many reviews of things long before I heard or saw them, and in a lot of cases reading the review of something I would never experience firsthand was a perfectly adequate substitute for the experience.

Q: Because they were negative reviews that convinced you not to bother?

A: Sometimes. But more often because criticism was perfectly satisfying in its own right—complete and fulfilling enough to make anything more seem superfluous. A lot of the time, I should add, the thing I was reading about wasn't available to me in the first place. Criticism was a way of getting the news. I never went to CBGB

or a Broadway play, but for years I read all the theater and club show reviews I could get my hands on, to the extent that I felt like I had a pretty good understanding of what I was missing—of the scene, the aesthetics, the arguments that might be going on about this or that band or show.

I had a roommate in college who grew up in an expatriate colony in the Middle East. His father, who was an executive in an American company, got him a subscription to the *Sporting News*. My friend at ten was obsessed with and fantastically knowledgeable about baseball, but only as it had been rendered in sportswriter prose and box-score statistics. He'd never seen it played. In high school and college, I had a similar relationship with Broadway and punk rock and especially experimental theater. This was largely thanks to the *Village Voice* in the 1980s, which I read devotedly every week, even though I lived hundreds of miles from New York. That paper in those days was a teeming hive of brilliant and prickly criticism. I read Stanley Crouch on jazz, Robert Christgau and Ellen Willis on rock, J. Hoberman and Andrew Sarris on film, Peter Schjeldahl on art. And also C. Carr on underground, avant-garde theater and performance art. I didn't know that the C. stood for Cynthia. I didn't know if the byline belonged to a man or a woman. And I never saw a single thing she wrote about—never set foot in La

MaMa or the Ontological-Hysteric Theater, had no firsthand experience of the work of Laurie Anderson or David Wojnarowicz or the drag performers of Alphabet City.

I don't say this to brag. On the contrary, it's pretty embarrassing. Looking back, I don't know why I never worked up the nerve or saved up the money to take a bus to the city and see for myself. But my point is that the performance that really interested me was Carr's: the spectacle of her judgment; the drama of her arguments; the way she interwove her descriptions of various performers and pieces with reflections on sexual politics, AIDS, urban life, and everything that seemed to be going on at once right around me and far beyond my reach. What won me over finally was not the force of her ideas but the charisma of her voice.

Q: Do you think she would be happy to hear that? Don't you think that she was trying to persuade her readers, to engage them on the level of opinions and ideas, rather than to charm and dazzle them with her prose?

A: Most likely, yes. Argument is as essential to criticism as volume is to sculpture and pigment to painting, or gesture and stance to stage performance. But just as sculpture and painting are arts of the hand and acting is an art of the body, criticism is, above all, an art of the voice.

Q: Not what is said but how it's said? That doesn't sound right.

A: I don't quite mean that: criticism is not a matter of technique or form so much as it is a matter of personality, of who you imagine is doing the talking. It's always bothered me that some publications run their reviews anonymously—a more common practice in the past than now—as if the reviews were nothing more than the expression of an institutional sensibility.

Q: But they are, in a way, like the unsigned editorials on the opinion page. It's perfectly normal to say: "The *New York Times* hated it" or "*Entertainment Weekly* gave it an A." On the Internet it goes even further in the direction of impersonality, or collective judgment: a 74 on Rotten Tomatoes; a Yelp score of 4.5. The individual critical voice might not matter as much as you think.

A: It's a mystery and a horror to me that people are so blindly trusting of aggregated or dubiously sourced opinion. Not to mention a personal insult. But you're absolutely right that there has always been a measure of aggregation in criticism, though in the olden days it might have been less driven by data than what we have now. How else does conventional wisdom take shape? How else does the possibility of dissenting from the conventional wisdom arise?

But I'm talking about something a little different

now—not about judging and rating, but about reading and writing.

Q: Okay.

A: Reading is a profoundly intimate experience. The writers I care about feel like people I know very well. I think I understand how their minds work. I believe I know what makes them happy or angry. I internalize the rhythms of their sentences. This might be truer, in my case, with critics than with any other kind of writer, and that may be why a critic is the kind of writer I grew up to be.

When I was young, the writers I read were both sources of information and teachers, models to imitate. Greil Marcus. Pauline Kael. C. Carr. Vincent Canby. Clive James. Susan Sontag. I still find traces of them in my prose, and of other, older but more recently assimilated influences as well, like Mary McCarthy and Randall Jarrell and James Agee. To say nothing of Hazlitt and Ruskin and Roland Barthes.

Q: But your voice is surely your own.

A: Nice of you to say. But that might just be because there's no way that chorus could produce anything coherent, or even intelligible. The cacophony in my head is completely unmanageable, and it's out of the failure to blend all those dissonant voices smoothly that what-

ever individuality I might have has managed to emerge. Imitation is the condition of originality. Or, to put it another way: imitation is the shortest route to and the truest test of proficiency. To mimic a master requires skill and practice, which become the sources of your own mastery.

Q: Were you really writing criticism?

A: Not exactly. I would certainly parrot opinions and ways of expressing them in conversations, which I imagine made me pretty unbearable. But my aspiration was to be a writer, and I fed it by obsessively reading *Paris Review* interviews with famous novelists and poets. Really I think my dream was not so much to write novels and poems as it was to be interviewed about what it was like to write them—*Do you write first thing in the morning or in the small hours of the night? Sharpen your pencils first? Do you sit or stand? What kind of typewriter do you prefer?*—a dream that I'm perhaps fulfilling even as we speak.

I wanted to talk about writing, and the poems and stories I would try to write had a way of turning very talky—very critical—on me. Which made them seem worse than they probably were, not only inept, but somehow wrong. The dominant styles of fiction at the time were rigorously averse to thinking. You were supposed to write like Raymond Carver or Ann Beat-

tie, in that deadpan, anti-inward representation of facts and details. Or else like Donald Barthelme, with disciplined and whimsical consciousness of form.

Q: You were? According to whom? And why did you have to listen? You might be just a little too hung up on imitation as a creative principle. Why couldn't you just write how and what you wanted?

A: Shallowness, maybe. Lack of nerve. Insufficient talent.

Q: So maybe the critic is a failed writer after all?

A: I'm not going to argue about that. But it's interesting that some of the successful fiction writers of my own generational cohort turned back toward a more cerebral manner, toward a literature of ideas that (at least partly) incorporated criticism into the body of fiction.

Q: You're thinking of David Foster Wallace?

A: Among others. But yes. All those footnotes. All that discourse. The endless self-questioning. You may have noticed that the format of our little chats is borrowed from his *Brief Interviews with Hideous Men*.

Q: And here I thought it was Oscar Wilde. All this time I've been trying to impersonate a late-Victorian gentleman of leisure.

A: As have I. But let's not get too meta.

Q: Please, no. This line of questioning is supposed to be practical. How did you get into this? How do you do it? You see movies and you write about them. It can't be that complicated.

A: I guess not. Everyone goes to the movies. Everyone has an opinion. The challenges faced by film critics are variations on what critics in other disciplines face. Every critic has to contend with the forces of publicity and hype, with a cultural apparatus that exists for the purpose of blunting and marginalizing critical voices.

Q: Oh, come on. You're quoted in ads! You have the run of the arts section of a big newspaper. You can say whatever you want. You can piss off movie stars and studio bosses with impunity. Can't you?

A: Sure. Kind of. But that freedom exists in a world dominated by advertising and marketing, by the imperative to buy and sell rather than to stop and think.

Q: The old battle of art versus commerce.

A: Not quite. Art and commerce have always collaborated. Their antagonism is a bit of a fairy tale. What I'm talking about is the struggle between criticism and publicity. Now from one angle publicity is perfectly benign, and criticism is its willing handmaiden. There's nothing wrong, in principle, with soliciting the attention of the public, with seeking out an audience for

whatever it is you're selling. There is some art to that, and some science too. Plenty of excellent movies have languished in semioblivion because of poorly conceived or executed marketing campaigns, and others, good and bad, owe some of their success to the intelligence and intuition of marketing executives. You look skeptical.

Q: I'm a little surprised to hear you praising your natural enemies. And isn't connecting with an audience really the responsibility of the artist?

A: That's the digital-Utopian pipe dream of our time, isn't it? The sharing economy. "Makers" will peddle their wares in an old-fashioned, artisanal manner, assisted by new technologies. "Just put it out there!"—whatever it is. Your self-published e-book, your Web series, your hand-knit scarves and home-brewed bitters. People will find it.

How will they find it, though? How will they know what to do with it? And—this is the most important question—whose interests are being served by this system? Not the artists': the returns on their labor have eroded steadily, apart from a handful of superstars. The rest of them scramble for pennies.

Q: What about the public's interest, though? We have so much to choose from, and so much of it is cheap or free.

And a lot of it is better than what came before. Greater abundance, higher quality, seamless distribution—why complain about any of that?

A: I'm not! But there are hidden costs, and lingering questions. How are you supposed to choose, in the face of this abundance? What will guide your choices? There are really only two options: marketers, whose job is to sell—that is, to spin, to hype, to *lie*—and critics, whose job is to tell the truth.

Q: How can it be the truth, though? It's only your opinion. I thought we'd established that: your voice.

A: You haven't been listening. The voice of the critic is, above all, an honest voice, a voice that can be trusted. Not obeyed or blindly agreed with, but trusted in the way you'd trust a friend.

Q: Well, friends can lead you astray. And how is that trust earned? What if it's betrayed? What if the voice in your head turns out to be wrong?

Chapter Five

How to Be Wrong

Everybody likes to be right. It feels good to win an argument, to claim ownership of the relevant facts, to say *See! I told you so.* But it is the sacred duty of the critic to be wrong. Not on purpose, of course, and not out of laziness, ignorance, or stupidity. No: the critic's task is to trace a twisted, looping, stutter-stepping, incomplete path toward the truth, and as such to fight an unending battle against premature and permanent certainty.

The rush to be correct, to claim the bragging rights that rightness confers, has the effect of turning the pursuit of truth into a game in which error, paradoxically enough, is stripped of consequences. Recent history abounds with examples of designated experts—statesmen, scholars, CEOs, people on television with nice suits and important hair—who were spectacularly and egregiously wrong about matters of great importance: elections, the economy, the environment, the advisability of waging an open-ended

land war in the Middle East. In almost every case, being wrong did little serious damage to their professional standing. On the contrary, their humiliations were assumed to have a humanizing effect. Their mea culpas served as invitations to take comfort in the fallibility of experts and the toughness of reality. *I screwed up! Math is hard! No one could have predicted . . .*

Honest mistakes or outright lies? It is tricky to discern, and impolite to speculate. What is truly vexing, though, is how frequently the shamed experts' shrugging admissions of guilt follow—and then, after a brief interval of contrition, are followed by—brazen declarations of certainty. Truth earns a small reward of temporary, equivocal glory while error goes blithely uncorrected. This is because the prevailing climate of argument favors and perpetuates clear and categorical, and frequently overstated or outright bogus, distinctions: between left and right, between government and the market, between data and intuition, between science and faith. To participate in a debate on just about any topic is to state an allegiance, to declare oneself a partisan, and the difficult dialectical work of discerning the good, the beautiful, and the true is lost in the noise of contending pseudoprinciples. Polarization may or may not be the natural state of the polity, but there is no doubt that it makes for good television and that it makes life easier by discountenancing thought.

I don't mean to suggest that nothing is at stake in pub-

lic quarrels, which are so loud partly because the issues really do matter. Nor do I want to slide into a facile, luke-warm relativism that symmetrically assigns fault to the extremes and locates virtue in the soft, indeterminate, both-sides-have-a-point, both-sides-are-guilty middle. No self-respecting critic can be an apostle of moderation. I would suggest, rather, that the tiresome theater of contending certainties—of boasting and *gotcha*-calling and loud accusations of bad faith—is enabled by a relativism that refuses to distinguish between truth claims and assertions of opinion, or between skepticism and invention. We find it so easy to be wrong, and to recover from the shame of error, because we have trouble crediting the real difficulty of being right. The desire for a shortcut—whether in the form of an unshakable worldview or a set of nifty algorithms—feeds the suspicion that every assertion is a scam, and is therefore vulnerable to simple debunking.

The essential modesty and rigor of the scientific method is widely and cheaply travestied and willfully misunderstood. The work of scientists consists to some degree of trying, over and over, to prove themselves wrong. A hypothesis is only valid if it has been exposed to repeated attempts at falsification, and once it has it wears the deceptively humble name of theory. The enemies of science take this humility as a warrant for strategically raised eyebrows. The fact that scientific knowledge is always in a state of incompletion, and sometimes in a condition of outright error,

adds fuel to efforts to undermine scientific claims about climate change, evolution, and public health, as do occasional, inevitable episodes of fraud, bad methodology, or other malfeasance.

The fragile authority of journalism has been similarly undermined, from within and without. Gathering facts is treacherous and confusing work, in constant need of internal and external policing and correction, a need that has given rise to a cottage industry of conspiracy mongering, slippery fact-checking, and cheap-shot media criticism. The result is a perpetual and self-perpetuating state of epistemological crisis, in which the default position is not that we *don't* know but that we *can't*. In possession, as if by some inviolable birthright, of our own truths, we are permitted—indeed encouraged—to argue. But we're not allowed to say "You're wrong." That would be uncivil! Instead, we fall back on the pseudowisdom of the Dude in *The Big Lebowski* and say, "That's just your opinion, man."

But even as we drift into a state of antiscientific mock skepticism, we also worship idols of vulgar pseudoscientific empiricism. The opiate of the half-enlightened masses in the digital era is information, data, "the math"—impersonal, unarguable, but nonetheless mysterious numbers that promise to turn our messiest and most intractable problems into sudoku puzzles. The burgeoning industries of TED-talk idea-flogging, pop-science publishing, and slick "explanatory" journalism offer the steady seduction of cool,

counterintuitive insights and frictionless solutions. Matters that once had to be pondered and argued—deep questions of politics, morality, art, and justice—can now be mapped and quantified.

Sometimes this kind of thinking—what Evgeny Morozov, a fierce and eloquent critic of modern tech ideology, calls "solutionism"—can yield new perspectives and can dislodge venerable, taken-for-granted habits of mind. Knowledge is always better than superstition. But more often the cult of data, abetted by the culture of opinion, seeks a shortcut around difficulty. Digital visionaries excitedly project a future in which the dreary, intractable problems of history will be solved by the flow and organization of information. Social networks will become the agents of human freedom, just as apps will be the vehicles of human creativity. Meanwhile, ideas culled from neuroscience and evolutionary psychology will finally complete the task of explaining why we are the way we are. Once we isolate the adaptive strategies and brain functions that underlie our desires and behaviors, we will be able to say, with unprecedented decisiveness, what we like and why we like it. The work of criticism will become obsolete, a form of witchcraft or, at best, a quaint artisanal relic of the days before we all knew better. This is another version of the mythical end of criticism.

Critics are not scientists, and even though many of us are professional journalists, we are not reporters either. We

don't live—criticism as an intellectual activity does not live—in the world of facts and laws and axioms, but rather in the fuzzier realm of intuition, judgment, and conjecture. There is no data set that will confirm our points, in spite of the fashion for attaching numerical values to them. The mock science of aggregation—the tabulation of Yelp scores or Rotten Tomatoes metrics—is not without its uses, since it can sometimes produce a statistically accurate picture of what some people think, or an amusing record of what they have said. What it can't tell us is if they're right.

The individual critic, I will admit, is not much more trustworthy. Being a statistical sample of one, he or she stands a very good chance of being overruled, corrected, or outvoted by the verdicts of history, public taste, or common sense. This is not an accident, or a flaw in the system by which aesthetic values are produced and transmitted, but rather a feature that is crucial to the system's functioning. It is, in other words, the job of critics to be wrong. It is the one job we can actually, reliably do.

There are, however, many different ways to go about being wrong. The only genuinely helpful guide to the practice of criticism would be a compendium of error and misdirection. This is not the same as a list of ways to do it badly. Quite the opposite: the essential malfunction of criticism can only be achieved when it is done as well as possible, with sincere and tenacious effort. Lazy, sloppy, or obnoxious criticism does nobody any good, and while it

may be hard to avoid, it is not difficult to spot. There are things not to do—vices and taboos—that are no less regrettable for being widely practiced. Nor are they excused because of deadline panic, space limitations, peer pressure, tenure requirements, or any of the other petty demons that harass every writer. Hackery in various forms is our default condition, and mediocrity the fruit of most of our effort. Our bad habits and shameful peccadillos are best passed over in silence.

But since you asked, and in no particular order . . . The first habit of highly ineffective critics is the promiscuous hurling of adjectives. Some of us seem to keep an alphabetical list taped to the wall above our desks: Astonishing Beautiful Captivating Deadly Execrable Flabbergasting Gorgeous Horrifying Inimitable Jaw-dropping Kicky Laughable Mesmerizing Nugatory Overpowering Painful Quirky Riotous Stunning Terrific Unforgettable Vexing Wondrous Yummy . . . These are all just synonyms for "good" and "bad," and like those bland, childish words they push a writer off the stony slopes of argument and into the clammy bog of assertion. That they are prized by advertisers—and used, in isolation and with the gratuitous addition of exclamation marks, in marketing campaigns—is proof of their conceptual nullity. Of course, these words are unavoidable, but so many unworthy things are, and the fewer you fall back on the closer you will come to the promised land of error.

Similarly, it is wise to avoid what might be called the fallacy of the decoy intransitive. To the immature ear it sounds smarter—sounds more like really saying something—to assert that a book or a play or a movie "satisfies" or "frustrates" or "disappoints" without specifying who exactly is being satisfied or frustrated or disappointed. In every case, it is you (who else could it possibly be?), but by lopping off the "me" that should logically and grammatically follow those verbs you pretend to have delivered a universal judgment instead of a personal reaction. This muffling of the subjective dimension takes other forms as well, nearly all of which reveal a lurking insecurity on the part of the writer. To call something "pretentious" means you are worried that you didn't understand it. To dismiss it as "silly" discloses your suspicion that you have no sense of humor. To resort to the supremely empty word "compelling"—Whom does the thing compel? To do what? Why is this praiseworthy?—is to confess that you have nothing to say.

Of course, sometimes you don't, and need to manufacture a few hundred words anyway. Newspapers, magazines, and the Internet are full of hurried, time-serving, muddled attempts at criticism, most of them perfectly sincere, some of them written by the author of this book. Amateurs too can find themselves gassing on uselessly as they succumb to the pressure to have an opinion, take a position, register a vote. You cannot always safely shrug and demur, even if

that is your true response, and so you wander into thickets of noncommittal or insincere expression.

That is your problem, and your business. The war against bad writing is ultimately a private one, fought in the minds and fingers of individual writers. Any battle plan I could offer here would turn into a scolding, hypocritical roster of Dos and Don'ts. Don't be stupid. Do think clearly. Don't dangle modifiers or split infinitives. Do make effective use of em dashes. It's not so hard.

Really, though, it is. And one reason criticism is difficult is that, apart from narrowly technical rules of thumb or overly general pieces of advice—like those above—the Dos and Don'ts are interchangeable. The best practices are also the worst vices. The obvious and egregious crimes of haste and hackishness—the puffed-up adjectives, baseless assertions, and slippery syntax that used to fill up the arts sections of newspapers and now bloat the Internet—are symptoms of just how difficult criticism is, how elusive its goals and how paradoxical its principles. That these would seem to be elementary—describe what you see; tell us if it's any good—is the source of the difficulty. How do you begin to translate an experience or an object into words, and, simultaneously, to make an argument, render a verdict, take a stand? The only reliable guide would be the map of a *via negativa*, a path of aversion, avoidance, and doubt. So in the spirit of negative capability, and perhaps also of reverse psychology, since the critical mind is as per-

versely attracted to transgression as it is fascinated by rules, I will here explore some of the fallacies, shibboleths, snares, and temptations that every conscientious critic should strive to avoid. What follows is also a guide to criticism's highest values and noblest goals.

The great falsifier of critical judgment is time. This is just another way of saying that the surest way to be wrong is to say anything at all. A critic committed to sniffing out the new is by definition dazzled by the present. The glare of the freshly seen work can be blinding, and what may come to seem a cheap and tacky façade of novelty may look, in the flush of enthusiastic discovery, like the revolutionary real thing. Or, contrariwise, its apparent drabness will turn out to be a temporary patina obscuring its true luster, which will reveal itself only to future eyes.

Tastes change, and while some criticism may oppose, question, or qualify the dominant taste of the era, no criticism can outrun or float free of its age. And so a critic is always at risk of committing, in the moment, what will seem to subsequent generations an inexplicable lapse in judgment. There are famous and outrageous examples of this myopia—the mocking of *Moby-Dick*, for instance, or the wholesale rejection by the nineteenth-century French critical establishment of successive incarnations of modernism in painting and sculpture—but there is also a less

dramatic, more quotidian pattern of misapprehension, of overrating, underestimation, and stubborn missing of the point.

Missing the point is just what critics do, of course. But like most manifestations of the obvious, this one deserves further study. The history of criticism can't just be a series of mistakes with a few lucky guesses or stopped-clock co-incidences thrown in to sustain the illusion of credibility. There is a logic of fallacy, a pattern of error.

For an example of how that logic works—of how a self-evidently correct judgment can mutate into its opposite—we can turn to the *New York Times* of March 4, 1938, and to the film critic Frank S. Nugent's brisk four-paragraph dismissal of *Bringing Up Baby*, a movie that would go on to become one of the most cherished comedies of the studio era, the very quintessence of screwball.

Not right away, though. The picture, released by RKO, saw mediocre returns and mixed reviews on its initial release, which helped temporarily to stall the careers of its director, Howard Hawks, and its female lead, Katharine Hepburn, who had already been branded "box-office poison" by the head of the theater-owners' business association. Hawks and Hepburn are, of course, now enshrined in the pantheon of Hollywood legends. Their more immediate fate was foretold in Nugent's review, which found Hepburn's performance "breathless, senseless, and terribly, terribly fatiguing." More than that, the movie itself suf-

fered from conceptual exhaustion. Enumerating some of its "deliberative gags"—the bits involving leopards and dogs, drunken Irishmen and men in women's clothing— he concluded that "if you've never been to the movies, 'Bringing Up Baby' will be new to you—a zany-ridden product of the goofy farce school. But who hasn't been to the movies?"

He'd seen it all before. Everyone else had too. This may seem astonishing to anyone who has had the good fortune of stumbling across *Bringing Up Baby* on television or DVD, at a revival house or in a film studies classroom, where it will be called upon to illustrate the genius of the old Hollywood system, the artistry of Howard Hawks, or the dynamics of gender and knowledge in the classic studio-era marriage comedy. Such platforms and contexts were, of course, unheard of in Nugent's day. It was still, in 1938, possible to pretend that some people might *not* have been to the movies, and also to suspect that moviegoing might turn out to be a fad, a novelty that would eventually use itself up. The movies, as a theatrical spectacle and an economically important industry (as distinct from a nickel-and-dime fairground or arcade amusement) had been around for scarcely a generation. Talking pictures had existed for barely a decade, and regular movie reviews in American daily newspapers for about as long. The middle years of the Great Depression marked a period of wild fertility, as motion-picture genres solidified into shapes we still recog-

nize: the Western, the musical, the gangster film, the romantic comedy. *Bringing Up Baby* fit into the last category and was thus vulnerable to a double prejudice. Movies were silly to begin with, and this was an especially silly specimen of a notably silly kind.

Frank Nugent suffered from a malady that has afflicted most of his heirs. He had seen too many movies—too many of the same kinds of movies—to be able to discern the distinguishing features of individual specimens. The parts of his brain that might have triggered the laugh reflex had been overloaded by superficially similar stimuli. A film critic today might be in the same condition with respect to action blockbusters or comedies based on the kind of overt sexual and scatological humor that *Bringing Up Baby* and its contemporaries in the early days of the Production Code took such elegant pains to sublimate.

Nugent, you might say, was too busy hacking his way through the forest to appreciated the virtues of this particular tree. Not that he was in any but the most exalted sense a hack. In his years as a newspaperman—he was both a regular reviewer and the motion picture editor for the *Times*—he was acquiring the writing skills and cinematic knowledge that would lead to a stellar second career as a Hollywood screenwriter. Perhaps his most notable achievement in that line was the script for *The Searchers*, a movie whose ascent to classic status was a bit smoother than that of *Bringing Up Baby*. A blue-chip project by a name director

(John Ford), populated by established and rising stars (John Wayne and Natalie Wood, most importantly), *The Searchers* was greeted by Bosley Crowther, Nugent's successor at the *Times*, as "a rip-snorting Western, as brashly entertaining as they come."

Over time, it came to be seen as something more than that, but only after the popular entertainments of the postwar years started to be enshrined as art and mined for sociological significance. Its kitschy elements—the corny song at the beginning, the caricatures of plain-folks homesteaders and paint-box Indians, the absurdity of the conceit (noted by Crowther) that Monument Valley, however cinematic, could look like a sensible place for farming and ranching—were revealed to be part of an ingenious, if only partially intentional, design. *The Searchers* stands, in hindsight, as a potent and complicated allegory of America's tragic history, with Wayne's Ethan Edwards as a terrifying national archetype, a man at once honorable and hateful, a guarantor of safety with no place in the society he sacrifices everything to protect. The mythology of *The Searchers* has grown more troubling and volatile over time, as it reveals the racial animus and patriarchal ideology, the violence and paranoia, woven into the nation's deepest wellsprings of identity.

The artist credited with bringing all of this vibrant adventure and unsettled subtext to the screen is, of course, the director, John Ford. (Poor Frank Nugent!) To praise

Ford for its accomplishments (or blame him for its lapses) seems obvious enough, but the idea that a movie's director is its principal creative intelligence—its author—is an assumption that belongs to a later critical dogma. While Crowther is happy to applaud Ford's work, he begins his review with a blazing encomium to the film's producer, C. V. Whitney, a breeder of horses turned novice movie impresario. The equestrian simile that occurs to Crowther is to liken Ford to the jockey who brings the picture— "Mr. Whitney's first film"—"thundering in a winner." Turning back to the review of *Bringing Up Baby* by the future *Searchers* screenwriter, we note that Howard Hawks's name is mentioned in passing along with those of the writers (Dudley Nichols and Hagar Wilde), and that he is only credited with having produced rather than directed it.

Hawks would, before too long, stand alongside Ford (and Alfred Hitchcock, Fritz Lang, and a few others) as one of the artistic giants of the classical cinema. Whether he or Ford would have accepted such a description is beside the point. Ford was notoriously contemptuous of the suggestion that what he did was art. That nearly everyone else who cares about movies now takes the idea for granted is testament to the power of what is still sometimes called the auteur theory, a notion floated by French critics in the 1940s and '50s and popularized in the English-speaking world by Andrew Sarris a bit later. The fundamental assumption of the theory is that the director is the author of

the picture, that any film that appears to be something more than the indifferent product of an industrial system will turn out, on close examination, to bear the fingerprints of an individual artist.

For Sarris in the '50s and '60s, the auteur theory was an approach to film history, a way of organizing and ranking a rapidly accumulating archive of work that had not yet received systematic attention. Nowadays, auteurism is most often used to describe a critical disposition toward the present. Every dutiful critic learns, when attending to a new movie, to pay some attention—maybe most of his or her attention—to who made it. In some circles, movies are habitually referred to by their directors' surnames, like paintings. Mingle with the international flock of scribblers who migrate to Cannes each May and you will hear them chirping about "the Tarantino," "the Woody Allen," "the Kiarostami," or "the von Trier." But the idea in its first strong manifestation represented a radically revisionist stance. It was meant to cure exactly the blindness displayed by Nugent in his *Bringing Up Baby* review, which failed to notice the artistry so clearly—and yet, somehow, so imperceptibly—in front of the critic's nose. *Bringing Up Baby* may have looked, at the time, like a product of "the zany school" or RKO, but it survives as "A Film by Howard Hawks."

Leaving aside the theoretical merits and limitations of auteurism itself, we might say that Nugent's error was to

see *only* what was in front of his nose, to live too myopi-
cally in the present. This is an especially acute occupational
hazard for daily-newspaper journalists, perhaps, but it is
also, as such, an aspect of the modern and maybe even the
human condition. The newspaper and other periodical
publications breathlessly track the present, the endless suc-
cession of nows shaping our perception of the world. They
and other media—including digital media, with its ethos
of immediacy, transparency, comprehensiveness, and rapid
obsolescence—turn cultural participation into a treadmill.
We chase after what's coming up next, grab ahold of it, and
let it drop, in the process letting go of the chance to ascer-
tain its lasting value, to see it for what it is. We are prone
either to be too credulous, buying into the ephemeral ex-
citement that so often heralds the birth of the new, or else
overly cynical, preemptively convinced that what everyone
else is going crazy for is really just more of the same.

Like nearly every other aspect of human existence—
like every other stubborn *given* imposed on us by accidents
of time and place—our imprisonment in the now is some-
thing we labor to overcome. Criticism offers two distinct
and antithetical correctives to the day-to-day, thing-to-
thing ad-hockery that constrained Frank Nugent, our mo-
mentary scapegoat (as *Bringing Up Baby* was his). We can
steady our gaze by looking backward, or squint toward the
future, looking in each case for a standpoint from which to
judge the chaos of the present.

The corrective lens of hindsight that allows us to re-appraise the once-neglected masterworks of the past can impose its own distortions. In fact, our habit of underesti-mating what is right in front of us rests on a foundation of unacknowledged necro- or at least gerontophilia, a fetish for the old and the dead. Stepping through the looking glass of time, we cast a jaundiced eye on the coarse and noisy comedies now playing and wonder why they don't make movies like *Bringing Up Baby* anymore.

Criticism, has, since roughly the day after the begin-ning of time, consecrated itself to the veneration and pres-ervation of masterpieces and traditions. That this is valuable work goes without saying. Those of us arriving late, stum-bling into the repository of human achievement in search of knowledge and diversion, can always use guidance. Strictly speaking, even new work is old to the extent that it reaches us in a state of completion. Hours and months and years of planning, composition, revision, and rehearsal lie behind what we see, invisible and implicit. The more thor-oughly their traces have been forgotten or removed—the farther away we are from the immediate circumstances of making—the more perfect, the more inarguable the thing itself is likely to seem. And the more likely it is to cast a shadow over subsequent efforts, to bathe itself in an aura of unsurpassability. They don't make them like that anymore because we can't really remember how they made them back then.

It's astonishing how frequently this essentially sub-jective—and therefore unassailably *true*—intuition is raised to the status of an empirical insight or a theoretical princi-ple, and also how reliably it is falsified by later develop-ments. Limiting our attention to the relatively young, thoroughly modern art of motion pictures, we can observe that, around the time Frank Nugent was swamped by a surfeit of zany comedies, other film critics were perform-ing last rites over the dying body of cinema. The German aesthetician Rudolf Arnheim declared that, with the ad-vent of sound, which robbed cinema of its uniqueness, "the art of film began to wither away."

That was in 1935, scarcely two decades after D. W. Griffith had discovered parallel editing in *The Birth of a Nation* and forty years after Thomas Edison and the Lu-mière brothers had independently midwifed the double birth of movies. The funeral has continued, lasting for the entire history of movies so far and turning that history into an endless chronicle of decline. For Arnheim, the addition of recorded dialogue to filmed stories spoiled the artistic purity and specificity of film and turned it into commercial entertainment. (His prophetic word for that was "televi-sion.") Over the years, other culprits have been identified: the U.S. Department of Justice's Antitrust Division, which ended the classical studio era when it forced the studios to sell off their theaters in the Paramount Consent Decree of 1949; actual television, around the same time, which pulled

creative talent and public attention away from movies; home video; the Internet; digital technology; globalization; George Lucas; teenage boys; video games; greed.

Not that a single perpetrator needs to be arraigned. In nearly every decade in the history of movies it has been discovered—it has been assumed—that the art form has entered a phase of terminal badness, in which good movies must be seen as anomalies. Some of the most respected and shrewdly perceptive critics in the field have shared this view, at moments that would in due course be held up as pinnacles of glory: James Agee in 1941, Manny Farber in 1962, Pauline Kael in 1979, David Denby in 2012. Denby's dour book-length elegy for cinema, *Do the Movies Have a Future?*, was published in a year that saw the release of *Lincoln*, *Beasts of the Southern Wild*, *Django Unchained*, *The Master*, *Amour*, *Zero Dark Thirty*, and at least a dozen more testaments to the vitality of the art form. The luster of some of those movies may fade in time, and others, misjudged or underrated at the moment, may rise, but 2012 is hardly an outlier in movie history, any more than Denby is uniquely curmudgeonly in his sense of his own era. James Agee's brief career as a film critic—the first great one America produced—coincided with the flowering of the studio system and with a series of technological innovations (sensitive lenses, mobile cameras) that raised sound cinema to new heights of refinement and flexibility. The early 1960s,

which filled Manny Farber with despair, saw the cresting of the French New Wave; heroic periods of Soviet, Swedish, Japanese, and Italian cinema; and the growth, in the United States, of a cosmopolitan film culture (institutionalized in 1963 with the founding of the New York Film Festival) eager to take in what the rest of the world had to show. The late 1970s, which provoked Pauline Kael to ask, "Why are movies so bad?" were the apex of the New Hollywood, a time of homegrown auteurism when personal vision and commercial appeal seemed tantalizingly compatible. You could see this in *Jaws* and *Star Wars* and *Superman* as well as in the work of Robert Altman, Martin Scorsese, Brian De Palma, and other favorites of Kael's.

We know all that now, of course, but our knowledge, rather than chastening our tendency to venerate the past, deprecate the present, and despair of the future, is more likely to provide ammunition for the next wave of lamentations and assaults. This time it's really happening. The sky has at last begun to fall.

Modern culture, as surveyed in the annals of modern criticism, looks like a series of funerals punctuated by episodes of zombiism. All those renaissances, revivals, and reawakenings confirm the prior fatalities and prepare the way for the next wave of deaths. Painting, poetry, the novel, and rock 'n' roll keep movies company in the boneyard. Civilization, culture, taste—whatever we call the

aggregation of sensibilities and practices that holds the arts
together—will join them soon. In the meantime, we lurk
around the cemetery, dusting off the monuments, plucking
weeds, and laying out fresh wreaths.

The cult of the dead is challenged—and also comple-
mented—by an equally dogmatic religion of the new. The
funeral procession marches on a parallel and opposing
course with the parade of the avant-garde. Every genera-
tion of artists seeks to crawl out from under the overhang
of past masters—to improve on them, to challenge their
authority, or just to do something different—and they seek
out allies as they do. Death notices compete for attention
with birth announcements and prophecies of the Next Big
Thing, the One to Watch, hymns to the revolution and the
cutting edge.

Occasionally these impulses collide, meeting in a more
or less formal battle. France in the 1690s was galvanized by
the Quarrel of Ancients and Moderns, in which defenders
of tradition—of the classical wisdom of the ancient Greeks
and Romans and their recent domestic imitators—crossed
rhetorical swords with apostles of modernity. The leading
Ancient was Nicolas Boileau. His rival was Charles Per-
rault, a man perhaps less well remembered than the fairy-
tale characters he introduced to posterity, including Mother
Goose and Little Red Riding-Hood. Boileau, whose major
works included a translation of Horace's *Ars Poetica*, coun-
seled fidelity to the old models and deference to the self-

evident superiority of work that had already stood the test of time. Perrault, in practice a pioneer in mapping new terrain for literature, was in theory a champion of experimentation, of new forms suited to changing times.

Their fight has resurfaced periodically in the centuries since, with special frequency and intensity since the second half of the nineteenth century, when the idea of an oppositional, future-facing artistic vanguard became a permanent presence—or at least an attractive rally point—on the cultural landscape. The attitudes of artists themselves toward their precursors are always a complicated mixture of veneration, resentment, envy, and emulation, but critical discourse has a habit of simplifying that ambivalence into antagonism. So a succession of movements took shape, issuing manifestoes that called for the smashing of tradition, the gut renovation of the edifice of art, the purging of all that was false, overdone, and secondhand, the recovery of a primal creative truth. These imperatives energized Dada and Italian futurism, the early Beat generation, punk and New Wave music, free jazz and living theater and countless wavelets and insurgencies in cinema, dance, and every other art. In many cases, they inspired, at least among some critics, a rearguard action in defense of the traditional canon, a predictable response that just as predictably inflamed the rebellion still further.

In every instance, both sides are right: the old ways are exhausted and routine, the wild fevers of the new destruc-

tive and ephemeral. The impulse to conserve and move slowly, to build incrementally and protect what has already been done, is an honorable one. So is the drive to start again, to bend the energies of creation toward an unseen future. But this is also to say that both sides are wrong. Each one's error is inevitable, since it reflects an ineradicable fact of the human predicament. We live at the mercy of time and can only fail in our efforts to master it, to speed it up or slow it down. The party of the Ancients dreams of applying the brakes and declaring victory, freeing the time that remains for the savoring of accomplished glories. The consecration of unsurpassed, unsurpassable masterpieces— the great plays and musical compositions that need only be performed again and again; the great books that will furnish an immutable literary curriculum; the paintings bolted to the walls of museums except when they tour the world in blockbuster shows; the thousand movies you must see before you die—is in effect a wishful declaration that the human project is complete. All that is left is to take stock, to appreciate, to annotate and interpret. Against this, the progressive or revolutionary view imagines that our failures as a species may yet be redeemed, and that our ability to fashion images, stories, and beautiful abstractions will only improve, and will indeed one day get it right, whatever it may be. The great work always remains to be done—the detritus of the past is what prevents it from being done—and the golden age is just about to dawn.

HOW TO BE WRONG

It is neither necessary nor possible to choose between these positions—choosing is the primal and inevitable mistake of criticism, the gesture that calls it into being—but it is vital that both exist. Otherwise, if we scramble too hastily toward a temperate middle ground that welcomes the new and honors the old, we will remain stuck in the exhausting flux of the present, condemned to misconstrue what is right in front of our eyes, and to roll those eyes rather than gasp with laughter when a Connecticut leopard leaps into view.

What are we looking at, anyway? That question too—an easy question, a necessary question, basic and childish and openhearted—leads us into a minefield of misapprehension.

One of the founding myths of criticism—really an ancient premise of Western thought, going back at least to Plato and perhaps residing in the primordial architecture of human consciousness—is that we are always looking at two things, or at one thing essentially divided within itself. The handiest, hoariest way of talking about this dualism, this version of the mind-body problem translated into the realm of artifacts, is to refer to the distinction between form and content. There are other names, or course. Poets may speak of meaning and manner; visual artists might prefer to think in terms of concept and technique; English teachers of a certain generation or temperament will instruct their

pupils to chase after themes and nail down motifs. But in each instance a strange dogma attaches itself to works of human intention as to no other species of thing. Ordinary objects, made by the workings of nature or the accidents of time, are simply themselves. Or, to be a little Platonic about it, they are and have *only* forms. The belief that a tree or a stone or a sunset has meaning is now almost universally regarded as an anthropomorphizing fallacy or a quaint superstition, a vestige of old, animist religious beliefs. Art, come to think of it, might be the atavistic remnant of those archaic ways of thinking. The modern aesthetic ideology, given voice by theorists of painting like Vasari and Ruskin, holds that the making of representations—of pictures, explicitly, but also of songs and stories—is a human imitation of divine creation. God, the old saying goes, makes no mistakes, and while the evolutionary theory that has in many respects supplanted this view makes room for contingency and accident, it also makes, if anything, an even stronger commitment to the sufficiency—the necessity, the perfection—of natural phenomena. They follow their own logic, indifferent to our own petty human needs and interests. We can respond to them with simple awe, or seek to unlock their secrets, an enterprise that is called not criticism but science.

Our own products—the things that now crowd the earth, shaping and obstructing our view of everything else—call forth a different response. Much as we might try

to set our inquiries on a systematic, scientific basis, we find our best efforts gummed up in subjectivity and category confusion. The form/content distinction is both the result and a symptom of this fogginess, of our stubborn inability to see things as they are. Attempts to direct the practice of criticism, to discipline our attention in order to prevent or minimize error, typically force an uncomfortable choice: we are instructed to look at the shape or the substance; the outward aspect or the inner, often invisible core; the vessel or the essential stuff that has filled it up.

"Formalism" is both an epithet and a banner, a code word for sterility and a slogan for higher discernment. In modern criticism, it characteristically presents itself as both the more knowing and the more embattled position, a redoubt of wisdom that needs to be defended from the vulgar habit of treating form as a husk around meaning, an envelope to be discarded once the message is delivered. The prestige of formalism rests on a handful of easy cases, and on the pedagogical usefulness of certain kinds of rudimentary analysis. Look past the face in the portrait (who is it, anyway?), and focus on the colors and the brushstrokes that bring it to light. Listen to the melody that lifts and carries the song. Read the poem for the sound and rhythm that lie beneath and beyond the sense. Ignore the movie's plot— chances are you've figured it out already or seen it all before—and marvel at the mise-en-scène. Don't worry about what any of it is about. Appreciate how it is what it

is. "A poem should not mean, but be," Archibald MacLeish wrote in a poem that survives as an obvious paradox, since the being of that line is only what it means.

Hard cases have a way of multiplying, until the boundaries become invisible where once they had seemed obvious, and what had looked like empirically grounded definitions turn out to have been airy suppositions all along. To address this confusion, it might seem promising—it has, at various points in history, seemed advisable—to plot the arts along a spectrum from most to least formal, which is almost to say from abstract to representational. At one end, closest to pure form, is instrumental music, which is thought to unfold in a space of abstraction, free of the encumbrances of meaning. A piece of music makes no obvious argument, tells no literal story, soars above politics and history in an ether where logic and feeling coexist interchangeably. When Walter Pater wrote that "All art constantly aspires towards the condition of music," he was making a claim not only about all art but also about all criticism, whose job is to isolate those attributes of other specimens of art that bring them closest to music and are least burdened with representational duties. A piece of music is the limit case of nonmimetic art. It is not about or of anything. It says or espouses nothing. It advances no moral and presses no cause other than its own integrity. Music is to art what its cousin, mathematics, is to science.

Once the supremacy of music is established in principle,

the other arts fall into line. Dance might come next, provided we downplay the narrative and dramatic elements and concentrate on the disposition of bodies in space. Then perhaps the plastic arts, again provided that we suppress or marginalize the representational aspects and forget that we are looking at deities or aristocrats or historical figures and dwell on line and volume, on the curve of the marble, the impasto and chiaroscuro, the being and not the meaning of the statue or the picture. Nonrepresentational art makes this easier, of course.

We then descend through poetry down into narrative prose, and begin to encounter a stubborn, possibly indissoluble kernel of content by the time we reach, say, documentary film. Criticism would land at the very bottom of the ladder, qualifying by the barest courtesy (or its own unruly insistence) as an art at all. If music is pure form, then criticism is surely its antithesis: pure argument, absolute matter. Who has ever paused to admire the shape or inflection of a review or a critical essay?

Readers of Walter Pater, that's who. His place in the history of philosophical aesthetics is marginal at best, but that's just a case of a thinker being excluded from a club in which he never sought membership in the first place. Pater belongs in the canon of English-language Victorian prose artists, along with Thomas Carlyle, Ralph Waldo Emerson, and, of course, Oscar Wilde, the disciple who would eventually surpass him. And at its finest, say when he was

writing about the Renaissance paintings he loved and did a great deal to introduce to the modern English-speaking public, Pater's prose does approach the condition of music, as his thoughts are borne forward on sentences of complex beauty arranged in exquisite balance:

> Hers is the head upon which all "the ends of the world are come," and the eyelids are a little weary. It is a beauty wrought out from within upon the flesh, the deposit, little cell by cell, of strange thoughts and fantastic reveries and exquisite passions. Set it for a moment beside one of those white Greek goddesses or beautiful women of antiquity, and how would they be troubled by this beauty, into which the soul with all its maladies has passed! All the thoughts and experience of the world have etched and moulded there, in that which they have of power to refine and make expressive the outward form, the animalism of Greece, the lust of Rome, the reverie of the middle age with its spiritual ambition and imaginative loves, the return of the Pagan world, the sins of the Borgias. She is older than the rocks among which she sits; like the vampire, she has been dead many times, and learned the secrets of the grave; and has been a diver in deep seas, and keeps their fallen day

about her; and trafficked for strange webs with
Eastern merchants; and, as Leda, was the mother
of Helen of Troy, and, as Saint Anne, the mother
of Mary; and all this has been to her but as the
sound of lyres and flutes, and lives only in the
delicacy with which it has moulded the chang-
ing lineaments, and tinged the eyelids and the
hands. The fancy of a perpetual life, sweeping
together ten thousand experiences, is an old one;
and modern philosophy has conceived the idea
of humanity as wrought upon by, and summing
up in itself, all modes of thought and life.

This is part of his famous evocation of the *Mona Lisa*, and
you can see the problem. Where, in this flight of logic that
very nearly becomes a flight from sense, does the form
yield up its content? And furthermore, if we could separate
the two elements of the passage, we would still be left to
wonder at the way it so thoroughly and sublimely scrambles
the form/content distinction with respect to da Vinci's
painting, its ostensible object. Though his gaze never en-
tirely strays from the surface of the picture, from the eyelids
and hands and smile as rendered on the canvas, Pater's mind
and his pen sweep through history and philosophy, as if the
painting contained not just the face of an enigmatic woman
but human civilization itself. The effect that she has on
him, an effect of ecstasy at once sensual and cerebral, is

re-created in the reader. A Pater essay is a blizzard of cognitive and emotional effects, encompassing enlightenment, admiration, frustration, and bewilderment. Do we ascribe those to Pater's matter or his manner, his personality or his placement in history? How do we tell those things apart—the man from the time, the style from the gist? And if we can't, then how can we hope to have better luck with da Vinci, or anyone else?

It can be objected—Pater himself might object; Wilde most certainly would—that this is a puzzle without a solution, a classic false problem. Calls for attention to form can always be answered with the question: As opposed to what? Turning our attention back to movies: Are the formal qualities of a film synonymous with its visual attributes, a matter of lighting, lenses, and film stock? Are they summed up in the delightfully vague phrase "mise-en-scène," imported from France (and from the theater) in the 1950s and pressed into service by ambitious American critics? Mise-en-scène is often understood to refer to the composition of shots and the placement of actors, but what about the editing, the music, the production design, and all the other elements that combine to create a mood and tell a story? And what about the story itself? Does the narrative structure count as form? The rhythm of the dialogue? And what about the actors? Does the rest of the film contain them, or are they among the vital formal elements that bring it to life?

It is, of course, possible to answer such a question with another: Who cares? Surely we can agree that the experience of the movie—the painting, the book, the symphony, the dance—depends on the fusion and confusion of content and form. But if the form/content dichotomy is a theoretical shibboleth and an empirical dead end, it is nonetheless a mistake with enormous and productive consequences in the history not only of criticism, but of art as well.

Formalism can be the name of a method or a school of thought—a specific mode of analysis tailored to the defining features of a given creative discipline—but it is, above all, an argument. It is an argument both for and against the primacy of judging by appearances, and as such an invitation to consider the uniqueness, the untranslatability, of the work. Formalism is a defense of art, or at least a defense of art's disengagement from other concerns. Wilde, in his great mock-Platonic dialogue "The Decay of Lying," gave this argument its most extravagant—which is also to say its most coherent—articulation:

> The only beautiful things, as somebody once said, are the things that do not concern us. As long as a thing is useful or necessary to us, or affects us in any way, either for pain or for pleasure, or appeals strongly to our sympathies, or is a vital part of the environment in which we

live, it is outside the proper sphere of art. To art's subject-matter we should be more or less indifferent.

Wilde's position, here placed in the mouth of an outrageously opinionated alter ego named Vivian, has been caricatured under the slogan "art for art's sake," the rallying cry of what was known at the time as aestheticism. Over time, the defiant, counterintuitive force of aestheticism has been tamed, its insights standardized and its attitudes parodied. Wilde's array of impulses—his commitment to seeing the world through the lens of style—has hardened into a set of rules and poses. His fundamentally democratic insight into the universal availability of aesthetic experiences became a warrant for snobbery and exclusivity. Wilde urged his readers (as Vivian coaxed his affable, literal-minded friend Cyril) toward keener perception and nudged them away from the kind of Victorian moralism that would find lessons and messages in pictures and poems. He invited them to separate themselves from the common way of seeing—or not seeing—and enter a world of finer feeling and truer judgment.

But, of course, it is not hard to detect the shadow of latent elitism within this idea, since it depends on a potentially invidious distinction between the aristocracy of correct taste and the middling masses who lack it. I am convinced that Wilde's generosity of spirit recoiled at such

prejudicial, a priori divisions, but it is also true that he was a man of notable pedigree and position, born on the ragged lower slopes of the Anglo-Irish ruling class and educated—classically, in classics—at Oxford. He had a genial but also intimidating way of assuming that his audience (the Cyrils and Ernests who populated his critical dialogues) possessed a range of reference and a facility of discernment commensurate with his own, which is absurd and unfair but also encouraging. Who would not wish for such gifts?

Still, aestheticism and its legatees—tendencies in taste and criticism devoted to keener, more knowing discrimination, free of the didactic drag of content—often look less like movements than like clubs or cults, with their own initiation rituals, secret handshakes, and esoteric lore. They depend on a distinction that may be less ontological than social, less a matter of seeing things as they are than of being seen in the right company, the company of people who get it.

Those people are both worshipped and stigmatized for their ability to make the rest of us feel dumb and out of it. Film snobs, comic-book geeks, college radio-station djs, and their kin all stake out esoteric ground within the popular arts. In our populist age, meanwhile, interest in what were once broadly accessible, widely discussed forms—poetry, novels, opera, most of the visual arts—has itself become a mark of suspect aspiration, a sign of someone who thinks he or she is better than everybody else.

It is clear enough that more than mere taste is at stake here. The ascent of such people into places of visibility and influence—as creatures to be resented for their elitism or envied for their sophistication—is a consequence, at first glance a paradoxical one, of the democratization of the arts and their presumed public. In a static, hierarchical, caste-bound society, the close and universally recognized association of taste and status makes snobbery redundant. The ranking of persons encompasses the ranking of their various ways of taking pleasure. Aristocrats will have their masques and tragedies; the bourgeoisie its novels and symphonies; the groundlings will take their place in the pit to laugh at dirty jokes. Everyone and everything takes its natural place, and the work of criticism, which is at least in the formal sense the province of the few—of aspiring artists and of the self-selected coteries who are interested in art—has a clearly delimited set of tasks. The critic, able to assume an audience, a tradition, a canon of works and standards, will always be comparing apples to apples, and addressing a public of apple eaters. Such a world has never existed, of course, but a great deal of criticism—and the criticism of criticism—seems predicated on the belief that it does, or the wish that it would.

Formalism is thus less a theoretical mistake than a useful fantasy, a category error that helps to mark a crucial, con-

tested, perpetually shifting boundary, the one between art and everything else. This distinction turns out to be anything but obvious. For one thing, the supposedly simple matter of what does or doesn't count as art is a subject of endless debate, prejudice, disinformation, and plain idiocy. There are systems of social power that declare some activities and objects worthier of the name than others. There is also, in history (as in Robert Frost's idea of nature), something that does not love a wall, a mysterious, implacable force that erodes such exclusionary categorical distinctions. Criticism can aid in this process of correction, or opening, and it is only a slight exaggeration to say that criticism, broadly and properly understood, can be the engine not only of aesthetic reassessment, but also of social change.

The most visible and consequential examples of this can be found in modern popular culture, in particular as African-American contributions to it have been recognized and celebrated, usually not long after having been regarded as marginal and dangerous. This has been a slow, incomplete, and maddeningly reversible process, as deeply embedded white-supremacist assumptions about the value of black creativity have proven as durable and protean as other forms of racism. This is a very long story, and not mine to tell here, but it takes very little historical research to uncover, in white responses to black art, music in particular, a pattern of panic conjoined with fascination, a complex, neurotic dialectic of contempt, appropriation, and outright

BETTER LIVING THROUGH CRITICISM

love. You see this, episodically, with hip-hop, disco, rhythm and blues (especially as it mutates into rock 'n' roll), and, before them all, jazz.

Jazz is now venerated (if at times more dutifully than passionately) as a fixture of the nation's quasi-official mainstream culture of universities, public broadcasting, and nonprofit, dressed-up, donor-friendly performance. This is partly thanks to a vocal and ardent critical cohort of writers who, in liner notes and the pages of magazines like *Down Beat*, made the case incrementally—session by session, album by album, solo by solo—that the music was a protean and complex vernacular art, worth cherishing and taking seriously.

Jazz criticism was formalist to the extent that it looked through the improvisatory technique of the players toward the bedrock disciplines of composition and arrangement, and was thus able to appreciate both the virtuosity of gifted instrumentalists (Louis Armstrong, Charlie Parker, Max Roach, Thelonious Monk) and the work of great bandleaders and composers like Duke Ellington and Count Basie. In the face of racially condescending assumptions, sometimes voiced by admirers of jazz, that it represented, above all, the spontaneous eruption of primitive feeling, critics, black and white, emphasized its melodic and rhythmic intricacies, and arranged its luminaries into a coherent tradition, with divergent schools, regional variations, and genealogical lines of influence.

A similar pattern repeats itself across the popular arts through the twentieth century, though jazz may have the distinction of traveling the longest distance from low to high in the shortest time. Tunes that originated in brothels and dance halls in places like New Orleans and Kansas City and then migrated to fashionable (often segregated) night-clubs in New York and Chicago can now be heard in the plush philanthropic precincts of Lincoln Center, and in sleek concert halls in Oslo and Tokyo. And yet this tale of rags-to-riches triumph—which is echoed in the history of rock 'n' roll and movies, and is part of the current evolution of television, hip-hop, and video games—can also look, from a certain angle, like a chronicle of loss.

The vanguard passes into the mainstream. The band you and your friends discovered on the college radio station scores a Top 40 hit or a major label deal. The indie film-maker conquers Hollywood. The marginal and misunder-stood pleasures of a tribe of devotees—nerds, superfans, and wannabes—turn into a culture-industry profit center. At the same time, a posse of grazers roams the land rooting out rare, delicious, and unusual morsels to sample.

Two roads diverge in the forest of modern cultural abun-dance. The serious young person, intent on building a via-ble inner life, staving off boredom, and running with or against the cool crowd, can choose the path of the geek or the trail of the omnivore. The political philosopher Isaiah Berlin, riffing on an aphorism from an ancient Greek poet,

divided the world of intellect into hedgehogs and foxes, those who know one big thing and those who know many little things. The world of art has traditionally divided itself along different lines: between Apollo, the exemplar of order and harmony, and Dionysus, the avatar of ecstasy and sensation; between classical and romantic; between high and low; between ancient and modern, traditional and experimental, and so on. But much as these distinctions may apply to the attitudes embedded in the works themselves, the temperaments of art's admirers can be sorted according to a version of Berlin's zoology. There are aficionados, consumed with passion for a particular pursuit, and there are dilettantes, ranging far and wide in search of novelty and surprise.

The language of art appreciation is full of faintly condescending—or frankly pathologizing—terms for people whose love of a single genre or form surpasses all others: balletomanes, film buffs, jazz nuts, theater queens, folkies, foodies, groupies, gamers. Whatever the object of their affections, their ardor takes on similarly obsessive contours. They are avid collectors and fanatical partisans, at once united in solidarity against poseurs and outsiders and competitively suspicious of one another's bona fides. They gather into coteries and subcultures, in circles of the initiated, conspiring, sometimes, to rule the world.

Their passion gives rise to an intensive, exacting form of criticism, one heavily defended against disappointment

from within and incomprehension or indifference from without. It is a criticism of deep and esoteric knowledge, which is to say a criticism of tunnel vision and myopia. But the blithe generalism that is the alternative risks the blind spot of the bird's-eye view, the quick, cursory judgment that prefers momentary delight to true love.

When Harold Rosenberg, a cantankerous art critic of the mid-twentieth century, tartly characterized his fellow intellectuals as a "herd of independent minds," he was identifying a paradox that would receive its definitive formulation in a memorable scene in *Monty Python's Life of Brian*. In it, Brian beseeches a crowd of his followers to stop following him and think for themselves, advice they accept all too eagerly. "I am an individual!" they repeat en masse. "I am different!" And then a solitary dissenting voice pipes up: "I'm not."

That lonely soul, stubbornly insisting on his true autonomy from the false independence that beguiles everyone else, and at the same time acknowledging the limits of his control over his own mind, is a perfect embodiment of the critic. The critic is in a logically untenable position in relation to the rest of humanity, which seems to function as a mass, driven in lockstep by private and singular urges. Attempts to wriggle out of this contradiction lead to two distinctive positions, each one categorically wrong.

The first is the desire to dissolve the distance between oneself and the public, to form an allegiance, tactical or

definitive, with the conventional wisdom. Since that phrase is always pejorative—who wants to be an apostle of the obvious, or a mouthpiece for the ordinary?—it is generally preferable to invoke more obviously democratic values and speak of the wisdom of the crowd, plain old common sense, or, in the current jargon of evolutionary psychology and social media, the genius of the hive mind. Fifty thousand Elvis fans can't be wrong! While no critic is entirely comfortable standing on popularity as the sole or primary determinant of value, very few can avoid relying on it in a pinch. Art is tested in the public arena, after all, and one way of scoring the game is through quantitative measures: box office returns, weeks on the best-seller list, rank on the pop charts. Very few people would claim that something is good because a lot of other people like it.

But surely sometimes—maybe most of the time—a lot of people like something because it happens to be good. Then again, people can always be tricked by fashion or advertising, and a massive and complex apparatus has been created in the service of this trickery, a machine that includes the work of criticism in its gears and pistons. Something drives Rosenberg's herd: cowboys, dogs, dumb animal instinct. Brian's mass of unique individuals harkens to the voice of their messiah. Everybody knows that the general population—by which we mean everybody *else*—can be manipulated, distracted, and fooled by marketing,

peer pressure, and the force of lazy habit. Even sometimes by critics. And yet critics, if they sometimes figure among the imaginary puppet masters of public opinion, are also its most consistent enemies, apt to be scolded for being hopelessly out of touch and at times to pride themselves on precisely that disconnection.

The temptation bedeviling the individual critic is to embrace one of these two poles, to stand either as a tribune of the common mind—expositor of the democratic public, mouthpiece of the vox populi—or as its stubborn and principled antagonist, sidestepping the whims of the crowd in favor of eternal standards or her own idiosyncrasies.

Works of art, in the era of modern mass communication, undergo a familiar life cycle as they are welcomed, questioned, forgotten, and rediscovered. They come into the world on a whisper—or a roar—of hype, as specialized and general-interest media outlets, assisted by an invisible army of publicists, usher in a new season of cultural consumption. Every Web site, newspaper, and magazine will periodically stoke the marketplace with anticipatory features, profiles, teasers, and lists. Big new books, would-be blockbusters and Oscar bait, television shows everyone will be talking about at the office on Monday after weekend binges. Check out these hot new pop stars, rising artists, Broadway shows! So much promise and variety. So much you don't want to miss.

In time, a few of those will emerge, through a kind of Darwinian triage, into the daylight of wide attention or the spotlight of more specialized approbation. And the metaphor of "buzz" will become an almost literally audible hum of enthusiasm. Have you read *The Goldfinch* yet? You haven't seen *Mad Men*? *Boyhood*? *The Book of Mormon*? The Ai Weiwei exhibit? Other, unluckier entries in the contest for maximum approval meet equivocal verdicts—ambivalence, confusion, overworked "controversy"—while others are ignored, dismissed, or mocked. Some of those might actually be pretty good.

Into this scene strides the contrarian critic, intent on correcting the record and righting the balance. After the mob of breathless opinionators has caught its collective breath, the contrarian pricks the balloons of overinflated reputation and rushes to the aid of the wounded and neglected. The other critics have been swayed by bad faith, dubious ideology, collective psychosis, or plain stupidity. The contrarian, in turn, can always be accused of flogging an agenda of his own, or just wanting to be different. It's more exciting to spark a backlash than to swim with the tide of easy approval, and it feels much nobler to be the lone champion of something that has been reviled or ignored than to be another voice in the chorus.

But in the long run, that is all anyone is. Time blunts the edges of argument and banks the fires of opposition. What survives, if we're lucky, is beauty and truth.

. . .

So let's recapitulate—and expand—our register of critical errors. There are so many ways to go wrong! You can over-value the grand achievements of the past and underrate the still-wet, still-raw efforts of the present. Or you can turn your face bravely toward the future and neglect the glories that lie behind you. You can idolatrously worship the ex-quisite shape and tone of The Thing Itself or crack it open to sift through what is inside. You can celebrate artifice—the brilliant ways a thing can seem to know just what it is—or embrace authenticity, the mute sublimity of a thing just being itself. You can regard it with cool, self-contained skepticism or embrace it with heedless ardor. You can walk carefully in the footsteps of moderation and responsibil-ity, staying within a few standard deviations of the con-ventional wisdom, or you can wave the bright flag of opposition. You can be earnest or flippant, plainspoken or baroque, blunt or coy, dilettante or geek. You can follow the precepts of theory or just go on your nerve. You can labor to be consistent or blithely and capaciously contradict yourself.

It doesn't matter. Actually, it matters a great deal. It matters more than anything. You are guaranteed to be wrong—to insult good taste, to antagonize public opinion, the judgment of history, or your own uneasy conscience. And there is no beautiful synthesis, no mode or method of

criticism that can resolve these contradictions. They cannot be logically reconciled, any more than a safe, sensible middle path can be charted between them. Still less is it possible to declare a decisive allegiance, to cast one's lot with the party of form or the party of content, the armies of tradition or the rebel forces of modernity, the clique of skeptics or the church of enthusiasts.

It should go without saying that every good critic, every interesting critic, will commit some of the crimes enumerated above, whether brazenly or unwittingly. A great critic will be guilty of all of them.

Chapter Six

The Critical Condition

Criticism is complicated. The sheer variety of schools, styles, temperaments, and theories—to say nothing of the endless proliferation of objects and activities that invite critical scrutiny—makes it almost impossible to define. Highly credentialed scholars employed at universities identify themselves as critics; so do newspaper hacks sweating out a few inches of deadline copy after a night spent wrestling with a local repertory theater production of Chekhov, the first episodes of a new cable television series, or the latest iteration of a first-person-shooter video game. Bloggers writing about the same phenomena at greater length or tweeters dispatching 140-character verdicts can be called critics too, and so can the kibitzers trailing behind them, nodding vigorously or taking furious exception. The disembodied voices quoted glancingly in the Zagat guides are practicing a form of criticism, as are the variously angry, ebullient, eloquent, and unhinged reviewers on sites like

Yelp. The largest retail supplier of criticism in the world today may well be Amazon, a pioneer in the online distribution of consumer opinions along with books, DVDs, household appliances, binge-worthy series, original works of art, and nearly anything else that can be commodified. There is also a brisk market in critical derivatives, tranches of aggregated opinion securitized by Rotten Tomatoes and Metacritic, where data-crunching bots boil bushels of raw prose down into easily digestible numbers. *Avengers: Age of Ultron* is certified Fresh with 74%!

To sort out these claimants and adjudicate their claims would require a separate critical discipline, undertaken either by a sober and credentialed cadre of criticism critics or, more likely, by roving bands of Internet commenters. As it happens, the landscape of contemporary criticism is pocked with canyons of meta, recursive formations in which reviewers are perpetually reviewed and judgments extensively judged. Name-calling and position taking are part of the lingua franca of digital culture. Brave individualists huddle in self-protective coteries, tossing rhetorical grenades over the hedges at the idiots in the next yard. Meanwhile, on the green and tranquil lawns of academe, there are subfields devoted to the taxonomy of critical methods and theories, drawing and policing the lines that separate specialists from generalists, formalists from historicists, humanists from deconstructors, belle-lettrists from cultural-studies zeitgeist surfers. The fledgling critic, in and out of

school, is encouraged to choose sides early, to select role models, rivals, and allies in the unending, unwinnable, fight against error.

The history of criticism is, in large measure, a history of struggle among various factions, positions, and personalities, of schisms arising from differences of taste, temperament, and ideology. Since the business of criticism is argument, it is not surprising that over the centuries fierce quarrels have erupted about the nature and direction of particular artistic disciplines—over abstraction in painting, tonality in music, ornament in architecture, realism in literature, realness in hip-hop, and so on—and also about the best methods for examining work in those disciplines. Is each specimen to be examined on its own terms and judged by its particular merits, or should other considerations be allowed? And if so, which and when? Does art stand alone, illuminated by its self-generated aesthetic glow, or are its virtues and values reflections of something else—of politics or religion, of custom or history or evolutionary wiring? Often the arguments are more specific and personal, turf wars in the battle for influence and authority. Young upstarts challenge the power of their established elders. Careerism and idealism converge and clash. Irreverence contends with settled wisdom. New battles erupt as the old ones recede.

"Upon giving the matter a little attention," T. S. Eliot once wrote, "we perceive that criticism, far from being a simple and orderly field of beneficent activity, from which

impostors can be readily ejected, is no better than a Sunday park of contending and contentious orators, who have not even arrived at the articulation of their differences." That was in 1921, but the diagnosis can easily stand in the present. In fact, it's pretty clear that the disease has gotten worse.

At just about any moment in its modern history, criticism is in a state of paradoxical crisis, in danger of disappearing because there is just too damn much of it. "If literary criticism may be said to flourish among us at all," wrote Henry James in an 1891 essay half-facetiously called "The Science of Criticism," "it certainly flourishes immensely, for it flows through the periodical press like a river that has burst its dikes." This state of abundance—beneficial to James, who from the start of his novel-writing career burnished his reputation and augmented his income with a steady stream of essays and reviews—seemed to him to exist in defiance of economic as well as intellectual common sense. Criticism, he wrote, "is a commodity of which, however the demand may be estimated, the supply will be sure to be in any supposable extremity the last thing to fail us." Though "the quantity of it is prodigious," James found the general quality of the commodity notably lacking, marked by deficiencies in "what one may call literary conduct." The fault seemed to him not to reside primarily with the consumers or the producers of mediocre criticism, but rather with a system of distribution that structurally re-

quired more and more stuff without regard for how good or how useful that stuff might be: "Periodical literature is a huge, open mouth which has to be fed—a vessel of immense capacity which has to be filled."

Switching metaphors from the biological to the mechanical, James goes on to liken the press to "a regular train which starts at an advertised hour, but which is free to start only if every seat be occupied. The seats are many, the train is ponderously long, and hence the manufacture of dummies for the seasons when there are not passengers enough. A stuffed manikin is thrust into the empty seat, where it makes a creditable figure till the end of the journey." He pursues this curious analogy of a train with fake passengers until it runs off the track, which may lead one to suspect that the *New Review*, where "The Science of Criticism" first appeared, was paying him by the word. Still, James's point, however overdone, is both amusing and exemplary. A publisher who needs to bring goods to market—especially on a regular monthly, weekly, or daily schedule—can hardly be expected to wait until enough good material is ready, and so must pack in a certain amount of filler. But that filler will be all but impossible, at least at the outset, to distinguish from interesting, original, or worthwhile writing.

Does this mean that the manikin makers and ticket agents who stuff the train with dummies think that these inanimate figures are really people? Do the dummies, like sensitive robots in a science-fiction allegory, believe them-

selves to be real? And when exactly does the "end of the journey" arrive—that moment when the confusion is cleared up and the real criticism is at last separated from its artificial doppelgänger? When the next issue of the periodical in question appears? When the live passengers disembark and resituate themselves in first-class bound volumes? On the day of final judgment? Some time in between?

Of course, the only way to sort the real from the fake—the substantial from the shallow, the excellent from the mediocre—is by means of further criticism, something James's article proves by its very existence. Still, the essence of his argument, like Orwell's in "Confessions of a Book Reviewer," is that criticism would be better if there were less of it. This is an argument—or maybe a desire, a sentiment, an intuition—that is not particular to criticism. Susan Sontag's call, at the end of "On Photography," for an "ecology of images" in a world glutted by easily reproduced pictures is a version of this persistent modern longing for a cultural situation that is more austere, more manageable, more selective. And so are some of the most commonly expressed anxieties about the metastasizing of cable television channels and Internet sites. In the digital world, James's "huge, open mouth" of print has become a ravening maw, his railway station a buzzing airline hub dispatching manikin-laden planes across the globe around the clock. There is surely more criticism than ever before, and

yet—or is it therefore?—auguries of the death of criticism are louder and more insistent than ever.

This may seem strange, since criticism would seem to be a permanent, if mutable and sometimes obnoxious, feature of the landscape. How can it die? I have argued that, as an activity, criticism is immeasurably ancient—the later-born, scrawny, jealous twin of art itself. Criticism as a job, however, is a more recent and contingent phenomenon: the professional critic is a creature of print. There are important texts in the Western critical canon that predate Gutenberg, it is true (mostly works of generalization that survived from Greek and Roman antiquity), and also, more recently, a tiny handful of critics who have enlarged their fortunes and reputations in the McLuhanesque glow of television. But criticism is, above all, a discipline of writing, and a critic is a particular species of writer, one that has flourished over the past few centuries in a distinctively modern cultural ecosystem of widening literacy and periodical publication.

This species, not always beloved, appears at present to be facing the prospect of extinction. The critic's inky, pulpy native habitat, a sometimes mean and shabby place but a home all the same, is threatened, like so much else, by the blindingly rapid rise of digital media, which has already, in a little more than a decade, decisively transformed the world of print and may yet kill it off entirely. Farseeing

media mystics and hardheaded business analysts routinely show up on social media, on television, and between hard covers to prophesy the death of newspapers, the evolution of books and magazines into e- and app versions of their former selves, and the imminent obsolescence of all the old ways of doing things.

Their visions grow less outlandish and more self-evident every day. There is no question that the world of printed discourse, in which criticism has occupied a small but well-appointed corner, is undergoing enormous change. The questions—at least as they are routinely brought up in academic symposia, industry gatherings, and late-night drunken pity parties—have to do with the direction and consequences of the change. Given all the momentous and unprecedented transformations convulsing the globe— the rise of the Internet and the collapse of the public attention span; the spread of social media and the polarization of political life; the decline of everything and the triumph of everything else—what does the future of argument look like?

Over the last decade and a half, the explosion of digital communication technology has shaken the edifice of journalism and unsettled the foundations of print culture. Daily newspapers, glossy weekly and monthly magazines, learned journals, and bound books, for more than two centuries the flagships of civilized discourse and universal knowledge— that whole material infrastructure of literacy has, all of a

sudden, seemed in danger of vaporizing, or if not vanishing entirely then turning into something less tangible and more ephemeral. The shift has been rapid, relentless, and extremely confusing. New gadgets drop into our hands that perform some of the functions that used to belong to bound and printed objects, and some of those new inventions turn what had seemed to belong to the realm of science fiction into commonplace facts of everyday life.

The rise of digital technology and the expansion of apparently frictionless and instantaneous communication on the Internet have had a calamitous impact on older ways of distributing information. As hundred-year-old business models based on advertising, subscriptions, and retail bookstore and newsstand sales—an infrastructure of distribution built on a bedrock of copyright—have crumbled, so has the morale among those who work in what we have learned to call (with a sigh or a sneer) the traditional media. Revenues have fallen even when free online access has caused readership of periodicals to rise, since the formulas for linking circulation to advertising rates turned out not to obtain on the Web. Scores of newspapers and magazines have scaled back or gone under. Foreign bureaus and copy desks have shut down, and thousands of editors and reporters have been laid off, among them hundreds of critics. An anxious, fatalistic mood permeates newsrooms, journalists' watering holes, and expense-account lunch spots. Writers and editors have begun to feel like blacksmiths and buggy-whip

dealers contemplating the ascendance of the automobile. Nostalgia and artisanal pride may keep us around for a while, but nothing will ever really be the same. We must adapt or die, replacing old idioms and practices, rooted in the materialism of paper and ink, with the more abstract language of the virtual domain. We bid farewell to proofs and slugs, endnotes and front matter, and embrace feeds, hyperlinks, search engine optimization, social Web audience development, and whatever new catchphrase or concept promises to save us. We learn the vernacular of clicks and uniques and try to find a home and a voice in publications that are also publishing platforms.

From one perspective—on some days—this upheaval can feel tragic, even apocalyptic. A cosmos that has existed more or less since the eighteenth century—the age of London wits and Paris *philosophes*—teeters on the brink of obsolescence. This is not simply an august and ancient tradition fading into quiet, archive-bound oblivion, but rather an ethos of thought and writing that at its best could be speedy as well as rigorous, accessible as well as learned, passionate and irreverent as well as serious. In the United States, you can trace a bristling lineage of periodical provocation back to the pamphleteers of the revolutionary period and then through journals that played a crucial role in the organization of various native strains of thought and that spawned the careers of writers like Edgar Allan Poe, Margaret Fuller, Nathaniel Hawthorne, and William Dean

Howells. A few of these publications—*Harper's*, the *Nation*, the *Atlantic*—survive to this day, and the history of American magazines, through the twentieth century, is closely bound up with the nation's political, cultural, and intellectual history. Journals of opinion like the *New Republic* and *National Review*; little magazines like the *Dial*, *Hound & Horn*, and *Partisan Review*; general interest weeklies and monthlies; glossies and fashion magazines; the *New Yorker*, *Esquire*, *Rolling Stone*, *Collier's*, *Playboy*, the *Saturday Review*, the *Village Voice*, the *New York Review of Books*—all of these were hotbeds of cantankerous, lively, and brilliant argumentation.

They were also the engines of a motley professionalism, the economic as well as the intellectual scaffolding of writing as a worldly career. "No man but a blockhead ever wrote, except for money," Samuel Johnson declared in the eighteenth century, when the burgeoning business of print was hungry for content and the printers were willing to pay piece rates for it. Doctor Johnson was an epoch-defining genius, an embodiment of the skeptical, quarrelsome spirit of newly energized literary professionalism. As learned as any philosopher in London, Paris, or Leipzig, he was also an apostle of common sense and native wit. An able polemicist, a dogged lexicographer, a prodigious talker, and an industrious annotator and interpreter of Shakespeare, Milton, and other departed giants, Johnson was above all and in the highest sense a hack. Like other key figures who

came before and after him in the English literary canon—
Shakespeare the theatrical jobber and Dickens the brand-
conscious entrepreneur, for instance—Johnson embraced
a literary vocation that was also fundamentally a trade.

There is no scandal in this except insofar as a nagging
sense of purity or propriety insists that there should be one.
"People have got that ancient prejudice so firmly rooted in
their heads—that one shouldn't write save at the dictation
of the Holy Spirit. . . . Writing is a business." So says Jasper
Milvain, the striving young scribbler who is the protago-
nist of George Gissing's novel *New Grub Street*, published in
the same year as James's *New Review* essay. But if it seems
overly pious to maintain that art and commerce are funda-
mentally incompatible—precisely the piety against which
Johnson so brusquely protested—it also seems vulgar and
venal to declare them to be identical. Jasper, especially in
the novel's early chapters, is a careerist and a fool, an acid-
etched satirical study of a type that Gissing, who struggled
for distinction in the scrum of Victorian letters without
pedigree or privilege, knew very well. Nor has this type
vanished from the scene in the intervening decades. Clever
and ambitious, with a know-it-all quality that is (to his
friends, his family, and the reader) both endearing and an-
noying, Jasper confronts a changing marketplace with su-
preme confidence in the adaptability of his talents and the
keenness of his mercenary instincts. "Literature nowadays
is a trade," he lectures his mother and sisters over breakfast

in the book's first scene. "Putting aside men of genius, who may succeed by mere cosmic force, your successful man of letters is your skilful tradesman. He thinks first and foremost of the markets; when one kind of goods begins to go off slackly, he is ready with something new and appetising. He knows perfectly all the possible sources of income." The marketplace, Jasper points out, has changed since the days of the old Grub Street, which was governed by a now obsolescent artisanal mode of production. "[O]ur Grub Street of to-day is quite a different place: it is supplied with telegraphic communication, it knows what literary fare is in demand in every part of the world, its inhabitants are men of business, however seedy."

A vaguely impressive-sounding, supermodern catch-phrase, "telegraphic communication" is to the world of the 1890s something akin to what "digital media" would become a century later, when the ambitious young Jasper Milvains of the first dot-com boom embraced a new and seductive marketplace of start-ups and stock options. The successive revolutions of the eighteenth, nineteenth, and twentieth centuries—and the convulsions of the present—reveal a basic continuity in the economy of print as it expands through periodic jolts of technological innovation. At every phase in the history of media from Gutenberg to Zuckerberg, new methods of production and distribution have revealed ever greater demands for what we have just recently, in a Milvainian spirit, learned to think of as

"content." Jasper is a writer with no allegiance to any particular kind of writing beyond what he can sell. He muses at one point that he could just as well be writing criticism as the sensational novels he plans to produce; his choice is less a matter of vocation than a gambler's hunch. And the logic of trade—of the commodity form—declares all content to be equivalent. Whatever the nonblockheads of the world decide to write, the important, defining thing about them is that they do it for money.

Except that, as James was at pains to insist, all content is *not* equivalent. It can be quantified in columns, pages, and bandwidth, and cut to measure when necessary. Metrics can be applied to circulation—copies sold, advertising rates, page views—but everyone who actually reads knows that the essence of written discourse is qualitative. The nature of the content can hardly be, to a writer or a reader, an incidental detail; it's the whole point of the enterprise. The reason Jasper Milvain strikes us as comically callow— and also a little creepy—is that he is so completely and vocally indifferent to this basic fact. In his view, his great competitive advantage as a writer is that he has, at the outset, nothing in particular to write about. This means that he is, at least in his own mind, perfectly attuned to the fluctuations of demand, and immune to the risk that whatever he writes might turn out to be unfashionable or undesirable.

New Grub Street is in part a satire of literary manners,

and Jasper's bluster is a deliberate exaggeration. His honesty about his motives is appalling and absurd; it sets him up for a complicated and delicious comeuppance later in the book, and also—more importantly for my purposes here—makes him a useful foil for the more common kind of hack, whose career is a series of local, tactical compromises rather than a wholesale and preemptive surrender of integrity. There are different ways to sell out, after all, and different ways of tallying the ledger of sales. It is perhaps better to listen to an actual rather than a fictional careerist on this matter, one whose career is both exemplary and encrusted with legend.

Edmund Wilson, who was born a few years after the publication of *New Grub Street* and who died in 1972, attended Princeton with F. Scott Fitzgerald and went on to write novels and volumes of intellectual and literary history on Marxism, modernism, and the American Civil War. Like very few other modern writers of criticism, Wilson survived without the security of a regular academic post or a staff position at a magazine. He has therefore, quite apart from the durable merits of his work, ascended to an almost mythic status as a paragon of intellectual independence, "widely regarded," according to his contributor's note at the *New York Review of Books*, "as the preeminent American man of letters of the twentieth century." But Wilson regarded himself, stubbornly and not altogether modestly, as a journalist. Though much of what he wrote can be classified as criticism—including marvelously cranky and acute

assessments of contemporary authors and trends—he did not like to be labeled a critic. His identity as a writer inhered not in the type of writing he did, but rather in the way he supported himself at it.

"When I speak of myself as a journalist," he wrote, "I do not of course mean that I have always dealt with current events or that I have not put into my books something more than can be found in my articles; I mean that I have made my living mainly by writing in periodicals. There is a serious profession of journalism, and it involves its own special problems. To write what you are interested in writing and to succeed in getting editors to pay for it, is a feat that may require pretty close calculation and a good deal of ingenuity. You have to learn to load solid matter into notices of ephemeral happenings; you have to develop a resourcefulness at pursuing a line of thought through pieces on miscellaneous and more or less fortuitous subjects; and you have to acquire a technique of slipping over on the routine of editors the deeper independent work which their over-anxious intentness on the fashions of the month or the week have conditioned them automatically to reject, as the machines that make motor parts automatically reject outsizes."

This straightforward and wily account of a writer's tactical engagements with the marketplace reverses the logic of James's metaphor of the train stuffed with manikins.

Wilson takes for granted that most of what is published will be disposable junk: that is what the editors want, and what keeps the machinery running smoothly. The trick is to sneak in the good, serious, substantial stuff under the guise of trend-following trivia, to smuggle in real passengers, as it were, who might pass for manikins.

This is a highly practical and realistic approach to the profession of critical writing, one that takes for granted and takes advantage of an imperfect system and does not suppose that it might be perfected. The machinery by which critical intelligence is distributed to the public may be stupid and irrational, but it is nonetheless susceptible to exploitation by an independent-minded professional. Wilson is justly proud of his skill (and also aware of his luck) in being able to sustain a career while maintaining his independence.

Not everyone is Edmund Wilson, though, and not every critical career—his and Susan Sontag's, and maybe one or two more—is able to advance through the hustle and flow of the print economy. Around the time that Wilson was writing the brief account of his hack's progress that I have just quoted, his near-contemporary Yvor Winters, a poet, critic, and professor at Stanford, published an essay (later collected in a slim, quarrelsome book called *The Function of Criticism*) addressing "Problems for the Modern Critic of Literature." The first of these, he wrote, "is to

find a mode of living which will enable [the critic] to develop his mind, practice his art, and support his family. The universities offer the obvious solution, but the matter is worth at least brief discussion."

In the ensuing decades—from the post-Sputnik, post–GI Bill, higher-education boom of the early 1960s, through the campus revolts later in that decade and the periods of expansion, retrenchment, crisis, and reinvention that followed—the discussion has been extensive, not to say exhaustive. The study of literature, a cornerstone of the liberal arts curriculum through all of this time, has also been a flash point in the intellectual and cultural battles that periodically inflame the university. Even as the dubious employability of English majors is a perpetual source of humor, the question of what and how those students should be studying is treated as a matter of deadly political seriousness. In the 1970s and '80s, the literary academy would be seized by spasms of irritation about "theory," meaning approaches to prose and poetry rooted in esoteric European philosophy. In the '90s, the battle was over the canon of established great authors (most of them dead, white, and male) and efforts to expand the syllabus to cover not only previously ignored writers and books, but also nonliterary products that could be taught under the new, excitingly broad (or maddeningly empty) rubric of "cultural studies." More recently, the ground has shifted again, as proponents

of a technologically savvy, forward-looking "digital humanities" approach have squared off against defenders of the old-school liberal arts.

But Winters divined a more basic problem, a contradiction that would determine much of the unsettlement that came after. The critic's home in the university was built on a philosophical fault line that was also a highly contested piece of disciplinary turf. The departments where the critic might find his mode of living had been dominated by scholars, by analysts of the various arts—poetry in Winters's case—whose labors were undertaken according to quasi-scientific, objective methods. Winters himself was a credentialed member of this guild, having received a PhD from Stanford in 1928. Its members were researchers and philologists, historians and bibliographers, disinclined (at least in principle) to pass judgment on the merits and even the meaning of the things they study. More than that, they were temperamentally and morally distinct from the artists whose work furnishes material for their own: "[T]he professors have made a living by what they have regarded as the serious study of literature; but the men who have composed the literature were not serious, in the professors' opinion and sometimes in fact, and hence have been considered unfit to study or teach it. Each group has traditionally held the other in contempt." The campus-bound critic ambles into a cross fire. The scholars will re-

gard him as an interloper from the wild, irrational, intellectually suspect land of the artists, who may in turn suspect him of treason.

Winters, in this and other writings—the most important collected in an omnibus volume pointedly titled *In Defense of Reason*—does not so much try to call a truce as to declare the whole thing a mistake. Setting himself against the pervasive romantic idea of literature as a fundamentally expressive, intuitive, emotional pursuit, he insists that scholars and poets alike—at least those poets worth reading and those scholars worth listening to—draw from the same spring, and pursue the same goal, which is (to put it baldly) the truth. Criticism therefore, rather than occupying a middle ground between art and knowledge, proves that the two are identical.

If critics are going to be professors, they need something to profess: a body of doctrine and procedure rather than a congeries of impressions and whims. Leaving intact the idea that part of the fundamental business of criticism is judgment, Winters proposes that the aesthetic quality of a given poem is not just arguable, but provable. Elsewhere, in *The Anatomy of Nonsense*, he expands this claim through a series of axioms and syllogisms:

> Is it possible to say that Poem A (one of Donne's
> *Holy Sonnets*, or one of the poems of Jonson or

of Shakespeare) is better than Poem B (Collins'
Ode to Evening) or vice versa?

If not, is it possible to say that either of these
is better than Poem C (*The Cremation of Sam
Magee*, or something comparable)?

If the answer is no in both cases, then any
poem is as good as any other. If this is true, then
all poetry is worthless; but this obviously is not
true, for it is contrary to all our experience.

If the answer is yes in both cases, then there
follows the question of whether the answer im-
plies merely that one poem is better than an-
other for the speaker, or whether it means that
one poem is intrinsically better than another.
If the former, then we are impressionists, which
is to say relativists; and are either mystics . . .
or hedonists. . . . If the latter, then we assume
that constant principles govern the poetic ex-
perience, and that the poem (as likewise the
judge) must be judged in relationship to those
principles.

This argument, at once airtight and preposterous, has a
certain "Kant for Dummies" appeal. It is attached to opin-
ions that have a durable contrarian charm. Winters ex-
pended enormous polemical energy in the promotion of

an idiosyncratic countercanon, insisting that obscure and marginal pamphleteers and versifiers were superior to their better-known contemporaries. The great poet of the English Renaissance was Barnabe Googe. The titan of nineteenth-century American letters was not Emerson or Whitman but the unsung sonneteer Jones Very. Winters could prove it.

My intention in dragging Winters out of his own un-merited obscurity is not to mock his certainty, but rather to celebrate his singular honesty. (I will add that his prose, his verse, and his teaching deserve wider recognition than they currently enjoy.) As criticism began its partial migration, starting in the 1920s and accelerating through the mid-century, from Grub Street to the Arcadian groves of the American campus, Winters wanted to make sure that its place was well earned, and that it could sit comfortably and respectably amid the other arts and sciences.

It did, but not quite in the way he thought it would or should, and as a result of forces much larger than the per-suasive authority of any single critic. After World War II, on the newly thriving campuses—state and private research universities flush with government and foundation money; small, progressive liberal arts colleges; public satellite insti-tutions created to meet the needs of an expanding and aspiring middle class, an increasingly technocratic society, and a growing, mobile, and diverse population—literary study underwent a series of fissures and mergers. Critics

like Winters joined poets, novelists, and other "creative" writers seeking shelter from the literary marketplace in the state- and patron-funded sinecures of academe.

At the gates, they were sorted according to a new and often unstated set of functions, one that was to be replicated in other disciplines. Through one portal poured the doers, the artists, not entirely free of the stigma of unseriousness but nonetheless hired as role models for the young. Their classes were typically called workshops, and they were devoted to the honing of skills rather than the transmission of knowledge. Criticism was part of their pedagogy, criticism of an especially focused and practical kind, one that Winters the poet would have recognized, endorsed, and inflicted on some of his students. Studio art majors endure the "crit," an ostensibly constructive, frequently brutal rite of ego demolition conducted by instructors and peers. Creative writing workshops have their own version of this, during which the fledgling author, usually after reading something aloud, remains silent as the teacher and the other pupils dissect what does and does not work at the level of the sentence, the line, the image, or the overall structure. This is evaluative criticism at its most direct and functional, and it is also criticism from which larger questions of taste—and broader ideas about the world—have been excluded. We are here to figure out what is better or worse (Poem A or Poem B), not to interpret, contextualize, philosophize, or otherwise wonder about what it all might mean.

That kind of criticism occupies its own place on campus, sometimes in a whole other department. Rather than healing the divide between art and scholarship by revealing its irrelevance, criticism was installed as a newly empowered but always embattled form of scholarship. Professors of literature—historians of language, editors of annotated editions, authors of learned monographs on writers famous and obscure—began to call themselves critics. University presses published their work under that label. Their field blossomed with energy and contention, as the new discipline tried, simultaneously, to figure out its basic principles and to satisfy a burgeoning demand for new courses, textbooks, and conference topics.

The flourishing of academic criticism was not without controversy. On the contrary: controversy was its oxygen. The back numbers of scholarly journals are filled with the noise of once-urgent, now quaint-seeming skirmishes: the quarrels among Winters himself, the University of Chicago Aristotelians, and other apostles of the New Criticism; the bitter battles over structuralism and post-structuralism; the squabbles enlisting new historicists, psychoanalysts, gender theorists, and Marxists; the return to literary history; and the rise of approaches based in neuroscience and evolutionary psychology. In some cases, these fights reflected other engagements within and beyond the humanities, in others the grubby politics of ego and reputation. The real conflict,

though, has not been about which type of academic criticism should prevail, but about whether academic criticism can or should exist at all.

The English writer Geoff Dyer has railed against "dimwit academics shovelling away at their research, digging the grave of literature," and against teachers who strangle their students' delight in works of imagination. He is hardly alone. The idea that education has a soul-killing effect on art—on its potential makers and its eager appreciators—is a recurrent theme in modern education itself. The academy's relationship to art is deeply paradoxical. Art has always needed shelter from the marketplace, and the academy is a source of patronage and protection. This safety is purchased at considerable risk, though. The school is a place where the enthusiasm and energy of the young are disciplined and channeled by credentialed bureaucratic functionaries whose real work is to churn out papers and books that no one outside their own disciplinary circle will read. The normalization and standardization of intellectual activity is the goal.

That's not what the brochures say, of course. The university advertises itself, to prospective students and to the society at large, as a place of self-discovery and expanded possibility, where young minds, having snoozed and struggled their way through the routines of primary and secondary schooling, are opened up and set free. The campus is a

place of challenge and self-discovery, whose promotional key word is "passion," our new, touchy-feely term for what used to be called ambition.

An acute and early diagnosis of the contradictory state of the modern university came from Lionel Trilling, a Columbia English professor and eminent literary critic who straddled, from the 1930s to the '60s, the worlds of public intellectual journalism and academic scholarship. In his 1961 essay "On the Teaching of Modern Literature," he noted a radical disjunction between much of that literature's "hostility to civilization" and the inherently civilizing mission of liberal-arts instruction. "For some years I have have taught the course in modern literature in Columbia College," he wrote. "I did not undertake it without misgiving and I have never taught it with an undivided mind. My doubts do not refer to the value of the literature itself, only to the educational propriety of its being studied in college." The incompatibility of Thomas Mann, Franz Kafka, D. H. Lawrence, and even Henry James with the mind-set of twentieth-century American youth instilled in Trilling and his colleagues "a kind of despair."

> It does not come because our students fail to respond to ideas, rather because they respond to ideas with a happy vagueness, a delighted glibness, a joyous sense of power in the use of received or receivable generalizations, a grateful

wonder at how easy it is to formulate and judge,
at how little resistance language offers to their
intentions.

Trilling's concerns are a mirror image of the ones Winters
identified. The problem is not that scholarship—at least the
apprentice version practiced by bright young students at
fine old schools—is serious but that it is not serious enough.
It is the art that is grave and difficult. Winters solved this
problem by insisting that the split between art and learning
was based on a romantic delusion about the emotive, ex-
pressive, and personal essence of art. Trilling, while noting
that "nowadays the teaching of literature inclines to a con-
siderable technicality," found it impossible to contain the
discussion of modern writing within the ambit of technique.
To do it justice was to grapple with painful and personal
matters, with one's own thoughts about sex, alienation, in-
justice, and death, to "stare into the abyss" and then write
a term paper about it.

The wonder of modern American higher education is
that it has managed to have it both ways, to emancipate and
to regiment, to slot armies of dreamers, mavericks, and
iconoclasts into their assigned roles in a highly technocratic
society, to turn the most uncompromising and incandescent
works of imagination—the poetry of Trilling's erstwhile
student Allen Ginsberg, say—into fodder for classroom dis-
cussion and assigned writing. If nobody quite regards this as

a triumph—if the university remains an object of scorn and suspicion as well as celebration, including from its own denizens—that may be a further sign of how well the whole thing works. Like the literary marketplace (Wilson's world of journalism) that is its pretend rival, the academy makes room for oddballs and outliers, for thinkers and writers who cut against the grain. It does this by giving them jobs that are actually impossible to do.

"Making a living is nothing," Elizabeth Hardwick declared in the first sentence of an essay called "Grub Street: New York," which was first published in 1963 in the inaugural issue of the *New York Review of Books*. "[T]he great difficulty is making a point, making a difference—with words." It may seem like bad faith for a comfortable and credentialed literary professional like Hardwick—a well-regarded novelist and critic, married at the time to the prize-winning poet Robert Lowell—to brush away the material concerns that might preoccupy her less fortunate comrades. But her own point is a variation on Wilson's, and also James's, which is that the real work of the literary professional is accomplished against the grain of the economic conditions that enable it. The matters that so consume Jasper Milvain, the strategizing that he takes to be the main task of the writer, are trivial, perhaps because the production of words is so easy.

But how do some words come to have value, and how is that value measured? Hardwick's essay, a series of impressionistic vignettes and haunting evocations of an almost ghostly world of forgotten writers intermingled with cryptic assessments of contemporaries like James Baldwin and Truman Capote, does not propose answers beyond the exquisiteness of its own prose. Its final image, though, is a poignant emblem of how thoroughly writing can be devalued: "At the entrance to the subway station, there is often an archaic figure giving out a folded sheet of information about the Socialist Labor Party, or some other small, oddly extant group. In only a few minutes after the distributor takes up his post the streets are littered with his offering. The pages are not thrown away in resentment or disagreement, but cast down as if they were bits of Kleenex: clean white paper with nothing at all written on it, falling into the gutter."

The texts distributed by this poor anonymous soul make so little difference, have so little point, that they cease to count as writing at all. They are blank, worthless, and received with such pure indifference that consuming and discarding them amount to the same thing. And though Hardwick describes the distributor as an "archaic figure," a ghostly remnant of irrelevant, "oddly extant" ideological struggles, he or she can also be seen as a superstitious omen of things to come. The horror and pathos of this little scene dwell in the specter of writing cheapened into nonexis-

tence, reduced to literal nothingness because it is given away for nothing. The means of distribution—handing out printed matter by hand, one sheaf at a time, to a random audience—is old-fashioned, which may offer a sense of security and superiority to someone wired into the system of magazine and book publishing, a system whose newest emanation was the *New York Review* itself. Begun during a New York newspaper strike, the magazine was the brain-child of a cluster of writers and editors—including Edmund Wilson, who contributed a self-interview to the second issue—who shared a vague but acute sense of dissatisfaction with the state of literary discussion in America. Taking advantage of the fact that publishers, in the temporary absence of Sunday newspaper book review supplements, needed a place to advertise, the founders put together a prototype for what they hoped would be "a responsible literary journal." The high-mindedness of the manifesto in their inaugural issue is notable: "Neither time nor space," the editors declared, "have been spent on books which are trivial in their intentions or venal in their effects." None of James's dummies, in other words. None of the sweated scribbling-for-hire of George Orwell's anonymous book reviewer or the slick posturing of Jasper Milvain's pushy descendants. And if for the moment the contributors submitted their work "without the expectation of payment" to editors who had "volunteered their time," this was a sign not of amateurism but of professional commitment. (In subsequent years, the

Review would pay its contributors decently, and parlay its seriousness into modest but consistent profits.)

Hardwick's pathetic figure handing out socialist literature at the top of the subway station stairs poses no threat to the order and prosperity of the world of professional letters, whose residents balance the business of making a living with the vocation of making a point. Those blank sheets of wastepaper, emblems of writing without impact and therefore without meaning—printed matter that ceases in any real sense to be writing at all—are a nightmare that haunts the sleep of the profession. And "Grub Street: New York" is full of sad, grotesque, anonymous revenants who somehow, like Gloria Swanson's silent-film star in *Sunset Boulevard*, insist on surviving long after their moment is gone: a failed, middle-aged novelist who "has known a regular recurrence of literary disaster"; "[o]ld lady writers, without means, without Social Security, reading in bed all day"; a stranded Latin American intellectual who had come north to write a definitive study of Thomas Wolfe. These characters, comical though they may be, bring a whisper of premonitory dread into Hardwick's elegant and elusive prose. Could this happen to me? To us?

Has it already? The *New York Review* is still around, and in some ways more vigorous than ever. But the balance on which print seemed to depend—high seriousness tethered to a viable bottom line—is precisely what seems to have been upset by the arrival of the new digital dispensation. Its

consequences are succinctly summed up by the folksinger Gillian Welch:

> *Everything is free now*
> *That's what they say*
> *Everything I've ever done*
> *Gotta give it away.*
> *Someone's hit the big score*
> *They figured it out*
> *They were gonna do it anyway*
> *Even if it doesn't pay.*

Making a living, in other words, can no longer be taken for granted, precisely because the writer's greater desire to make a point—or, more generally, the artist's existential need to "do it anyway"—can be. And this is not just the liberation of content, of "information," from the constraints of traditional, paid distribution. "Someone's hit the big score" indeed, namely the heavily capitalized new companies that thrive by distributing creative labor without entering into the customary transactions with the creators. So while the record labels and publishing companies languish, the search engines, aggregators, and streaming services thrive, throwing musicians and writers back on their own resources, or into more primitive retail arrangements. Welch's weary troubadour can "get a tip jar" and "try to make a little change down at the bar" or else sup-

port herself with "a straight job." "Never minded working hard," she sings, "it's who I'm working for." Spotify? Apple? Pandora?

Of course, in the previous era she would have been working for a record company, part of an industry notorious for ripping off musicians and shackling them in exploitative contracts. Creative work—a category that includes critical work—has almost never been entirely free or independent. For most of history, artists have supported themselves through various combinations of patronage and exchange, relying on the subvention of benefactors, whether individual or institutional, and the goodwill of paying customers. Most of the time these consumers purchase work, or the right to experience it, not directly from its makers but through a chain of intermediaries (galleries, publishers and bookstores, movie theaters, advertising-supported publications or broadcasters). One of the alluring features of digital culture is that it will supposedly phase out those middlemen and foster a more direct relationship between artist and audience—more or less of the kind derided, over the centuries, by Samuel Johnson, Jasper Milvain, Elizabeth Hardwick, and everyone else who ever wrote for money. The relationship between market value and other, less tangible and sometimes antithetical values—of knowledge, beauty, originality, substance—seems to be in danger of falling apart, and as a result the basic distinction between professional and amateur threatens to collapse as well. "If

there's something that you want to hear," Welch sings, "you can sing it yourself."

But then again, why not? Is the unraveling of the distinction between the professional and the amateur—and the concomitant shrinking of the distance between writer and reader, artist and public—really destructive of anything beyond guild privileges? These distinctions, as we have seen, are frequently contingent and self-contradictory. The professional is the one who does not do it for free, but also the one who does not do it *only* for money—the person who manages to be serious even while being paid. And, of course, criticism is already a special case, a profession whose existence is shadowed by a fundamental doubt and whose abolition has been desired and prophesied for thousands of years. Translating the final, *Atlas Shrugged*–like challenge of "Everything Is Free" into the language of criticism turns it into a bluff that is all too easily called. "If there's something that you want to judge, you can judge it yourself." Isn't that what we were supposed to do, anyway?

So maybe Welch's lament should be transposed back into the major key of Internet libertarianism, and sung as an anthem rather than a dirge. Everything is free! Yay! What has happened to criticism is part of a broader change in the media landscape, where the jobs that are not disappearing altogether are mutating rapidly into hybrids of the traditional and the new. But a slight shift in perspective—a generational shift, partly, but also an adjustment of sensibil-

ities and expectations—brings a very different picture into view. There may be fewer print outlets, and fewer critics employed at them, but surely if the Internet is anything it is a hive of the kind of quarrelsome contention that is one manifestation of the critical spirit. Individual and group blogs devoted to various art forms—and catering to specialized communities of taste among devotees of those art forms—have proliferated. The Web may threaten to puncture the authority and challenge the permanence of print, but what it offers is a dizzying, sometimes overwhelming diversity of voices, a frequently cacophonous symphony of mockery, snark, rage, and mischief not infrequently leavened by clarity, conviction, and intellectual stamina.

Visions of the post-print universe tend to be either Utopian or apocalyptic. The emerging media dispensation is often imagined as a wild garden of unfettered expression, a democratic space liberated from old habits and hierarchies, in which the self-authorizing discourse of the engaged public will replace the potted wisdom of self-satisfied experts and dubiously qualified professionals. Instead of writers and readers, their interactions regulated by editors, publishers, booksellers, and librarians, there will be a community of friends and followers, joined together in the selfless, benevolent activities of liking and sharing. Helpful algorithms and user-generated reviews will assist us in the exploration of our tastes, and our culture will become at once more democratic and more fully individualistic, as the

power of elites to determine what should matter is swept away on a populist tide.

Or, if you prefer to look at the dark side: the orderly production and dissemination of information and ideas through the time-tested, self-correcting machinery of publication has been fatally disrupted by anarchy and amateurism. Where once there was civility, there will snark come to be. Vigorous public debate gives way to cyberrage, or is smothered in a shaming blanket of smarm. Online, we curl up in echoey cocoons of agreement, from which we occasionally venture to launch hostile forays onto the comment boards or Twitter feeds of our designated enemies.

The supposed battle between the upstarts of the Internet and the dinosaurs of traditional media is the subject of endless hand-wringing and chin stroking, and the posturing on both sides—the condescension of the old-timers and the belligerence of the newcomers—has both simplified and obscured the situation. Neither Utopian projections of the digital, democratic future nor laments about the eclipsed glories of the past are entirely accurate, and at worst the standoff between old and new media has become a battle of straw men, a quarrel of ancients and moderns destined to end in stalemate. The images that the antagonists project of one another are wearyingly familiar and at this point comically—or perhaps depressingly—distorted. An unwashed, sexually frustrated blogger is squirreled away in his mother's basement, undermining the efforts of trained pro-

fessionals who are, to reverse the image, lazy and entitled fat cats determined to guard their privilege from the brave and idealistic labor of citizen journalists. The hard work of thinking and writing is further imperiled by the quick, cheap, superficial trickery of aggregation and content farming. Or else the guardians and gatekeepers of the cultural elite have, at long last, been routed by an empowered and skeptical vox populi.

But anyone who actually reads, including, presumably, the prophets and doomsayers who herald and bewail the rise of the new digital dispensation, knows that things are not so simple. Or else that they are much, much simpler. Newspapers, those beloved tribunes of truth, justice, and the American way, have also, from the start, been swamps of mendacity and corruption, aiming for the lowest common denominator at least as often as they strive for the civic empyrean. The loss of daily, local critics is in some cases lamentable, but the newsroom morgues in most cities are less likely to house the piecemeal oeuvre of unsung Menckens than the hackwork of lifers reassigned from the local school sports beat when their drinking finally got out of hand. Meanwhile, many of the independent-minded iconoclasts of the Internet have a tendency to reproduce rambling and unedited (or glib and unedited) versions of conventional wisdom.

And also, if they stick around and get lucky, to turn pro. The professionalization of the blogosphere is surely, by

now, old news. Journalistic veterans have adapted to looser, faster online formats, often at the urging of editors and under the auspices of established, robustly branded publications. The young renegades who cut their teeth in home-made solo or ad hoc group blogs—the early-twenty-first-century equivalent of the little magazines or fanzines of previous eras—have been hired by legacy media companies or by new media outfits that resemble their precursors in every respect other than having a history on paper. The business models have changed, and are changing still, so rapidly that invocations of "the Internet" and "the blogo-sphere" already sound as quaint as references to "cyber-space" or "the information superhighway" (which is how we used to talk back in the '90s). In the sleek, propri-etary universe of clouds and tablets, the unruly tangle of the old Web is likely to be regarded with puzzlement and nostalgia—as an impossibly disorganized and dangerous zone of anarchy or else as a fecund wilderness of unfet-tered creativity sadly and inevitably enclosed by corporate interests.

We may, in other words, be in a period of retrenchment, as the digital frontier, like the territory in a John Ford Western, comes under the sway of law and private prop-erty. The effect this will have on the literary trades—on the market value of thought and expression—is a source of per-petual anxiety, enlisting writers in a daily battle between optimism and despair. A system of publication and distribu-

tion that has seemed, for most of the past decade, to be teetering on the brink of obsolescence may be gaining new life, as readers reacquire the habit of paying for some of what they had grown accustomed to receiving for nothing. Advertising revenue may continue to allow independent writers to eke out a living in the open spaces of the Internet, and social networks will continue to traffic in the self-promotion of professionals and the likes and dislikes of the laity. Or else there will be only listicles, reader-generated content, and endless aggregation, a digital equivalent of the blizzard of unread paper outside the Grub Street subway station.

The shape of the digital future is hard to predict—which will hardly deter self-appointed prophets and well-paid consultants from doing just that. What is certain is that there will be no shortage of words. Physical and economic barriers to the production and circulation of discourse have crumbled; digital culture is a culture of abundance, of and, of more. And yet this deluge is often perceived as a drought. The sheer quantity of text in the world threatens to erode the value of particular texts, to undermine the authority and integrity of writing as an enterprise.

This predicament is not new, though at every moment in the evolution of technology, as words, images, stories, sensations, and distractions pile up around us, it has felt newly and desperately acute. The Internet in this respect is not the end of print—or film, or recorded music, or

television—but the latest and most powerful extension of an expansionary, viral logic that began when mechanically reproduced texts replaced handwritten manuscripts. We dwell, much as previous generations did and yet more than ever, in a culture of surplus, a condition of perpetual over-stimulation that is at once exciting and disconcerting. The world—which is to say, more and more, the aggregation of our representations of the world—is too much with us, and the sheer abundance of available experience can be paralyzing. What am I supposed to watch, to read, to feel, to dream about? What do I want?

This state of wondering paralysis cries out for criticism, which promises to sort through the glut, to assist in the formation of choices, to act as gatekeeper to our besieged sensoria. There is only so much time, so much money, so much cognitive space, and we might require some help in using it wisely. The irony is that criticism produces its own surpluses, reproducing itself in such rapid profusion as to seem more like a cultural waste product than a vital nutrient, adding to the disorder it is supposed to clear up.

Which leads us back to the question of why criticism exists in the first place. We know what we like, don't we? And surely we know what things mean.

But we don't. We have no idea.

The End of Criticism
(A Final Dialogue)

Q: You have said a great many things about criticism—that it is an art form in its own right; that it exists to enhance the glory of the other arts; that it is an impossible activity; that it is necessary and vital to human self-understanding; that it can never die; that it is in perpetual danger of extinction—and you have said even more about what criticism is not. It is not mere faultfinding or empty praise. It is not just the expression of personal tastes and judgments. It is not science or philosophy or politics or poetry, though at various times it mimics all of those things. But to be frank I'm still not sure I know what criticism is, unless it is whatever a critic happens to be doing. And in that case what is a critic?

A: You've put your finger on it! Criticism is both paradoxical and tautological. It's whatever a critic does—a critic being anyone who is, at a given moment, practicing criticism. And it's an impossible undertaking that is

at the same time impossible to prevent from happening. You might as well try to stop *thinking*. It can't be done.

Q: So we're back where we started: criticism is thinking. Is it a particular kind of thinking, or just whatever a given brain gets up to in the presence of a particular stimulus?

A: Both, naturally. But rather than speaking so abstractly it might be better, in the interests of clarity and our own amusement, to trace the genesis of a particular critical act. Show me what you've been doing there.

Q: Doing where?

A: The drawing you've been making on the back page while I've been talking.

Q: It's just a doodle. I'm not really sure—

A: So much the better. It issues directly from your unconscious, and so is rich with accidental beauty and occult meaning. Let me see it.

Q: Is that a criterion of value then? Something spontaneous or reflexive—unreflecting, unmotivated—is better than something that required a lot of work and thought? You'd rather look at this offhand sketch than at something I sweated over for hours or days or weeks, something I

undertook after years of struggling to master the appropriate techniques? Or are you just arbitrarily looking for an object so you can practice your critical trickery?

A: Both, naturally. You have nicely identified the foundational act of criticism, which is the selection of an object, the willed decision to look. Your creative intention in this case, whether you thought you were making something worth looking at or just occupying a moment of boredom, is secondary to my intention, which is to scrutinize and judge it.

Q: So you can just look at anything? Criticize anything? The rug? The window? What's outside it?

A: Well, yes and no. Anything can be judged, analyzed, investigated, made into a vessel of feeling, meaning, narrative, moral significance, beauty, and so on. But the question is whether the thing in question can bear the scrutiny, which is really to say whether the act of scrutinizing it can be made interesting.

Q: But then isn't my drawing irrelevant? It would seem that the only interesting thing about it is what *you* have to say. Doesn't that mean that a critic is just somebody who can say something interesting about anything, and so get in between that thing and the other people who might be interested in it?

A: Yes and no. Let's say that a critic is a person whose interest can help to activate the interest of others. That's not a bad definition. I should have thought of it before. For that to work, what the critic writes or says has to be interesting in itself. And, of course, it can only really succeed in that way if the critic's own interest is genuine. I may or may not like your drawing, but it's essential that I care about it.

Q: But might your job also be to tell the world that it isn't worth caring about? Surely there are cases when a critic's duty is deflection and deflation. There is so much hype and hyperventilation in the world—so much breathless selling—that someone needs to draw a calm breath or throw cold water or just say look, it's not that big a deal.

A: Yes, and we also have a duty to redirect enthusiasm, to call attention to what might otherwise be ignored or undervalued. In either instance, though, whether we're cheerleading or calling bullshit, our assessment has to proceed from a sincere and serious commitment. Otherwise it's empty and reflexive. If I were, let's say, unmoved by any visual art, or hostile to the very notion that your doodle could be beautiful or profound, then the only ethical and honest course of action for me would be to remain silent and leave the discussion to others.

Q: As if.

A: I know. That rule is more often honored in the breach than in the observance. It's amazing how often supposedly critical arguments are launched from the logically and morally untenable assumption that the work in question is categorically unfit for criticism. Whole art forms are routinely condemned this way, usually those favored by the young or by other socially marginal groups—the poor, racial and sexual minorities, and so forth. To look at the record of contempt for jazz, hip-hop, disco, rock 'n' roll, video games, comic books, and even television and film is to witness learned and refined people making asses of themselves by embracing their own ignorance. And, of course, you can find a symmetrical, countervailing bias against what is perceived as difficult or highbrow or snobbish, whether it's abstract art or movies with subtitles or classical music. Whatever criticism is, it is surely the opposite of that kind of preformed, unreflecting dismissal.

Q: So you have said. But doesn't that just reduce criticism to fandom, and restrict it to a circle of aficionados, the ones who already "get it" and who speak to one another in the coded language of the initiated? Is there no room for a neutral—or skeptical, or just curious but not necessarily *knowing*—perspective, one that comes from outside the inner circle of the already convinced?

A: In fact, that's *all* there is room for. Now let's see your work.

Q: Oh, my "work." Really. If you insist. Don't laugh, though.

A: . . .

Q: Well?

A: I—

Q: Yes?

A: Is this supposed to be me?

Q: Well, it's kind of . . .

A: Do my jowls really sag that much?

Q: It's more an idea of you, really. I mean, not really you in the literal sense. You were talking and I just noticed the way your eyes cut sideways when you were looking for the right word and I just tried to capture that.

A: Yes, I can see.

Q: You hate it.

A: No. The hairline . . .

Q: Okay, but here's the thing: Let's say it wasn't supposed to be you. And let's say it wasn't drawn by me. Or that

you didn't know it was by me, or that you didn't know me. Let's say you saw it in a museum . . .

A: This? What museum?

Q: You know what I mean. Suppose you saw it in a different context. Suppose it was attributed to, I don't know, Degas.

A: Degas.

Q: It's a silly little cartoon I drew while you were talking. You said you wanted to look at it. And since you did and since that's the foundational act or whatever of criticism, I want to know: What are you looking at? How do you make sense of what you see? Do you analyze the formal qualities—the line, the use of negative space, the cross-hatching? Do you compare it to other drawings you've seen? Other works by the same artist, in the same genre? Do you try to find out what the artist might have been thinking or what kind of person the artist was, from what kind of background?

A: Yes, all of that.

Q: All of that. All of that is going through your head right now? Or all of that is what you will need to consider as you formulate your, ahem, critique . . .

A: I like it.

Q: You like it.

A: It's nice.

Q: It's nice. That's what the critic has to say?

A: Well, you have to start somewhere. Of course, it's very complicated.

Q: Oh, of course. You seem—uncharacteristically, I must say—at a loss for words. And isn't that because you're not really sure who you're talking to? You like to say that the essence of criticism is conversation—a passionate, rational argument about a shared experience—but I wonder if you really mean it. I think for you it might be more of a performance, a thing you can only do if there's an audience. And if it's just me, and I also turn out to be the "artist," then words might fail you. Or put it another way: You have spent many, many pages chasing after the pure aesthetic encounter, the moment of ecstatic contemplation when all context falls away and the beholder and the work find themselves in a state of mutual presence, but isn't that a fantasy? Aren't there always conditions attached? Even when it's just you and me and you're looking at a silly drawing?

A: Maybe especially then. And maybe—which I think is what you're implying—there's no such thing as private or personal criticism. It has to be a public act, something you're invited to do when something is submitted

for your approval (or disdain). Very little happens in the world without some kind of publicity, without it being known, promoted, hyped, whatever. So if criticism can be the corrective to that hype, it might also be true that the hype is the precondition for criticism.

Q: So if instead of your snatching the doodle out of my hands I had said, "Hey, take a look at this, tell me what you think . . ."

A: I might have suggested that if the softness of the jaw was meant to convey an indecisive temperament, the effect is undermined by the determined set of the mouth, and that the eyes are weirdly asymmetrical, as if one were turned inward while the other gazed out at the world with puzzlement and hostility. Though it's quite possible that you were not being inconsistent but rather trying to capture the contradictions inherent in your subject, and so turn this tossed-off portrait of a critic into an allegory of criticism itself.

Q: Now you're just showing off.

A: Well, yes. And trying to save face, as it were. Have you seen the movie *Ratatouille*?

Q: We saw it together. You cried the whole time.

A: I was moved. It's a movie about the symbiosis between artist and critic, the perfect summation of everything

BETTER LIVING THROUGH CRITICISM

I believe, at once "exuberantly democratic and un-
abashedly elitist, defending good taste and aesthetic
accomplishment not as snobbish entitlements but as
universal ideals."

Q: Are you quoting yourself?
A: Anton Ego, *c'est moi!*

Q: But isn't Anton Ego kind of the villain?
A: *Assurément pas!* He is Remy the rat's secret sharer, the
only one who truly understands his genius.

Q: Really, though, doesn't Remy just need the publicity that
a good review from Ego will provide? The critic may
fancy himself a priest of good taste and a champion of
high standards, but isn't he at bottom more of a shill?
And doesn't Ego's review of the meal Remy cooks at
Gusteau's lay waste to the whole critical enterprise? The
part everyone quotes is about how pointless criticism
is—how everything a critic does is forgotten, how no
one pays attention anyway . . .
A: "The bitter truth we critics must face is that, in the
grand scheme of things, the average piece of junk is
probably more meaningful than our criticism designat-
ing it so." I know it by heart.

[262]

Q: He also says that the one area where a critic risks some-
thing is in "the discovery and defense of the new." "The
new needs friends," he says. But that's a fairly limited
brief, isn't it? The best you can hope for is to be a carni-
val barker for novelty, an accomplice in the puffing up
of the next big thing. It's pathetic, really. Ego has
worked his whole life at something that nobody cares
about and that doesn't much matter.

A: Yes, but there's quite a lot more behind that review,
which is hardly the movie's only or final word on crit-
icism. Ego is not pathetic, though he is undoubtedly
shrouded in pathos. His is a lonely vocation, exactly as
lonely as Remy's, at least at first. And that's because,
though one cooks and the other writes restaurant re-
views, it is in essence the same vocation. Remy and
Ego both devote themselves, for reasons neither one
entirely understands but in ways that seem innate and
involuntary, to the especially intense appreciation of
something everyone else either takes for granted or en-
joys in a casual, undisciplined way. Food. This places
them at odds with other members of their respective
omnivorous species. Remy is driven from his rat family
when his culinary ambitions put them in danger. Be-
fore that he tries to educate his brother Emile, who like
the other rats eats whatever is in front of him, in the
higher registers of flavor. Mere nourishment, Remy

tries to explain, may be biologically sufficient to keep our bodies going, but there is so much more to our biologically bounded lives than mere survival. Remy, in other words, shows that the artistic impulse can be present even in the meanest, subsistence-driven circumstances—indeed, that it has to be there if it is to exist anywhere. He further shows that the artistic vocation is born in a critical—a comparative, discriminating, novelty-seeking—engagement with the environment. He transforms the given into the special.

If Remy starts at the bottom of the food chain, Ego, when we meet him, dwells at the top. But he is no less lonely and misunderstood. He is fortunate enough to live in Paris, the world capital of gastronomy and also, not coincidentally, of an ideal of culture that fuses intellectual discipline with a devotion to the pursuit of pleasure. But Paris in this movie, as in real life, is harassed by consumerism, threatened by a vulgar, cheapening mode of commerce embodied by Skinner, the bad chef who nearly destroys the legacy of Gusteau. The shallow customers who are happy to eat the branded swill he serves are his coconspirators in culinary corruption. So together, even before their fateful meeting, Ego and Remy are united in a project that the rest of the world can only dimly comprehend but that is nonetheless vital to the world's progress. Remy may think that pleasing Ego will help him realize his professional

ambitions, but what he requires more deeply is the recognition of a like-minded soul.

That is precisely what Ego needs from Remy. His love of food has been so frequently and thoroughly disappointed that it has nearly withered into cynicism. This is a moral danger—a danger to morale, and to decency—that many of us face as we age. Nostalgia is part of it: some portion of our formative experience takes on the status either of a lost Eden or a receding Utopian ideal. As reality keeps letting us down, a vital source of critical energy is lost.

Q: By vital source you mean a precritical capacity for simple delight, the ability to be moved without thinking.

A: Exactly. When Ego tastes Remy's ratatouille he is transported back to that primal scene. For him, the dish evokes a highly specific complex of emotions. They can't be explained, or even narrated, but are rather rendered through the kind of wordless, deeply emotional montage that is something of a Pixar hallmark. Through those images we know the pain of the boy, little Anton, who fell off his bike, and also the maternal solicitude that eased it, in the form of Mme. Ego's ratatouille.

Q: But really, what kind of mother comforts her child with stewed eggplant?

A: A French one. And also the mother of a future food critic. As Remy well knows, the rustic simplicity of ratatouille belies its technical sophistication. You have probably eaten—or, more likely, politely left uneaten— your share of mediocre, too-sweet, tomatoey sludge sitting alongside a drab piece of chicken or lamb at god knows how many bad restaurants, or eaten the stuff cold from a plastic tub while standing in front of the open refrigerator late at night—

Q: That was caponata.

A: Same difference, most of the time. But if you read Julia Child's original ratatouille recipe in *Mastering the Art of French Cooking* you will discover the key procedure that Mme. Ego no doubt knew and that most lazy or hasty cooks ignore. It is essential to sauté each vegetable separately, in a prescribed order, in the same olive oil, before layering them for the final simmer. I say essential because the essence of each vegetable—onion, eggplant, tomato, zucchini—is surrendered to the fat, and that sequencing of flavors is the key to the dish. It's not stewed vegetables; it's flavored oil. That oil is the medium and the meaning, the form and the content, the matter and the spirit . . .

Q: You're losing control of your metaphors.

A: I am, but let my exaggeration stand for the overwhelm-
ing nature of the experience, which our critic Anton
Ego must somehow distil into words. Words that may
not explicitly give voice to the experience but that will
subliminally connect it to the universe of public dis-
course, so that venturesome palates will want to share
in what he has discovered. And, of course, that's just
what happens.

Q: Well, actually, it isn't. When it's discovered that Ego has
published a review praising a meal cooked by vermin he
loses his job and his reputation. His greatest act as a
critic brings him ruin and disgrace.

A: Which is exactly what every critic must be willing to
risk at any time. The next phase of his career, by the
way, makes literal a crucial aspect of the critic's role,
which is to function as the artist's silent partner.

Q: Yes, but he isn't a critic anymore. He's finished. He's re-
turned to the pre- or noncritical state of simple enjoy-
ment. He's a patron in both senses of the word. The last
time we see him, he's sipping wine with a smile on his
face at Remy's new restaurant, as if he has been freed
from all care, granted a new lease on life.

A: He has attained an ideal state where there is not only no
more criticism, but no more art. Remember what Gus-

teau says: not everyone can cook, but a great cook can come from anywhere. I take this to be both an answer to and an elaboration on the insight that anchored Brad Bird's previous Pixar feature, *The Incredibles*. "If everyone is special," that movie insisted, "then no one is." In Gusteau's version, everyone may theoretically have the ability to cook, but only a select few will have the luck or discipline to elevate that skill to the height of art. If Remy is one of those gastro-incredibles, then so too is Mme. Ego, whose fame as far as we know is limited to her son's memory. What she and Gusteau represent is a Utopian dream, one that Remy and Ego turn into reality: that the boundary between art and life—and therefore the uncomfortably aligned, sometimes antagonistic roles of creator, consumer, and critic—will dissolve, along with the distinction between labor and pleasure.

Q: That'll be the day. In the meantime, let's have a drink.

A: If you'll pour. But we're far from done. There is a great deal more to discuss. The horizon of perfection is as far away as it has ever been, and therefore the work of criticism, properly understood, is endless. Nobody has ever figured out where to begin, or what to conclude. But in spite of that, a true critic is someone who knows, at long last, when to stop.

Afterword: A Reply to My Critics (One More Dialogue)

Q: Just to get us caught up: after years—too many years, maybe—of dishing it out you decided to see if you could take it. You wrote a book about criticism and tossed it, like a lamb into a den of lions, in front of your critical peers. How did that work out for you?

A: More or less as expected. There was the usual range of reviews—some glowing, some scathing, others variously mixed, measured, and lukewarm—and it won't surprise you to learn that it feels good to be praised and bad to be attacked. To be shrugged off or dismissed with "on the one hand, on the other hand" equivocation fills you with a special kind of despair. All your strenuous efforts and heartfelt passions turn into the dreary occasion for someone else's hackwork.

I've been on the giving end of all of that, of course, and I wish I could say that the payback was humbling or transformative. Reading my reviews in the aggregate was intense and exhausting—at times thrilling and infuriating—but what I mostly feel is vindicated. Nearly everything I wrote in this book has been proven true by its critical reception.

Q: I rather doubt that, though I don't at all doubt that you'd see things that way. But did you just say "in the aggregate"? Isn't your whole argument—or one of your arguments, anyway—that criticism is the expression of a precious and singular sensibility? An "art of the voice"? Are you going to quote me your Goodreads score, your Amazon average, whatever version of a Rotten Tomatoes rating you've cooked up for yourself?

A: How I've missed our little talks. They tend either to be people's favorite parts of the book or else the parts that piss them off the most. All my fault, of course.

Q: Don't be so damn agreeable. That, if I read some of your critics correctly, is among your gravest faults. You jump from one side of a question to the other. Laura Miller in *Slate* describes you as "flitting" and "dialectical," which she doesn't mean in a good way. Nathan Heller in *The New Yorker* seems to like you all right but says this book is "a mess."

Your refusal to make a commitment, to take a stand, drove poor Leon Wieseltier (*The Atlantic*) into a parox-ysm of rage. His erstwhile acolyte Adam Kirsch (*Tablet*) took your dithering as a sign of "anxiety." They both ac-cuse you of lacking the confidence, the sureness of judg-ment, that is the hallmark of true criticism. What's more, you fail to articulate a credible defense of the critical enterprise. Instead, you splash around in the shallows of pop culture—Kant and Keats and various Greeks not-withstanding—and embrace the supreme postmodern vice of relativism. You're a feckless dilettante and, much worse, the cause of dilettantism in others.

A: Well, I'm glad to see that you've been keeping up with your reading. Let me correct you on one small point. You say that I fail to articulate a defense of criticism as Kirsch, Wieseltier, and others of their kidney (notably Joseph Epstein in *Commentary*) define it, which is to say as the application of verifiable, externally existing stan-dards to works of art. But I don't fail to do that. I *refuse* to do that. I reject the terms of the assignment.

Q: Are you saying that they misread you? That sounds like the oldest, stalest anti-critical self-defense in the book. In this book, even. You've been misunderstood! Poor thing. But doesn't that just mean you didn't make your-self clear enough?

A: On the contrary. There are some reviewers, I guess,

who wrote about a book I scarcely recognized as my own. They were obviously projecting their own biases and neuroses onto my work. But that's perfectly normal, and part of the correct (which is to say the permanently and productively errant) practice of criticism. Recall Wilde: "The highest criticism is that which reveals in the work of Art what the artist had not put there." The book's most furious assailants, though, understand it perfectly well. They see it, correctly, as a betrayal of, an attack on, or at best an irresponsible departure from norms and canons they hold sacred. Wieseltier's review, for example, is amusingly personal— a portrait of me as a vain, vapid dabbler, distracted by trivia like Hollywood blockbusters and Marina Abramović and lacking the spine to fight for what I believe in. Not that I really believe in anything at all. Or rather, as Wieseltier puts it, "he believes in many things. But most of all, he believes in brunch." As opposed to, say, lunch at the Four Seasons, which is the kind of meal Wieseltier enjoys. "The battle for aesthetic integrity is not over," he declares, "but I'm not a combatant, just 'a man on the scene.'"

Q: Brunch?

A: It's a metaphor. Serious thinkers eat breakfast or lunch, and don't need to invent reasons to drink before noon. But the thrust of his review is not that I'm just a twerp.

I'm a symptomatic twerp, a sign of the rotten, relativistic, unserious times. Which in a way I am, given that the difference between Wieseltier and me isn't merely temperamental. It's philosophical.

He and I have fundamentally opposed ideas about the nature and purpose of criticism. His "battle for aesthetic integrity" is essentially defensive. There is this knowable thing called beauty (or excellence or value) that is perpetually under siege. The critic's job is to keep the bad stuff out, to police the boundaries, secure the gates, and correct errors of judgment.

Q: But isn't that accurate? Doesn't a critic function as a gatekeeper?

A: Certainly there are many people who perceive it that way, though I'm not sure most working critics do. Maybe that's part of the source of Wieseltier's despair— that modern critics, like modern parents, see themselves not as authorities but as friends. But the gatekeeper notion is an odd and oddly hostile way to think about art—as an enclosure that needs to be protected. A critic in this view is like the bouncer at an exclusive club, patrolling the velvet rope and turning the undesirables away. Of course what often happens is that the undesirables go off and start their own party. After a while the old establishment grows dull and stale and the crowd thins out. Eventually the place may be rediscovered, or

else it quietly changes its standards of entry and welcomes the kind of customers that had previously been turned away.

Q: That's quite a metaphor for someone who is usually in bed before ten. But this is where the charge of relativism sticks to you, I think. And also the accusation of aloofness. You stand at a remove from the daily rough-and-tumble of criticism, which often precisely involves throwing people out of the club, policing lines that should not be crossed. You do that all the time in your job, of course—you are hardly above a choke hold or a sucker punch when you think the occasion calls for it—but you're shy about making a case for the value of what you do. Instead you take such a long, tolerant view of the history of taste that everything becomes equivalent to everything else just because at some point somebody liked it. You don't have the guts to look at empty or meretricious work and say, as Leon Wieseltier does of Marina Abramović: "Who cares?"

A: Well, as you say, I make negative judgments all the time. I just don't find them inherently more valuable than positive judgments, which is the implication of both Wieseltier's view and his long record as a commissioner of hatchet jobs in the back pages of *The New Republic*. But what occupies me here, in this book, is the possibility that "who cares?" might not be a rhetor-

ical question. Surely it's worth asking in earnest who might care about performance art or video games or Beethoven's late string quartets. Which is not to say that such things are interchangeable, but rather that they are all plausible objects of intense human interest. I want to think about why people care about art, pleasure, beauty, and truth, and also to wonder if there can be judgment without prejudgment. What if we went into a given experience not knowing what to expect or how to think and had to invent our standards and reasons on the spot, with whatever conceptual tools we might have handy?

Q: That's all very abstract.

A: Yes, but that's part of what I mean when I say that this is a philosophical argument rather than a personal quarrel or a literary spat. At the risk of getting too academic, and also of drastically oversimplifying, I'd say that Wieseltier—and also Kirsch and Epstein—and I belong to antithetical traditions of thought. Although I try not to make a big deal about it in the book—I don't want to bore readers more than is absolutely necessary—among my principal guides are Ralph Waldo Emerson and John Dewey. If there's an implicit allegiance here, a school of thought in which I might claim membership, it's some version of pragmatism. That is, I believe that our understanding of art emerges

from our experience of it, and that our notions of beauty and value are the result of our arguments about them, rather than the conditions of such arguments Truth is the lovely echo of our noisy, contending ways of being wrong.

And one big way to be wrong—perhaps one I should have addressed at more length—is to buy into the fantasy of critical authority, to confuse the decidedly democratic power of persuasion with other kinds of power.

Q: And yet you yourself are, according to Calum Marsh in *The New Republic*, "A. O. Scott, Last of the Power Critics."

A: A title I'm only too happy to disavow. I'm not the last of anything, and I'm not interested in power. Marsh is, I think, succumbing to his own careerist daydreams. He's entitled to them, of course. Writing is a tough hustle. Envy is part of the lingua franca of the guild, and so is the thirst for inside dope. A few critics, some but not all of them younger than I am (Marsh makes a point of mentioning my age in his review) may have looked forward to (or looked forward to attacking) a more polished account of my professional life, or a more forthright embrace of the prerogatives and perks of my day job. Some readers may have been nonplussed by my apparent lack of interest in such things, and smelled some bad faith in my disinclination to write

explicitly from the position of a *New York Times* critic. My modesty could only be false and my optimism can only be forced given the prestige of my institutional connections and the abysmal state of the trade in general. It's easy for me to promise "better living" when my living is easy.

Q: And what about that? In the age of social media, sponsored content, cultural glut, and rampant touchy-feely dumbness—

A: Leon, is that you?

Q: —at such a moment your equanimity is pretty jarring. Maybe even tone deaf. Even one of your champions, Daniel Mendelsohn, concludes his review (in the Book Review section of your own newspaper) with the melancholy thought that you and he and the rest of your generation "may be the last professional practitioners" of the art of criticism. Your up-tempo, major-key, sing-along anthem is really a funeral march, and you either don't know that or don't want to admit it.

A: To be honest, I have wondered sometimes if my faith is misguided. Maybe this time the declinists and nostalgists are not wrong after all. The sky really is falling. The wolf is descending on the flock. The great work has all been done, and the great critics are all gone. But if I really thought that—

Q: —you'd be Joseph Epstein, whose plaintive review has the headline "Where Have All the Critics Gone?"

A: A piece of writing I will always cherish. I'm proud to have provoked such sustained and undiluted rage. Epstein begins by invoking Edmund Wilson and other great critics of the mid-twentieth century, a golden age that continues to cast a long shadow. Wieseltier worships at the shrine of Trilling. Adam Kirsch, a more cautious fellow, summons the shade of Stanley Edgar Hyman, a hardworking hack of the Eisenhower era. Compared to them, I'm a joke. I'm not even a critic, according to Epstein, but a mere reviewer, dispensing summaries and canned nuggets of consumer advice. (I'm also an obnoxious leftist, as evidenced by my use of the phrase "late capitalism.")

And, once again, I'm a noxious symptom of a much larger cultural catastrophe, which can be summarized as the shocking failure of the rest of the world to keep up with Joseph Epstein's tastes and interests. Or rather, its failure to freeze in place and continue to worship at the shrine of high culture as he recollects it. Criticism used to be all about James and Dreiser and Eliot, and nowadays it's all about movies and television and rock and roll and other things he doesn't much care for.

Q: "Were he alive today, [Randall] Jarrell might have to seek work reviewing video games."

A: Video games are to Epstein what brunch is for Wiesel-
tier. Once upon a time there were titans like Jarrell and
Wilson, who bestrode the world of letters far more co-
lossally than any of our current pip-squeaks could
dream of. And there was also a culture worthy of them,
even if it lay mostly behind them, in the masterpieces
of previous centuries. But they were never so foolish as
to imagine that the rising tide of popular culture—
"Masscult," as one of their contemporaries, the polem-
icist Dwight Macdonald, liked to call it—might toss
up anything worth taking seriously.

But what if Randall Jarrell was actually interested in
video games, or at least found something interesting to
say about them? (Not that he would have necessarily
found a lot of paying work reviewing them, at least in
conventional publications.) I don't think that's alto-
gether far-fetched. As an admirer of Jarrell's, I think it's
altogether probable.

And I wonder, speaking of video games, if Epstein
has read Tom Bissell or Anita Sarkeesian or Chris Suel-
lentrop, all of whom have written very well on the
subject. Okay, I don't wonder that at all. Nor do I really
wonder if he has read Emily Nussbaum or Wesley
Morris on television, any of his own contemporaries
(Ellen Willis, Greil Marcus, Lester Bangs) on rock, or
any of the generations who have followed them. Or for
that matter, any of the vigorous and contentious liter-

ary critics in our midst, some of whom (like Laura Miller, Christine Smallwood, and Laura Kipnis) didn't even like my book all that much. If you define "all the critics" as "all the critics who mattered to me when I was in college," then of course you'll mistake ordinary mortality for mass extinction. But again, let's take this question as something other than rhetorical. Where have all the critics gone? They're all around you. You just refuse to recognize them.

Q: But can any of them match Edmund Wilson?

A: I've never said this to you before, but what a stupid question! Edmund Wilson, when he was alive and writing, couldn't live up to the shibboleth his reputation has become. It's not a very happy fate for such a resourceful and unpretentious writer to survive mainly as a cudgel to be used against later generations. He's better than that. Far more interesting than Epstein gives him credit for being.

Q: And you are too?

A: That's not for me to say. Criticism is an art of the voice, and I can't complain if some people don't like mine (that "of a man who vastly overestimates his own charm," according to Epstein) or prefer the sound of their own. But I nonetheless insist that my version of criticism is stronger than that of my critics—in spite

of their fetish for power and authority—because it includes theirs. The narrative of doom and decline is a story that must be told anew in every generation. But it will always crumble in the face of new and contrary evidence. To proclaim the end of criticism is really to express the wish that criticism would stop. But as we have seen, it won't.

Q: Keats and Yeats are on their side. . . .

A: But they lose, because Wilde is on mine. But I don't fool myself that quoting Morrissey will convince anyone of anything, least of all an optimistic view of human possibility. Gloom is more appealing because it seems so much more serious, and fosters a feeling of lonely heroism.

Q: You're prone to that as well. Haven't you set yourself up as a heroic figure—the critic fighting for criticism in the face of disdain, indifference, and incomprehension?

A: No no no. You have misread everything! I'm not the hero of this book. You are.

Acknowledgments

Over the many years that I worked on this book—even when I didn't necessarily know that I was working on it—I was sustained by the unconditional love and the formidable critical intelligence of my parents, Joan and Don Scott, and my sister, Lizzie. I am also grateful for the love and support of Grace and Arnold Wolf (z"l), Joel Henning and Maria Ojeda, John and Sarah-Anne Schumann, Dara Henning and Steve Caton.

More immediately, the book owes its existence to Elyse Cheney, my remarkable agent, who has been a steadfast advocate and confidante for almost two decades and whose perfect blend of patience and impatience helped me overcome many obstacles and frustrations, almost all of them self-imposed. She and Allison Lorentzen conspired to bring the project to Ann Godoff at the Penguin Press, who saw what I wanted to do more clearly than I did and whose editing was a model of scrupulousness and skepticism—a work of critical art in itself. The same can be said of Jane Cavolina's acute and sensitive copyediting. I thank Casey Rasch, William Heyward, and Sarah Hutson for their hard work; Darren Haggar for his beautiful jacket design; and Scott Moyers for his friendship.

Criticism as I describe it in these pages can be a lonely undertaking, but it is also fundamentally sociable—a matter of endless conversation and fervent argument. Manohla Dargis, David Edelstein, Wesley Morris, and Michael and Stephen Trask have been my most reliable and provoking interlocutors, and also among the best friends a critic could ever want. So was David Carr. I miss him every day. I am lucky that two of my earliest critical role models, John Leonard and Greil Marcus, became my friends later on. I am sorry that John is not here to read this book, and much sorrier for the loss, to myself and other readers, of his voice and his example.

ACKNOWLEDGMENTS

John and Sue Leonard belong at the top of the list of editors who have given me room and encouragement to write. I would be nowhere and nobody without them and without Charles McGrath, Robert Silvers, Laurie Muchnick, Judith Shulevitz, Michael Kinsley, and Jack Shafer. At the *New York Times*, where I started as a full-time critic in 2000, I have had the good fortune to work with and for a succession of astonishingly talented editors, including John Darnton, Steven Erlanger, Jonathan Landman, Sam Sifton, and Danielle Mattoon in the Culture Department; Ariel Kaminer, Megan Liberman, Alex Star, Sheila Glaser, Adam Sternbergh, and Jake Silverstein at the Magazine; Ann Kolson, Jodi Kantor, Lorne Manly, Stephanie Goodman, and Sia Michel in Arts and Leisure; and Gabriel Johnson in Video. They collectively deserve much of the credit for what is in here—and perhaps a share of the blame as well.

Some of the ideas in this book were tried out in public, and I'm grateful to the organizers and audiences who permitted me to think out loud at Yale University, the University of Kentucky, Ithaca College, Cornell University, the New School, New York University, Columbia University, Brooklyn College, the University of California-Irvine, Fairfield University, Emory University, City Arts & Lectures in San Francisco, Temple KAM–Isaiah Israel in Chicago, and Congregation B'nai Emunah in Tulsa. My students in Film Studies 370 at Wesleyan University in 2014 and 2015 helped inspire me to finish the book. I thank Jeanine Basinger and Michael Roth for the opportunity to teach at Wesleyan.

The members of the Criticism Working Group at the New York Institute for the Humanities have buoyed me with their solidarity, their good humor, and their brilliance: thanks to Eric Banks, Ruth Franklin, Mark Greif, Rochelle Gurstein, Jennifer Homans, Laura Kipnis, Wendy Lesser, Arthur Lubow, Emily Nussbaum, and Alex Ross.

My children, Ezra and Carmen, have taught me how to think about all the things that matter, including but not limited to art, pleasure, beauty, and truth. This book is dedicated to my toughest, truest critic, who makes my life better in every way.

Index